AUGUSTE RACINET

FULL-COLOR PICTURE SOURCEBOOK OF HISTORIC ORNAMENT

All 120 Plates from "L'Ornement Polychrome,"
Series II

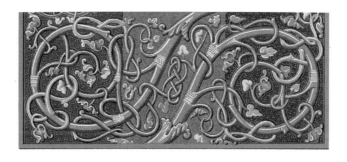

DOVER PUBLICATIONS, INC.

NEW YORK

Copyright © 1989 by Dover Publications, Inc.
All rights reserved under Pan American and International Copyright Conventions.

Published in Canada by General Publishing Company, Ltd., 30 Lesmill Road, Don Mills, Toronto, Ontario.

This Dover edition, first published in 1989, contains all 120 color plates from Racinet's *L'Ornement Polychrome, deuxième série*, originally published by the Librairie de Firmin-Didot et C^ie, Paris (see Publisher's Note for longer title and further bibliographical details). The original French text is here omitted, being replaced by new captions, Publisher's Note and List of Illustrations in English, all prepared specially for the present edition. The Arabic numbering of the plates is also a new feature.

Manufactured in the United States of America
Dover Publications, Inc., 31 East 2nd Street, Mineola, N.Y. 11501

Library of Congress Cataloging-in-Publication Data

Racinet, A. (Auguste), 1825–1893.
　　[Ornement polychrome. English]
　　Full-color picture sourcebook of historic ornaments : all 120 plates from "L'ornement polychrome." Series II / Auguste Racinet.
　　　　p.　　cm.
　　Translation of: L'Ornement polychrome, deuxième série.
　　ISBN 0-486-26096-8 (pbk.)
　　1. Color decoration and ornament.　I. Title.
NK1548.R3313　1989
745.4—dc20　　　　　　　　　　　　　　　　　　　　　89-11969
　　　　　　　　　　　　　　　　　　　　　　　　　　　　　　CIP

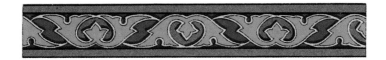

PUBLISHER'S NOTE

The French painter and illustrator Albert-Charles-Auguste Racinet, who was born in 1825 and died in 1893, was the editor of two impressive and influential collections of color plates.

One of these publications, *Le Costume Historique* (published in parts, 1876–1886; in volumes, 1888), totaled 500 plates, 300 of them in full color. In 1987 Dover published 92 of these color plates in *Racinet's Full-Color Pictorial History of Western Costume* (ISBN 0-486-25464-X).

Racinet's other monumental plate book was *L'Ornement Polychrome* (Color Ornament), a visual record in color of ornament and decorative arts from all over the world and throughout history. This collection eventually included 220 plates. The first 100 plates, which constitute Series I (not so called until the publication—not originally foreseen—of the second series), appeared in ten installments between 1869 and 1873, was published in volume form shortly after the completion of the installments and went into at least a third edition in that form. In 1988 Dover published all 100 plates of Series I under the title *Racinet's Historic Ornament in Full Color* (ISBN 0-486-25787-8).

The first series was so successful for Racinet that, from 1885 to 1887, he issued another 120 plates specifically designated as "Deuxième série." The original subtitle of Series II reads: "Cent vingt planches en couleur / or et argent / Art ancien et asiatique / Moyen Age, Renaissance, XVIIe, XVIIIe et XIXe siècles / Recueil historique et pratique / avec des notices explicatives / publié sous la direction / de M. A. Racinet / auteur de l'Ornement Polychrome (1re série), du Costume Historique, etc." (120 plates in color / including gold and silver / Art of antiquity, Asia, / Middle Ages, Renaissance and the 17th, 18th and 19th centuries / Historical and practical collection / with explanatory notes / published under the direction / of Mr. A. Racinet / author of *L'Ornement Polychrome* [Series I], *Le Costume Historique*, etc.).

The present Dover edition contains all 120 plates from Series II, with brief new English captions that summarize the French text. The copious material, ranging from Ireland to China and from ancient Egypt to the late nineteenth century, is derived from a wide range of arts and crafts including architecture, painting, woodwork, metalwork, ceramics and textiles. Racinet's purpose in publishing these masterpieces of decoration was the encouragement and improvement of the arts of his own day, not only the so-called fine arts but also the commercial arts involved in the designing and marketing of manufactured goods. Dover's reissue of the plates, recognizing their perennial value and appeal, naturally is meant to serve the same purpose. Racinet's breadth of insight and catholicity of taste, truly enlightened for his day, give his selection a welcome variety and a consistently high standard of excellence; while the consummate skill of his artistic fellow workers and of his printer-publisher, the celebrated Firmin-Didot company, make these plates true works of art in their own right.

Racinet's color plates were prepared on the basis of existing works of art by a number of capable commercial artists, identified in the original edition at the lower left-hand corner of each plate. The following artists are represented in Series II of *L'Ornement Polychrome*:

Bauer: 6, 26, 30, 31, 55.
Bénard: 36, 42, 50, 52, 77, 80, 82.
Brandin: 56, 59–61, 83, 88, 93, 94, 105, 111–113, 117.
Charpentier: 17, 75, 76, 85, 91, 92, 99, 103.
Chataignon: 9, 43, 57.
Cottelot: 41, 44, 101.
Daumont: 89.
Debénais: 39, 79.
Dreux: 86.
Durin: 32, 116.
Gaulard: 97, 98, 115.
Gautier, St Elme: 114.*
Guesnu: 46.
Lemoine: 24.
Lestel, P.: 1, 3, 10–13, 15, 16, 21, 35, 37, 45, 47, 64, 71, 90, 119, 120.
Manoury: 7.
Mathieu: 4, 78.
Mauler: 118.
Méheux: 5, 107.
Nordmann: 106, 114.*
Picard: 8, 104.
Schmidt: 14, 18, 19, 23, 25, 27–29, 34, 38, 40, 54, 62, 65–69, 81, 95.
Spiégel: 2, 33, 58, 63, 70, 72–74, 84, 96, 102, 108–110.
Taillefer: 20, 22, 51, 53.
Waret: 48, 49, 87, 100.

*The credit for No. 114 is: "drawn by St Elme Gautier, lithographed by Nordmann."

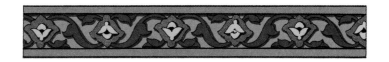

LIST OF ILLUSTRATIONS

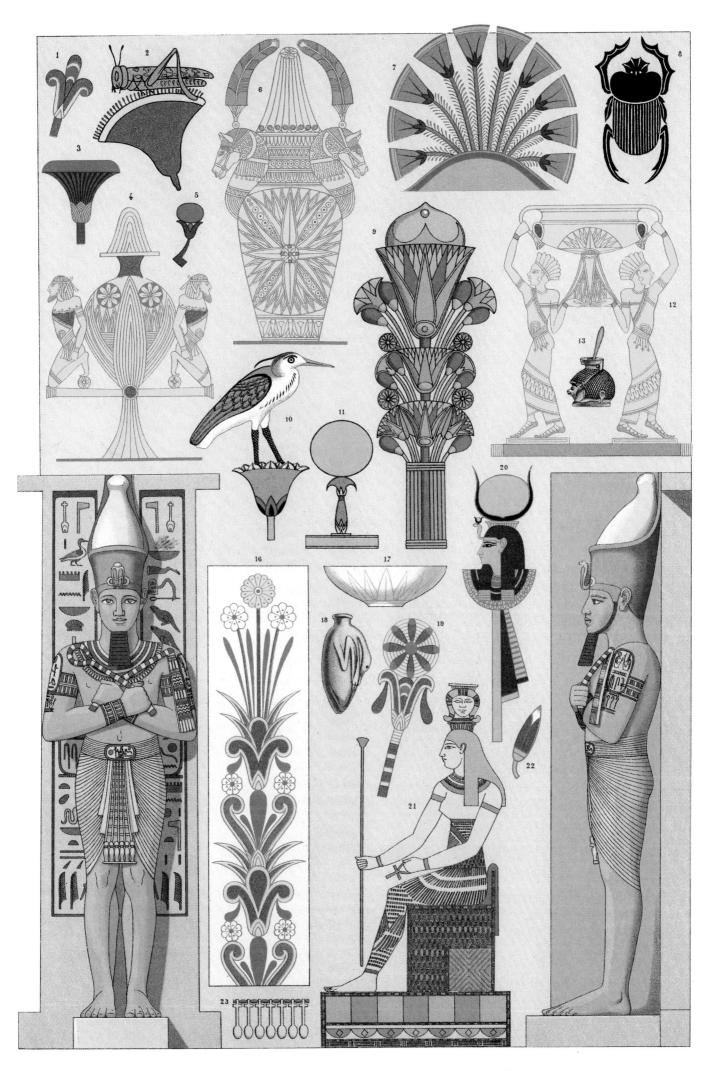

1. Ancient Egypt: Motifs from murals and reliefs, and various objects.

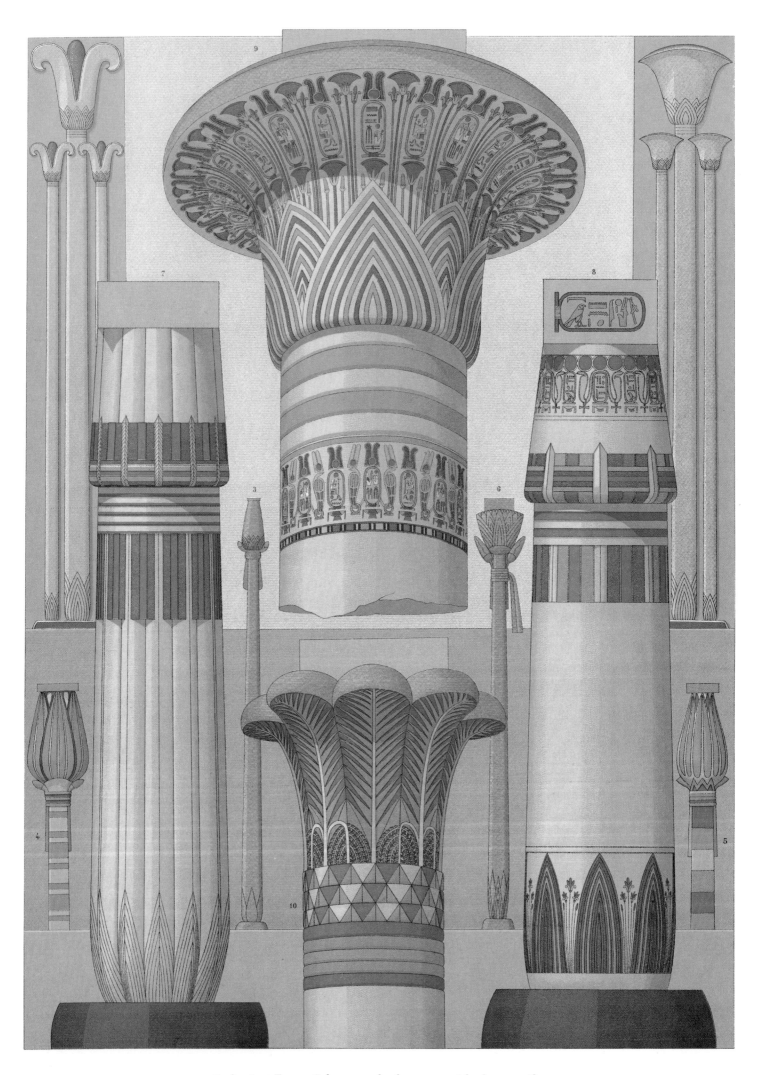

2. Ancient Egypt: Columns and colonnettes with plant motifs.

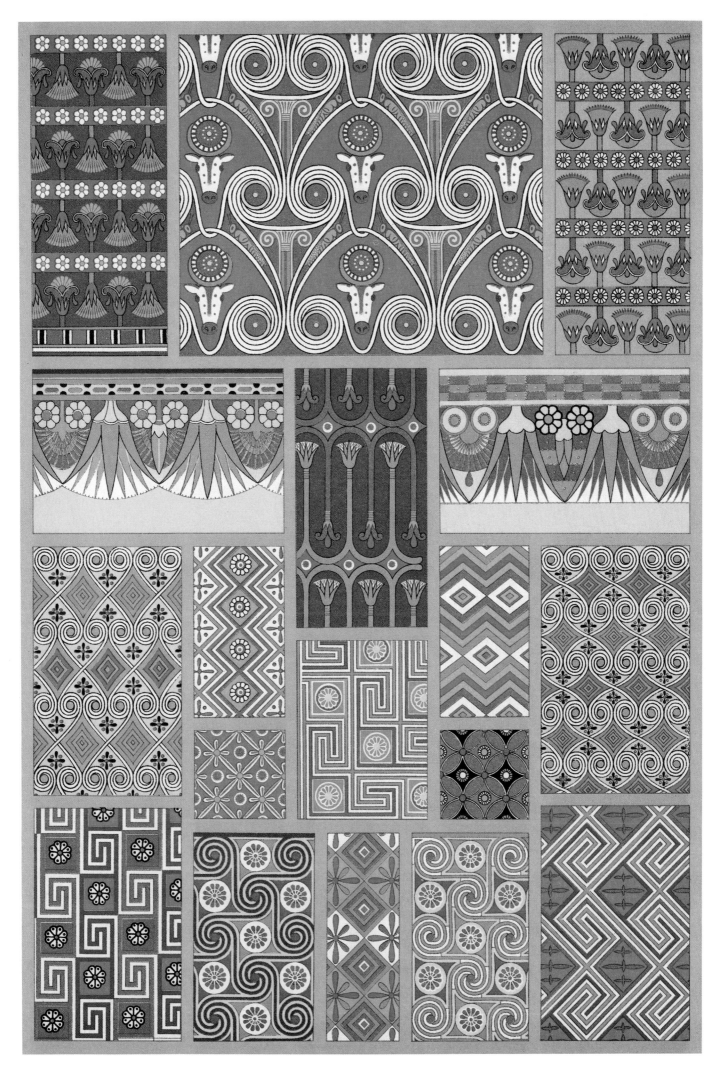

3. Ancient Egypt: Painted tomb ceilings and friezes.

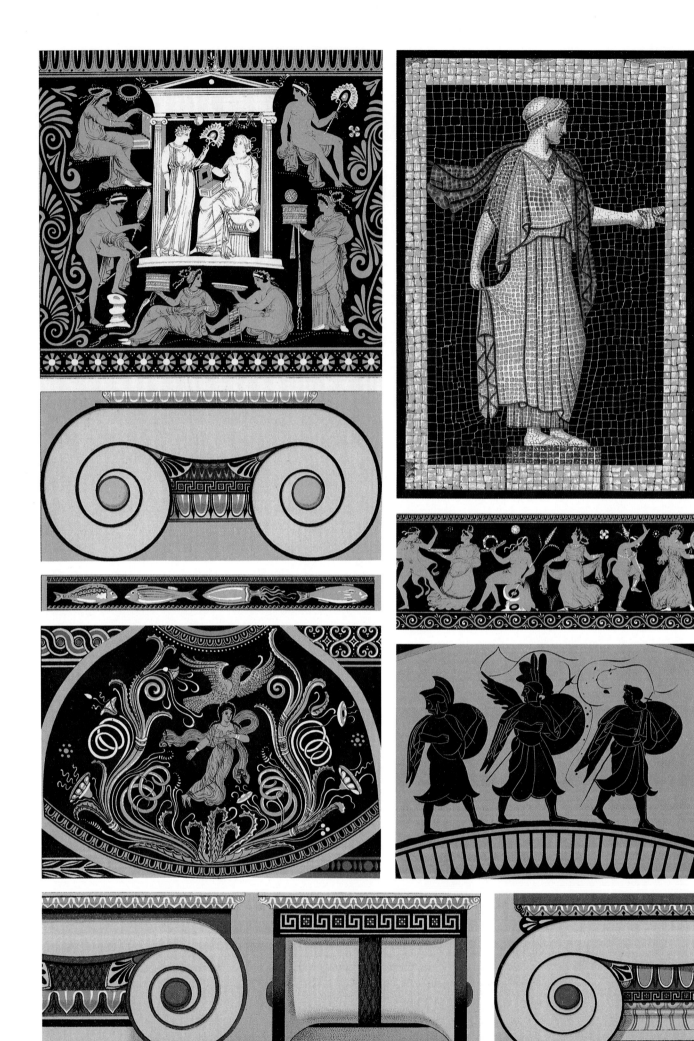

4. Ancient Greece: Vase paintings, capitals and a mosaic.

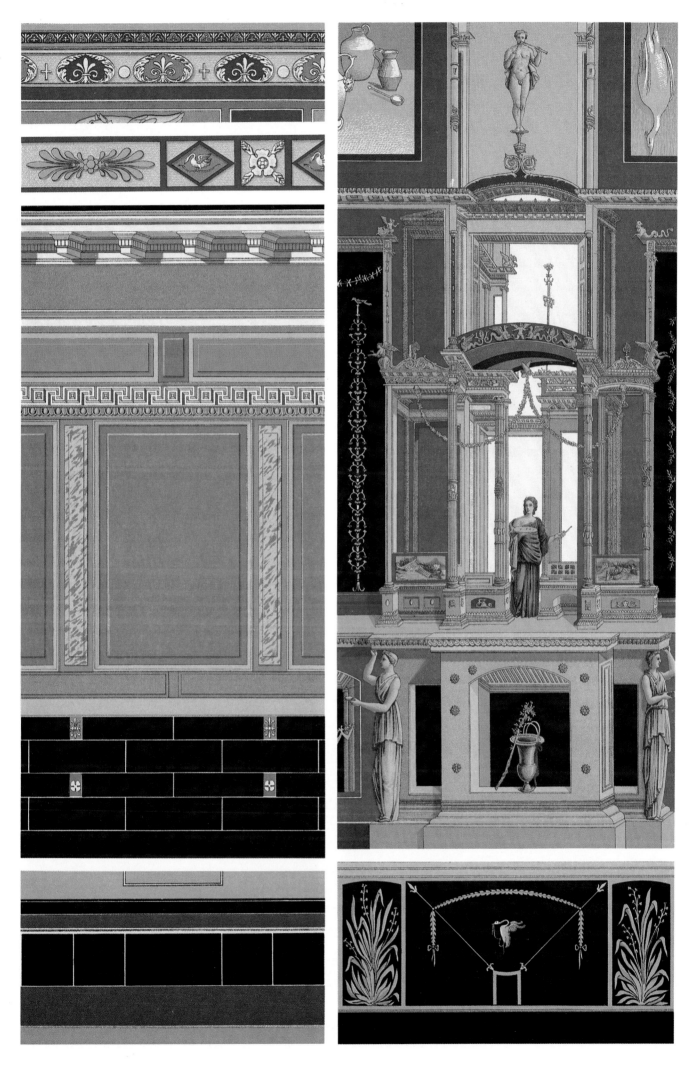

5. Ancient Italy: Wall paintings from Pompeii.

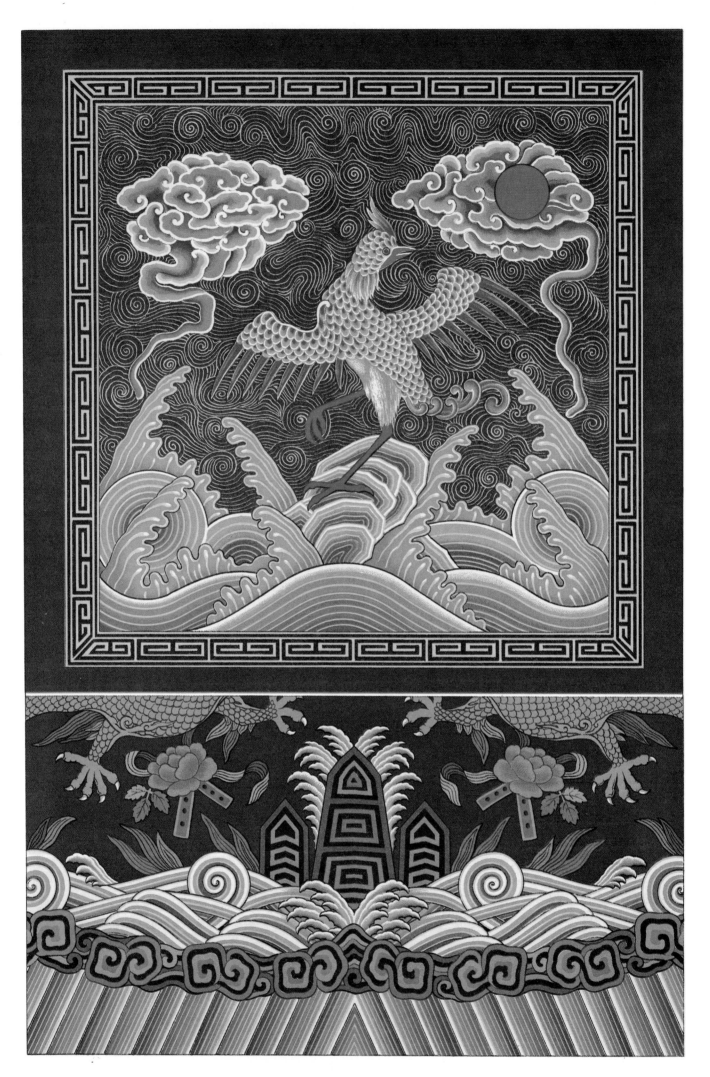

6. China: Embroideries (mandarin badge and detail from a court robe).

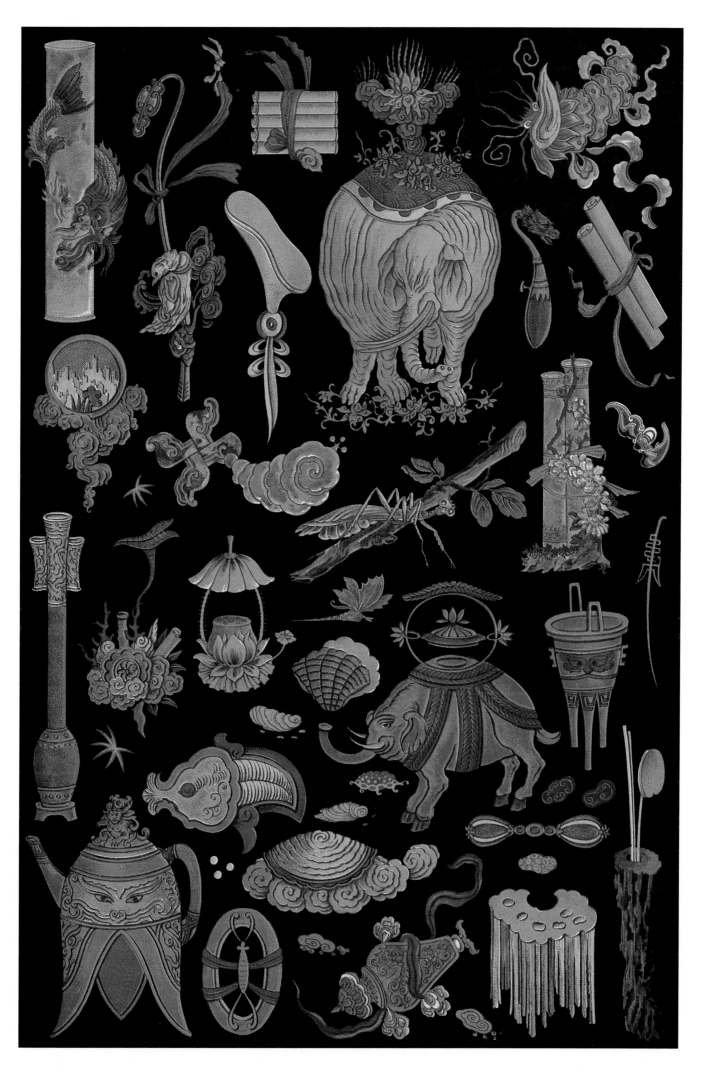

7. China: Painted and gilt motifs from lacquered wood.

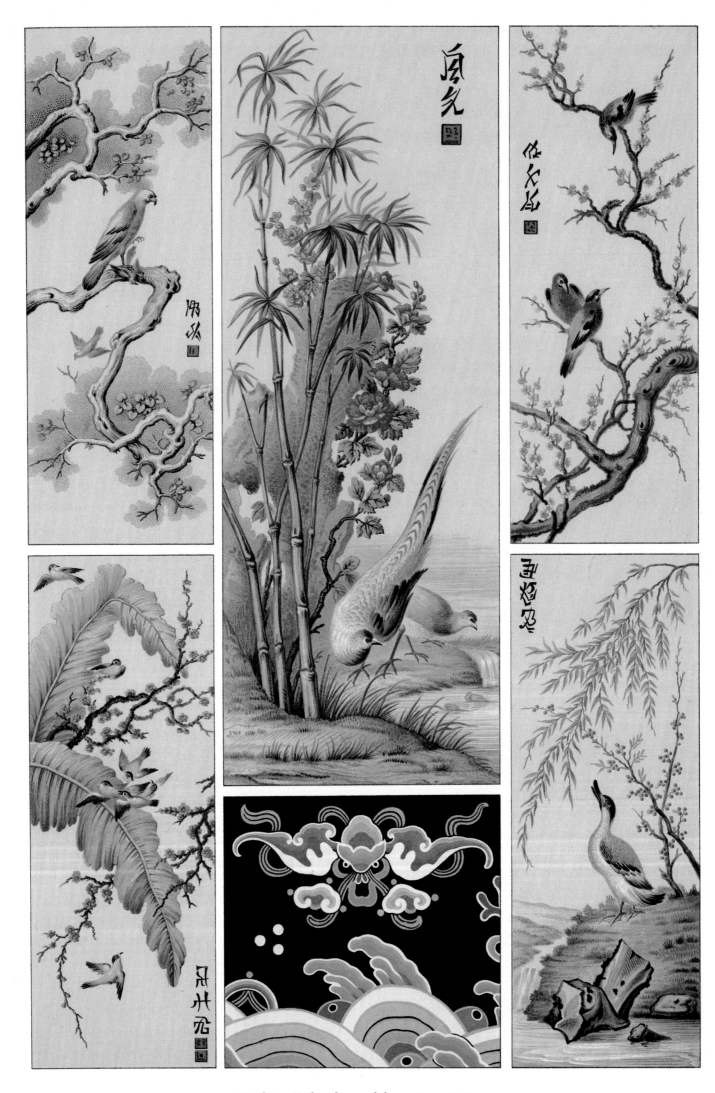

8. China: Embroidery and decorative paintings.

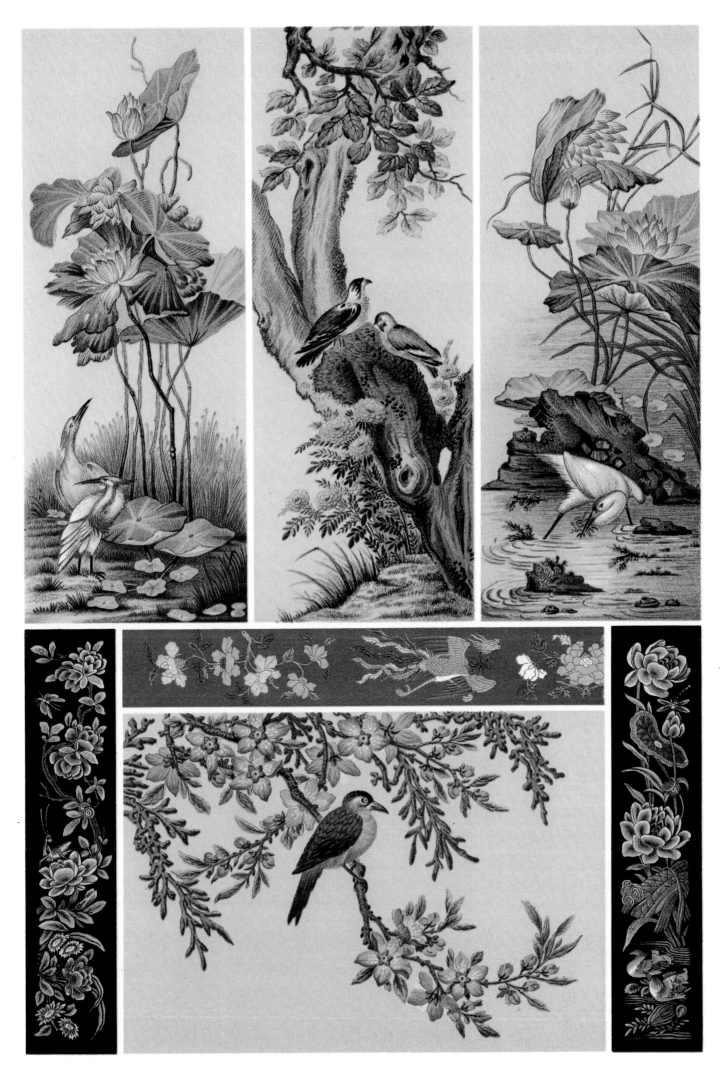

9. China: Paintings, embroideries, printed fabrics.

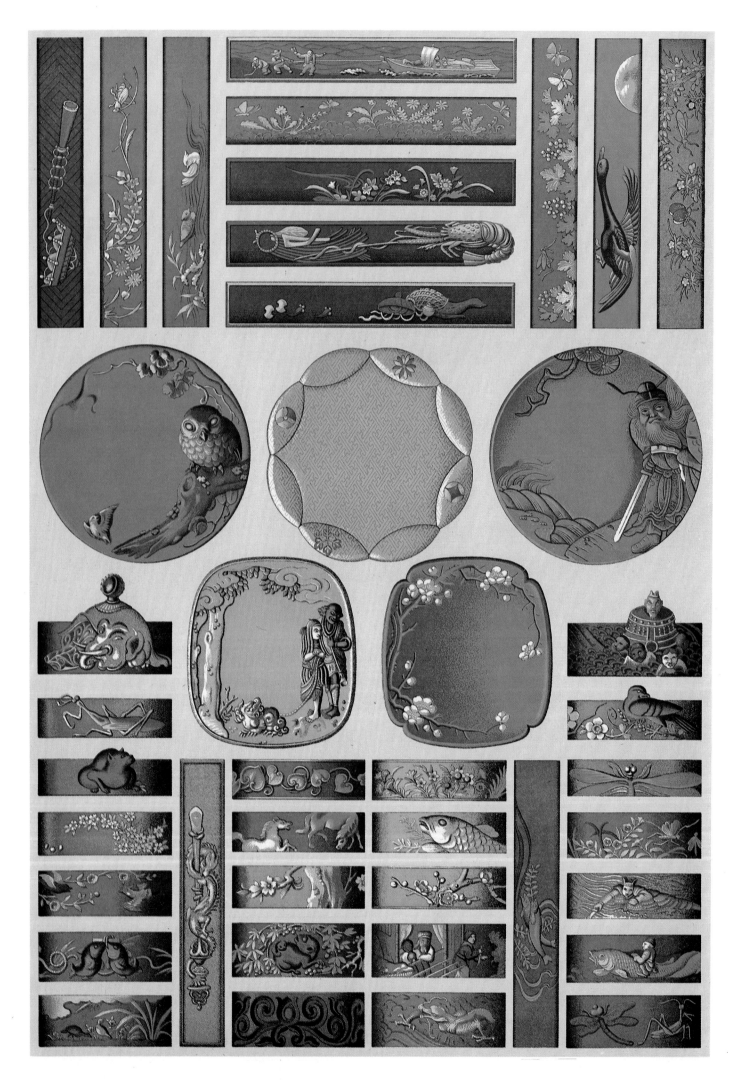

10. Japan: Sword and knife guards and handles, metal.

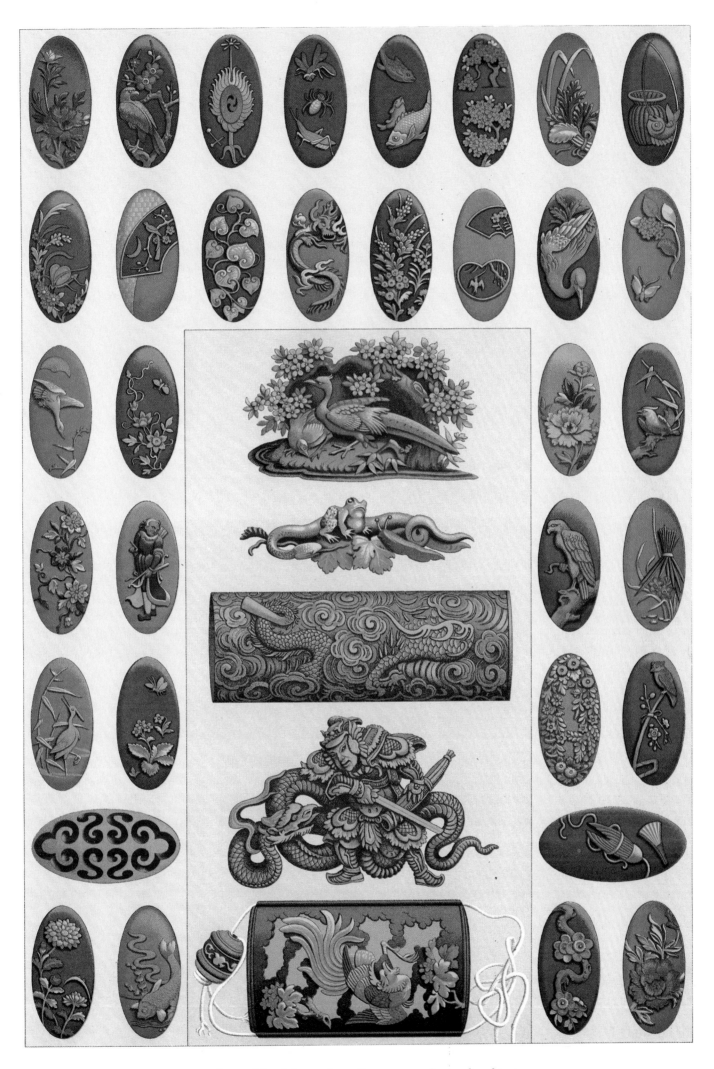

11. Japan: Metal decorations of weapons and everyday objects.

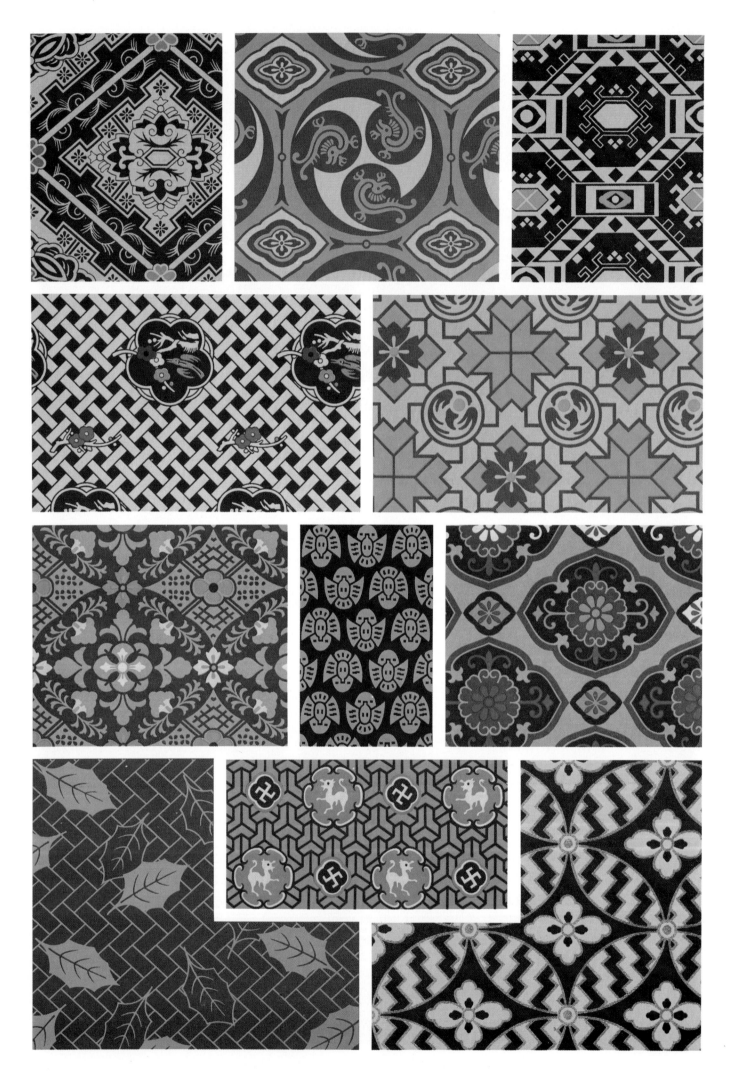

12. Japan: Motifs from textiles of the 17th and 18th centuries.

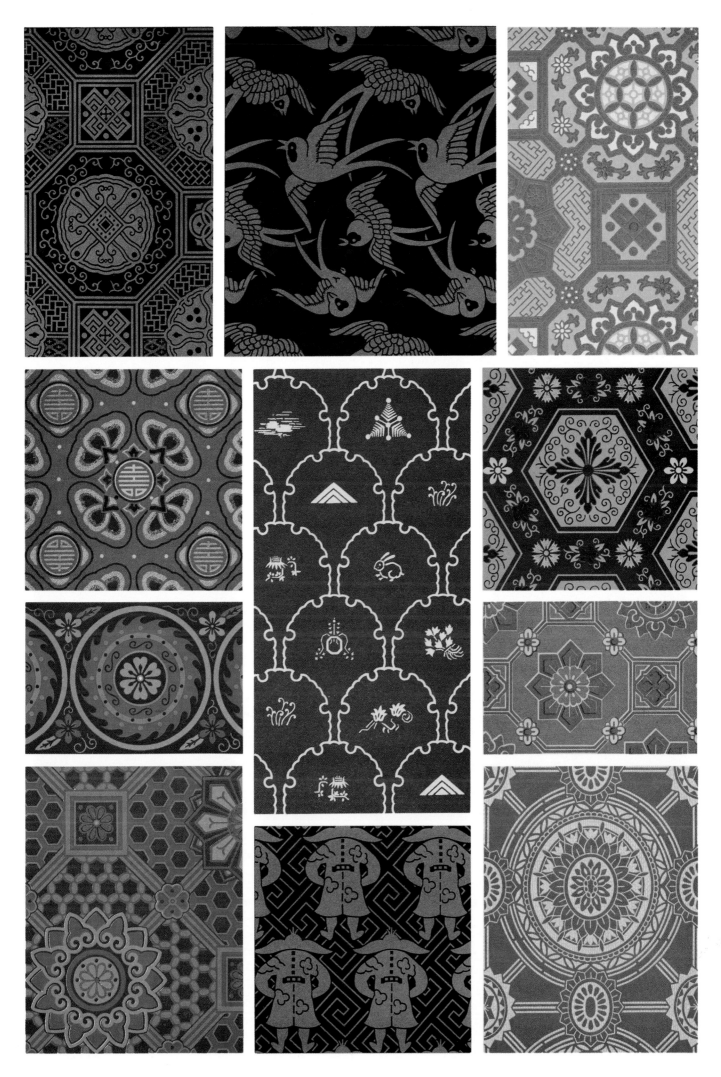

13. Japan: Motifs from textiles of the 17th and 18th centuries.

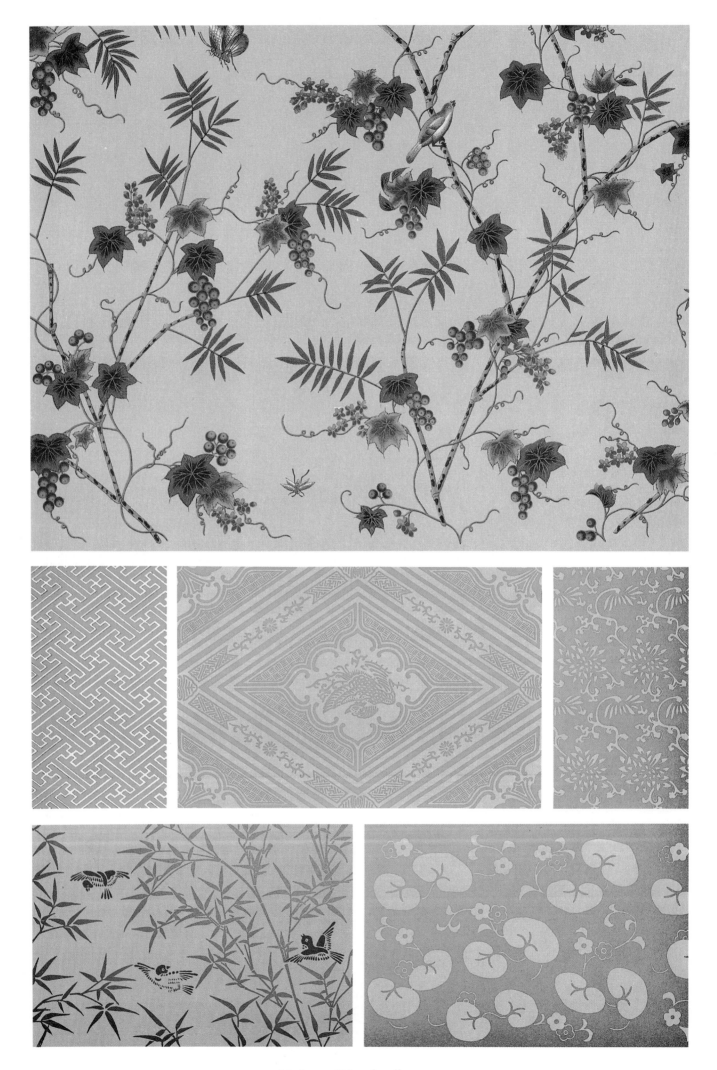

14. Japan: Printed wallpapers.

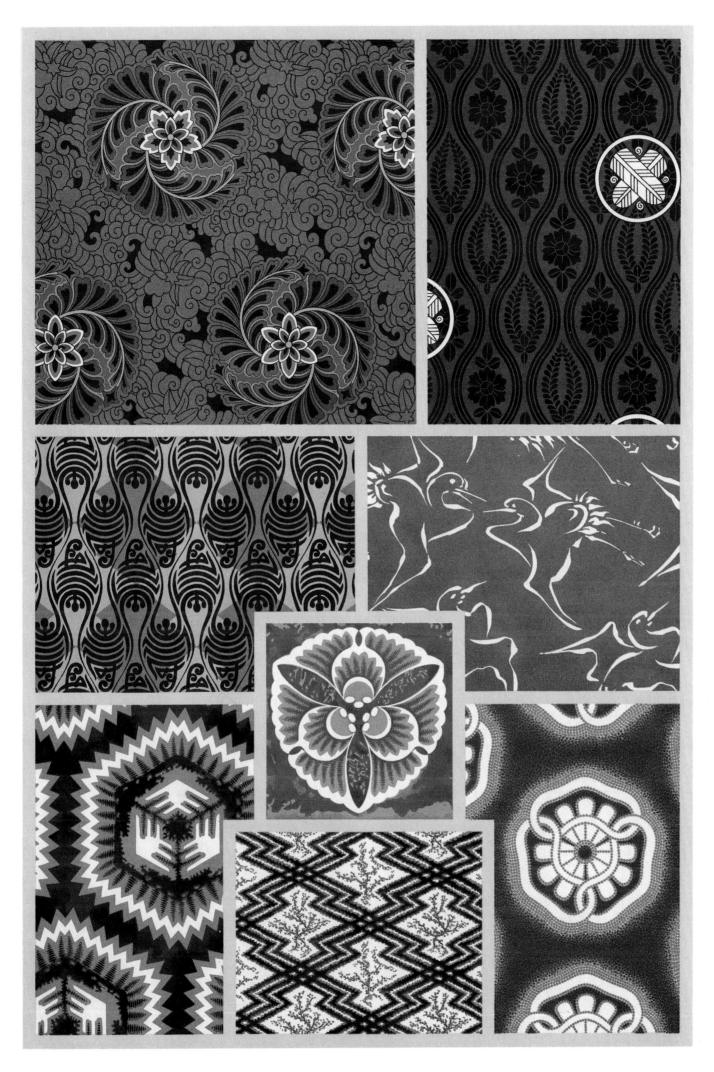

15. Japan: Motifs from textiles and wallpapers.

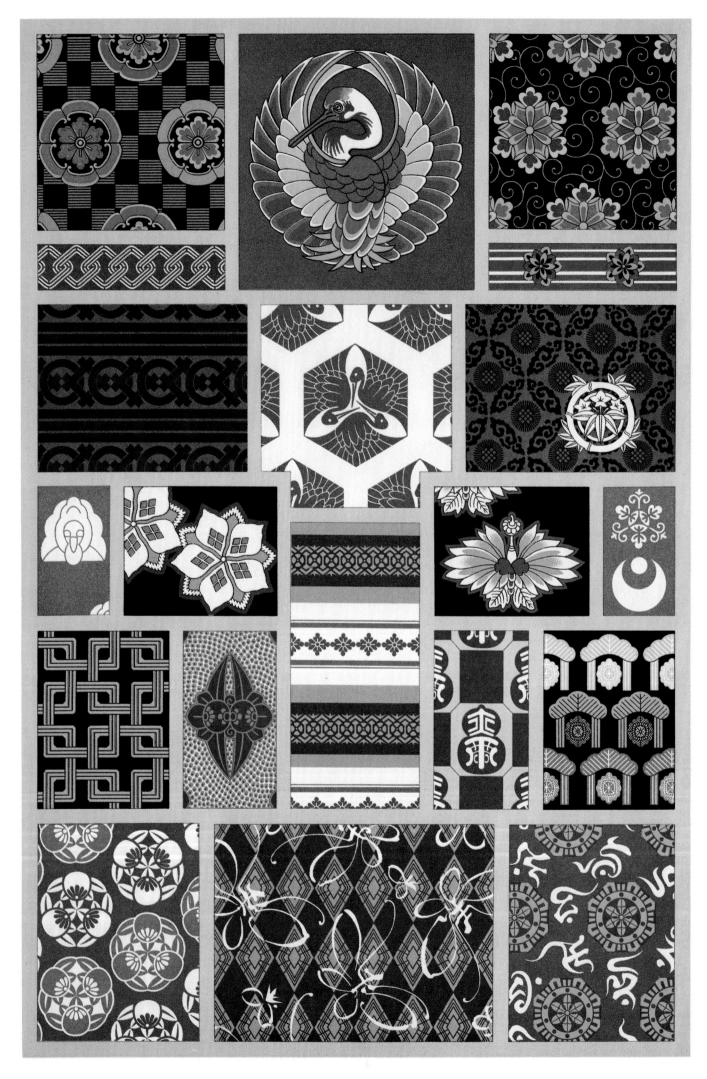

16. Japan: Motifs from textiles and wallpapers.

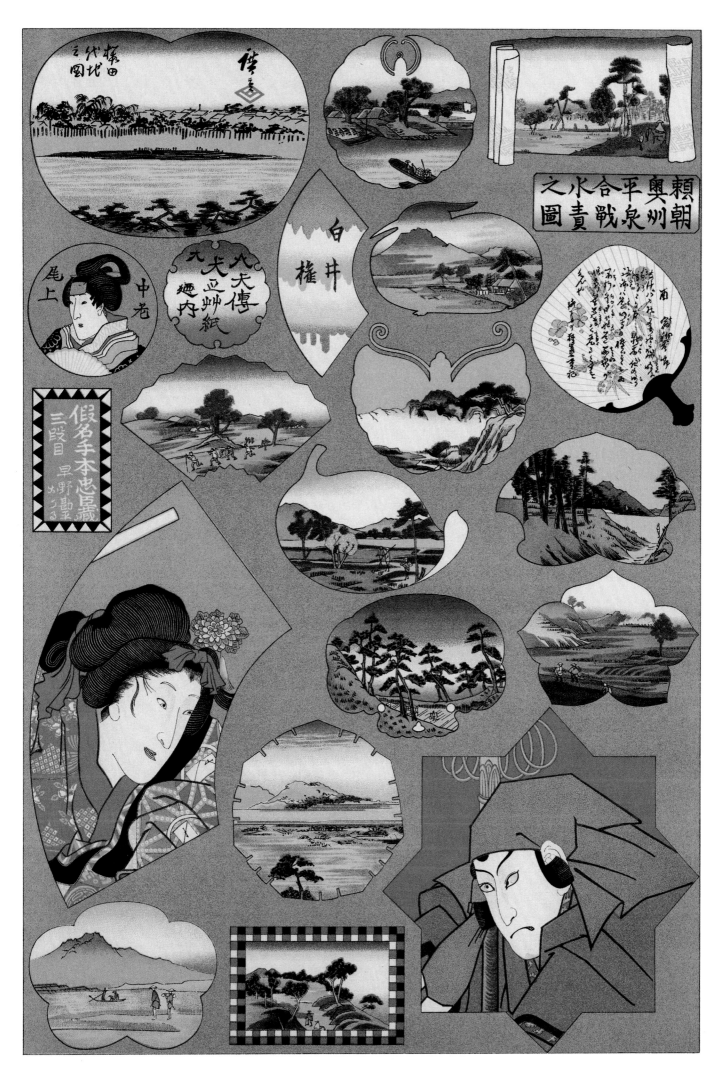

17. Japan: Ornamental cartouches.

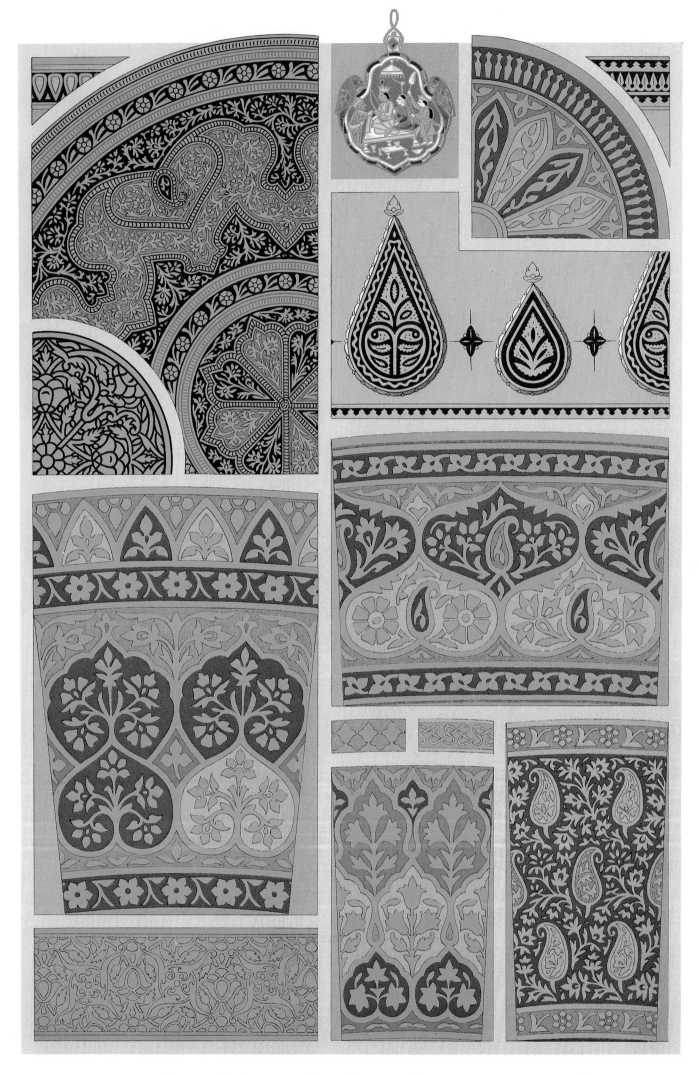

18. India: Enamels, cloisonné, niello and chased steel from Kashmir and the north.

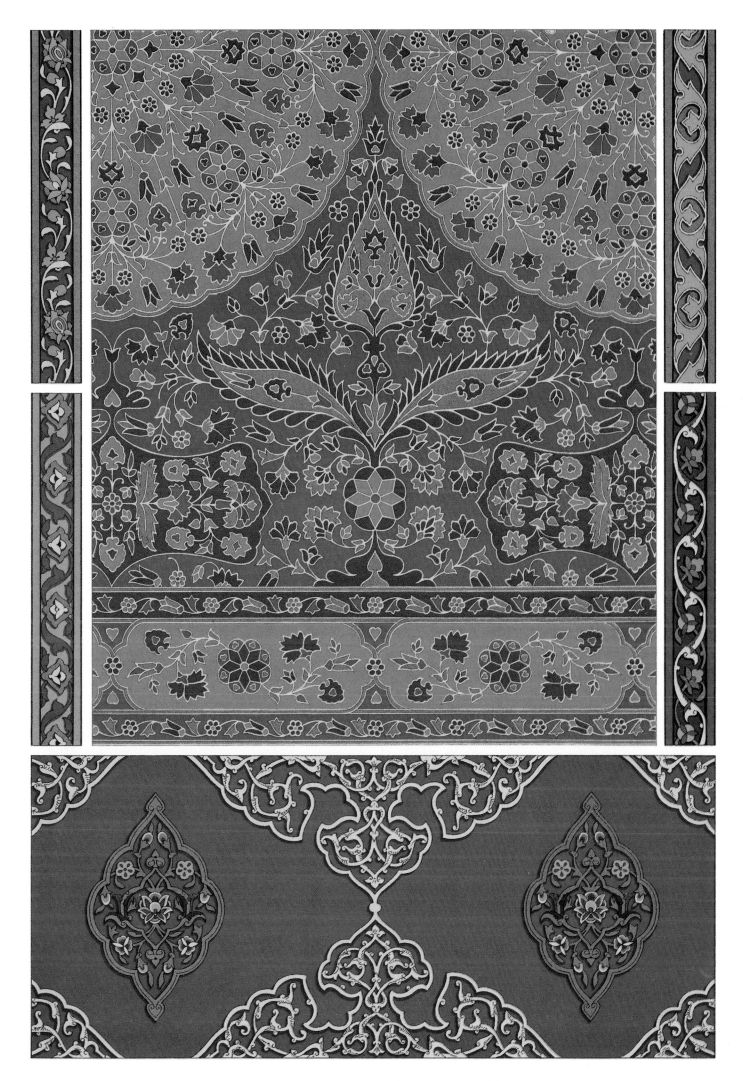

19. India: Appliquéd fabric and 16th-century painted designs.

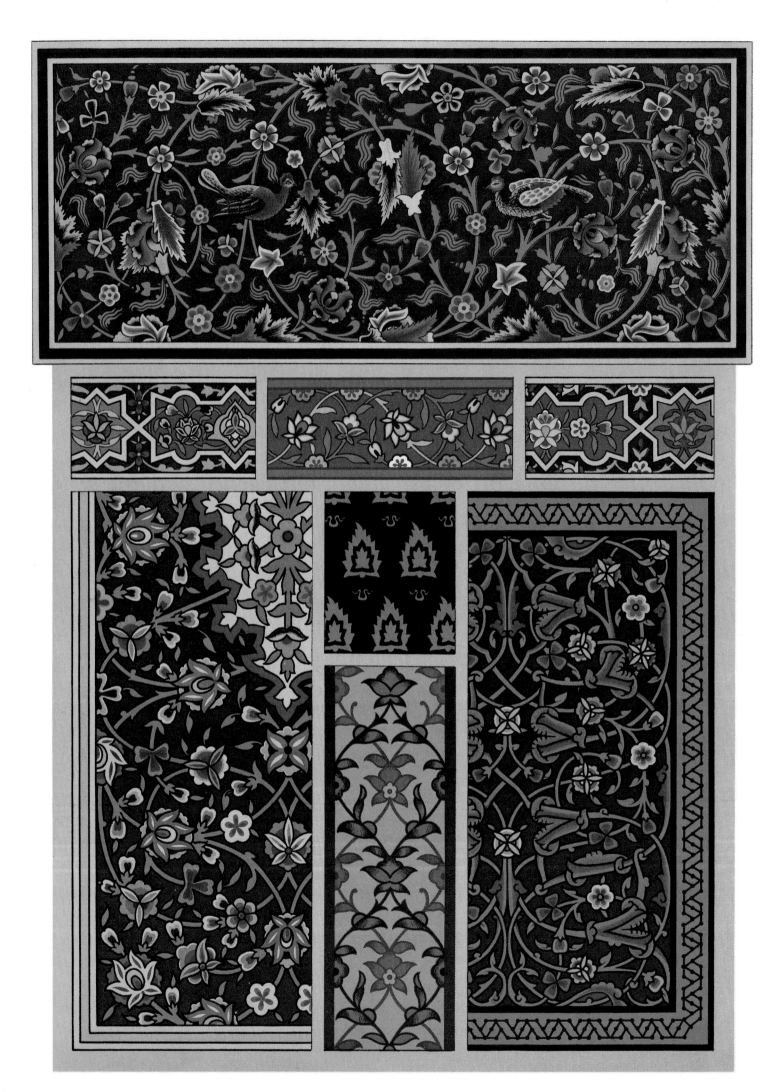

20. Mughal India: Motifs from architectural décor depicted in 16th-century paintings.

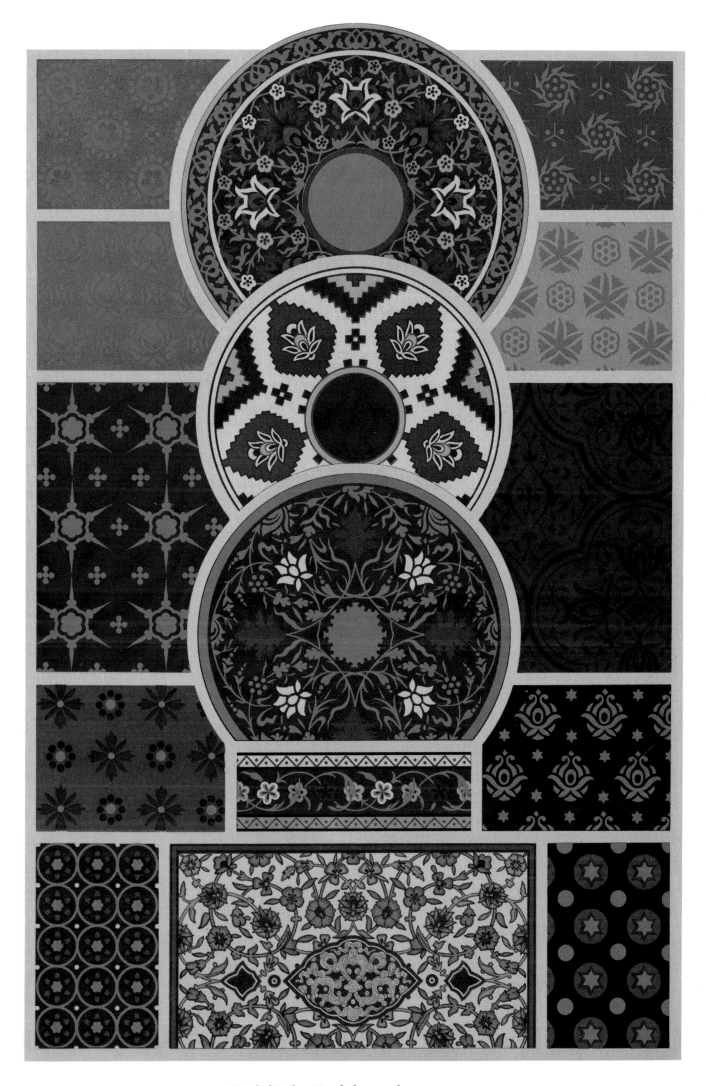

21. Mughal India: Motifs from 16th-century paintings.

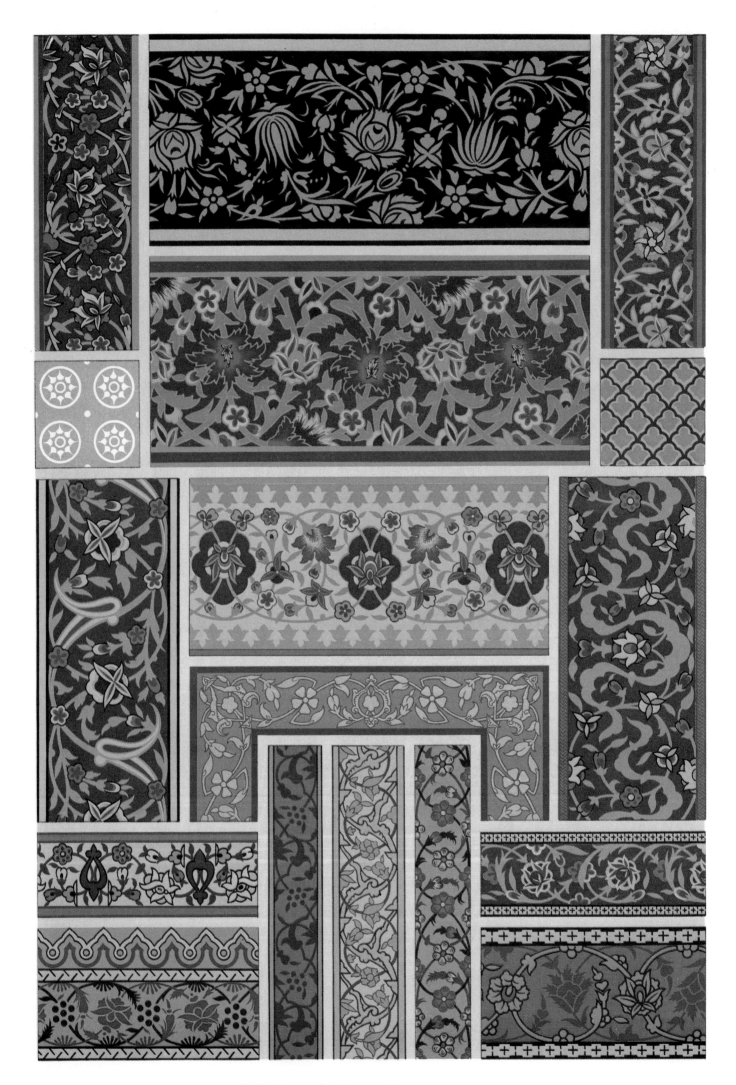

22. Mughal India: Border elements from 16th-century paintings.

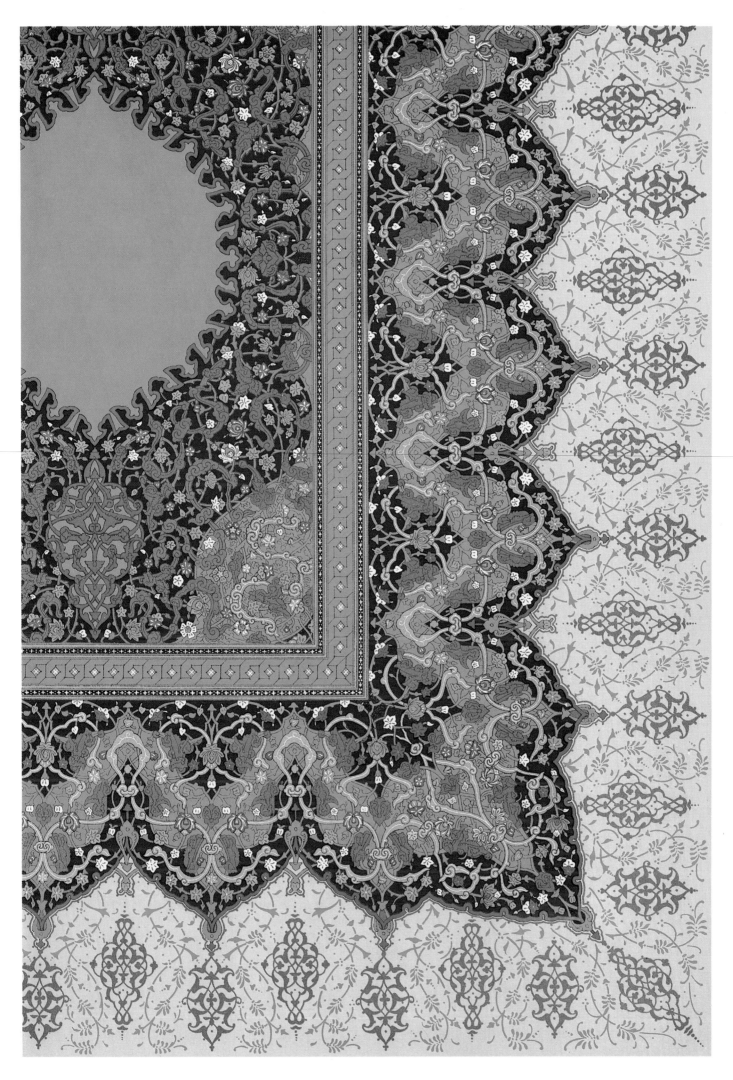

23. Mughal India: Portion of an illuminated page from a 16th-century Koran.

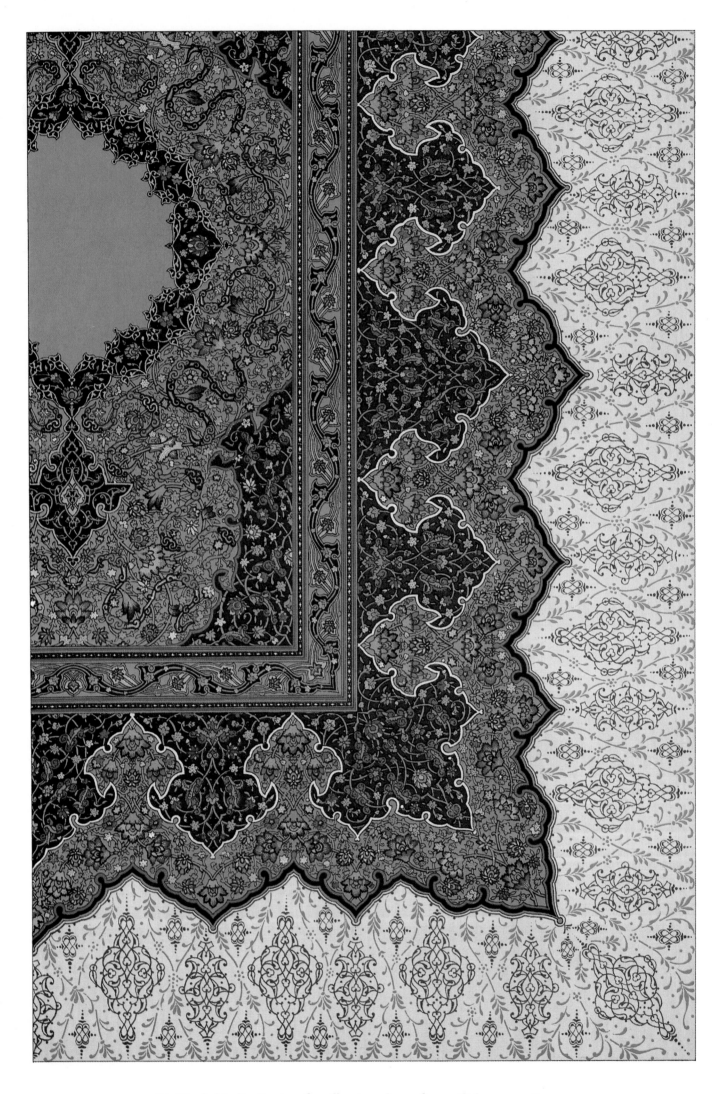

24. Mughal India: Portion of an illuminated page from a 16th-century Koran.

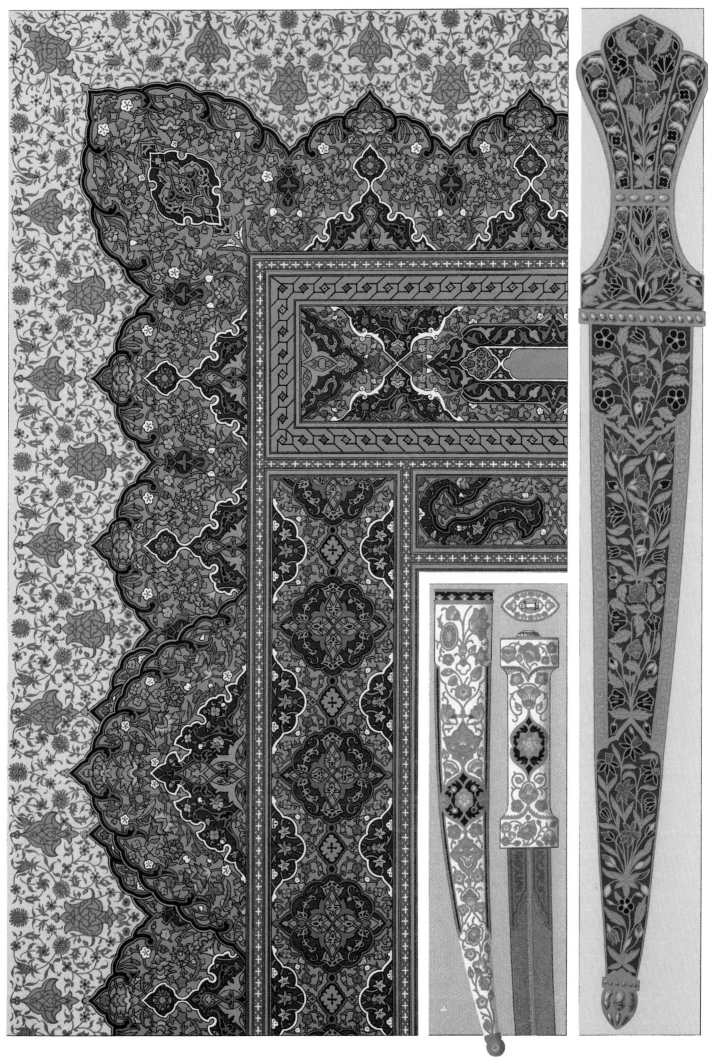

25. Persia and India: Koran decoration (Persia, 17th century) and cloisonné daggers.

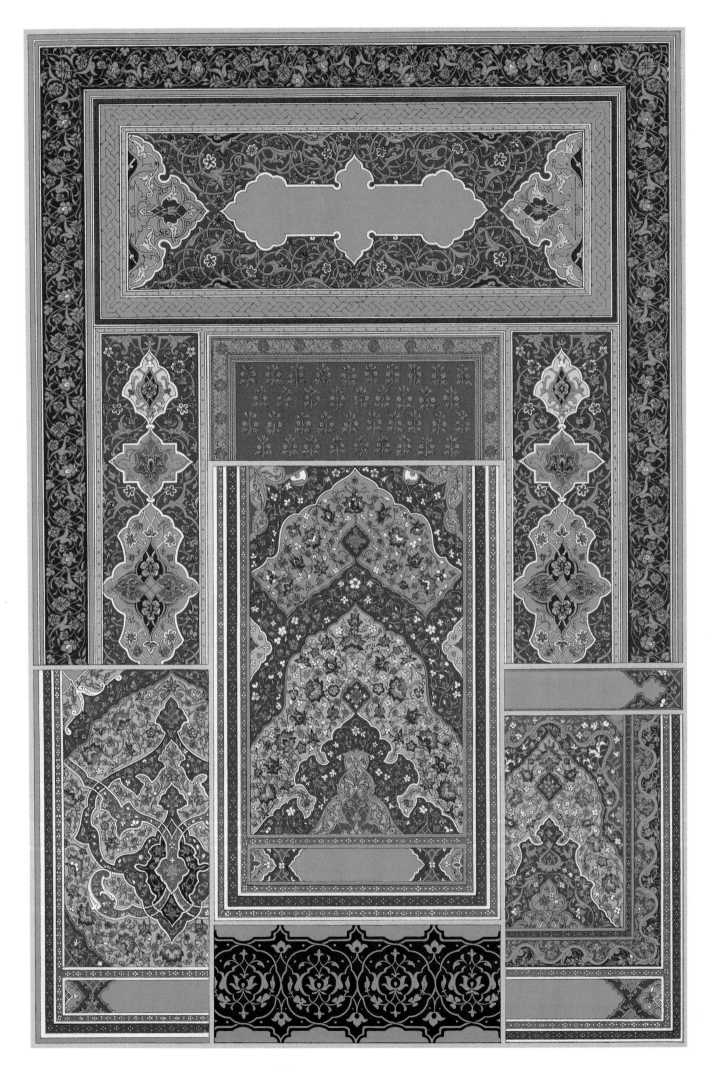

26. Mughal India: Motifs from illuminated manuscripts and niello metalwork.

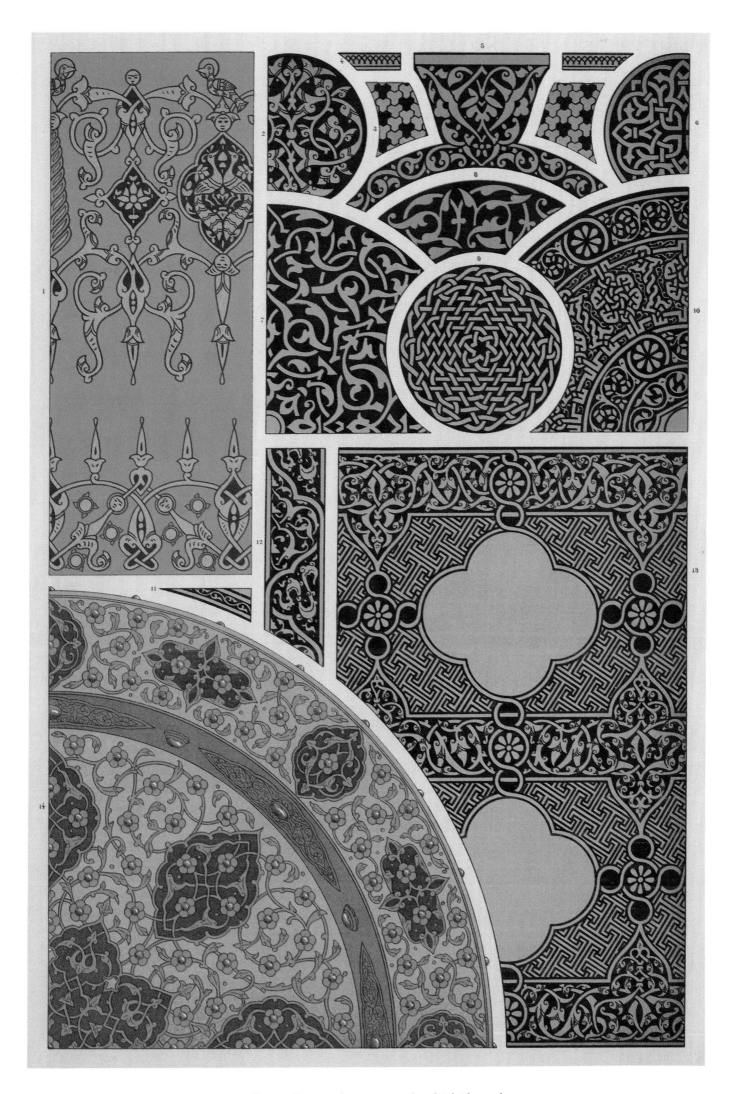

27. Persia: Designs from engraved and inlaid metal.

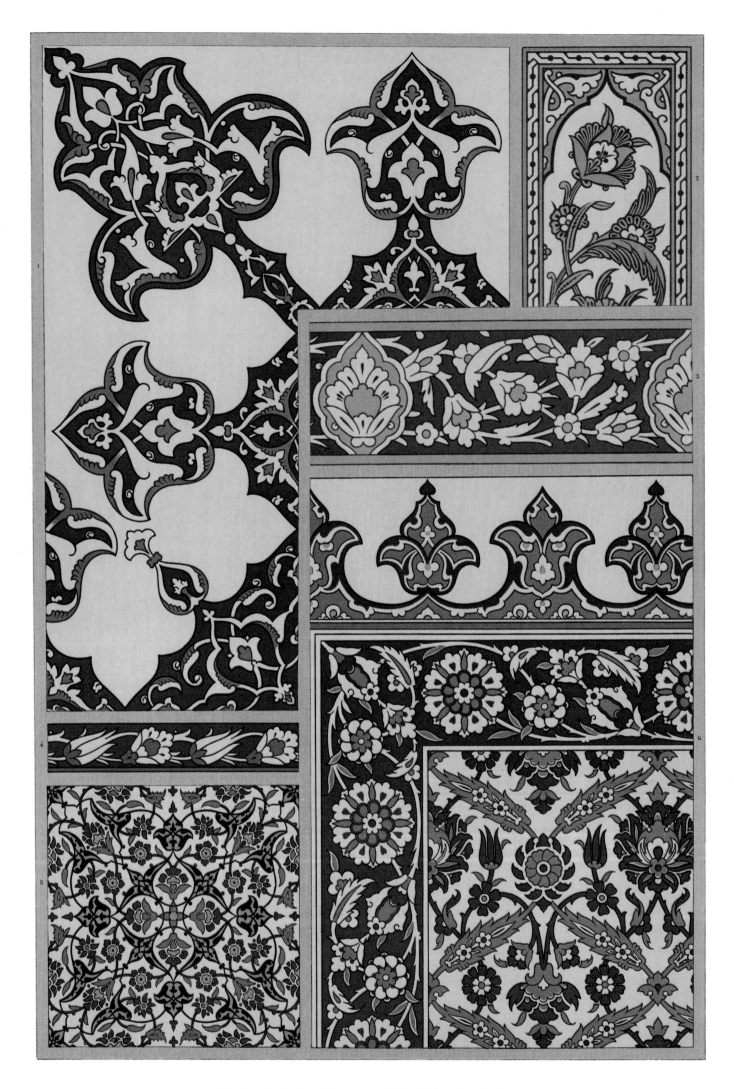

28. Persia: Designs from enameled and glazed wall tiles.

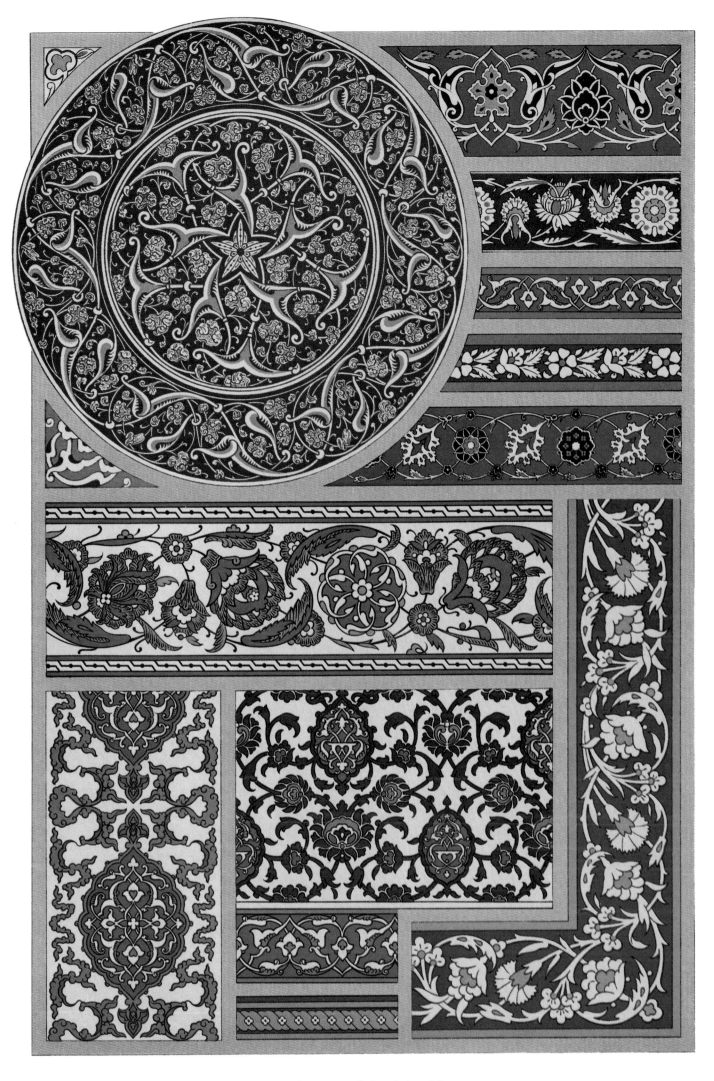

29. Persia: Designs from enameled and glazed faience ceramics.

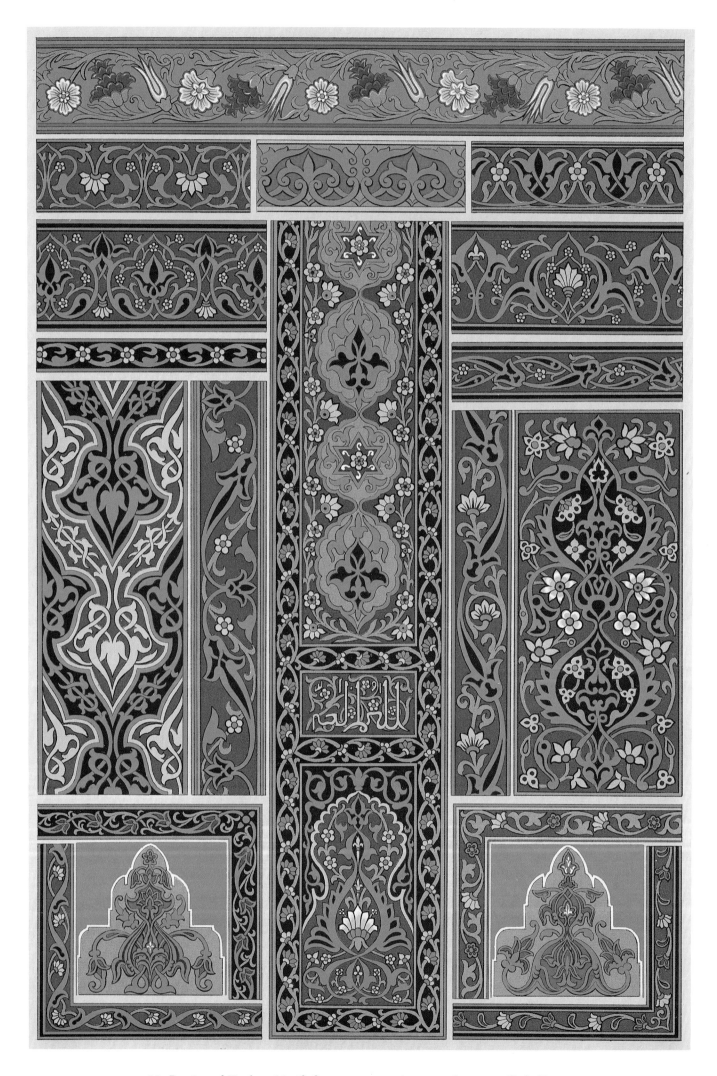

30. Persia and Turkey: Motifs from exterior and interior faience wall cladding.

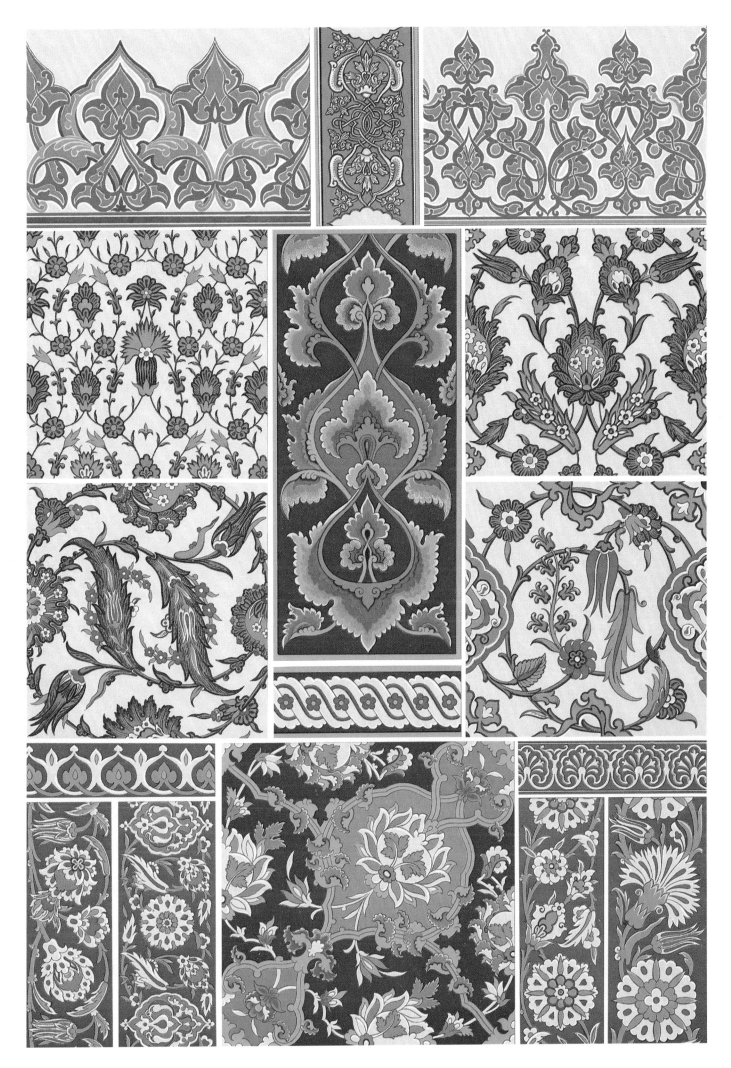

31. Persia: Motifs from enameled and glazed ceramic wall cladding.

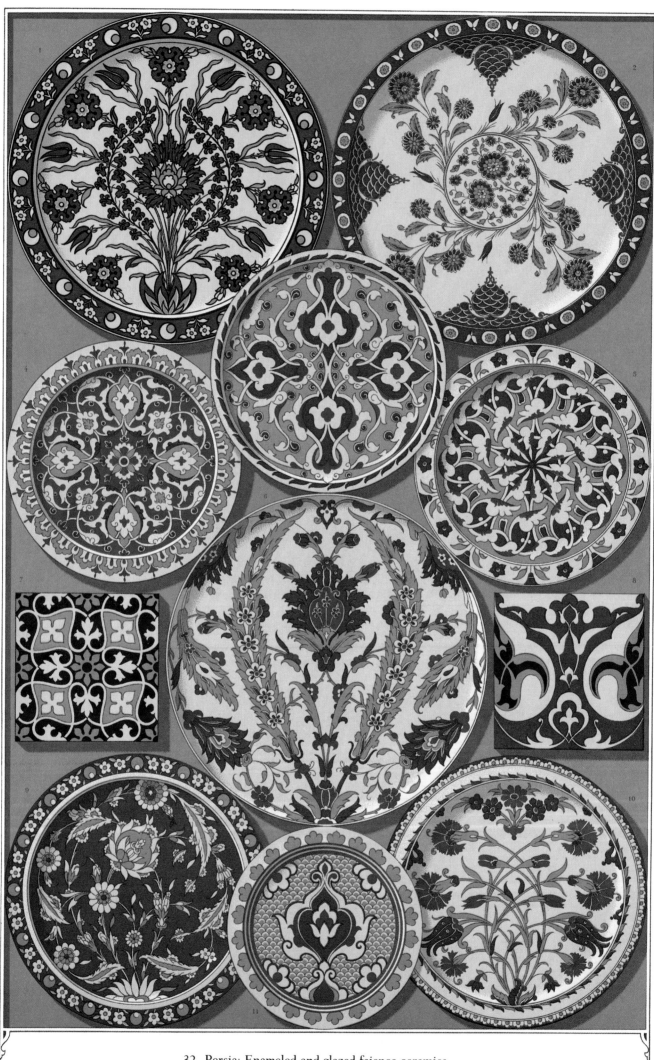

32. Persia: Enameled and glazed faience ceramics.

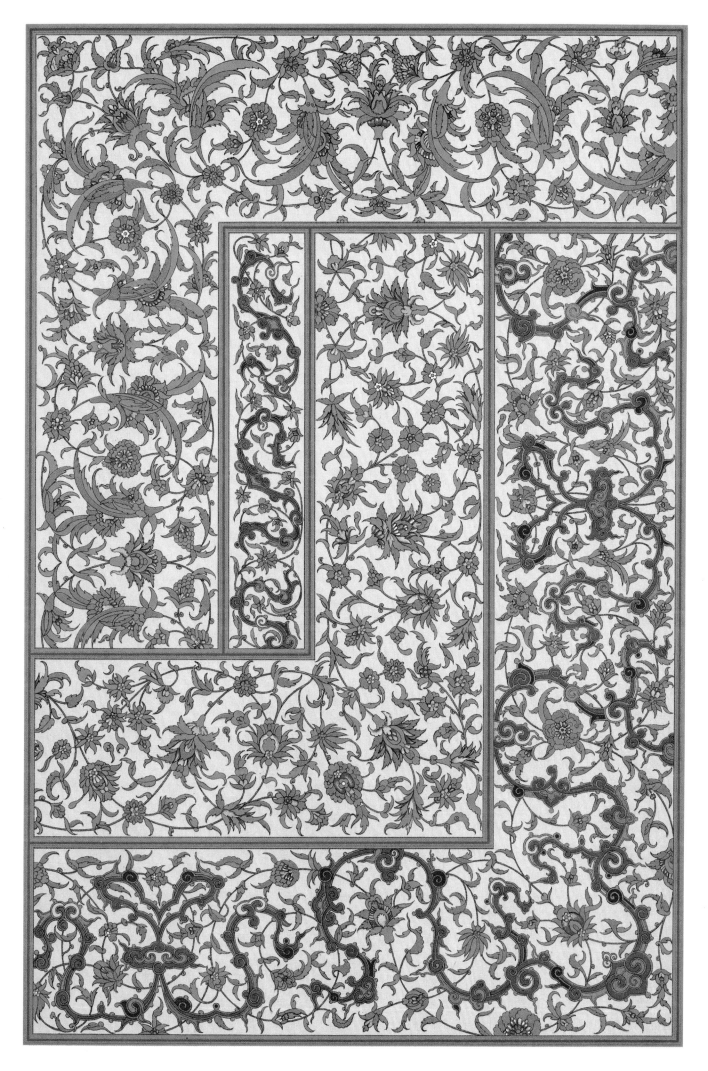

33. Persia: Motifs from margins of illuminated manuscripts.

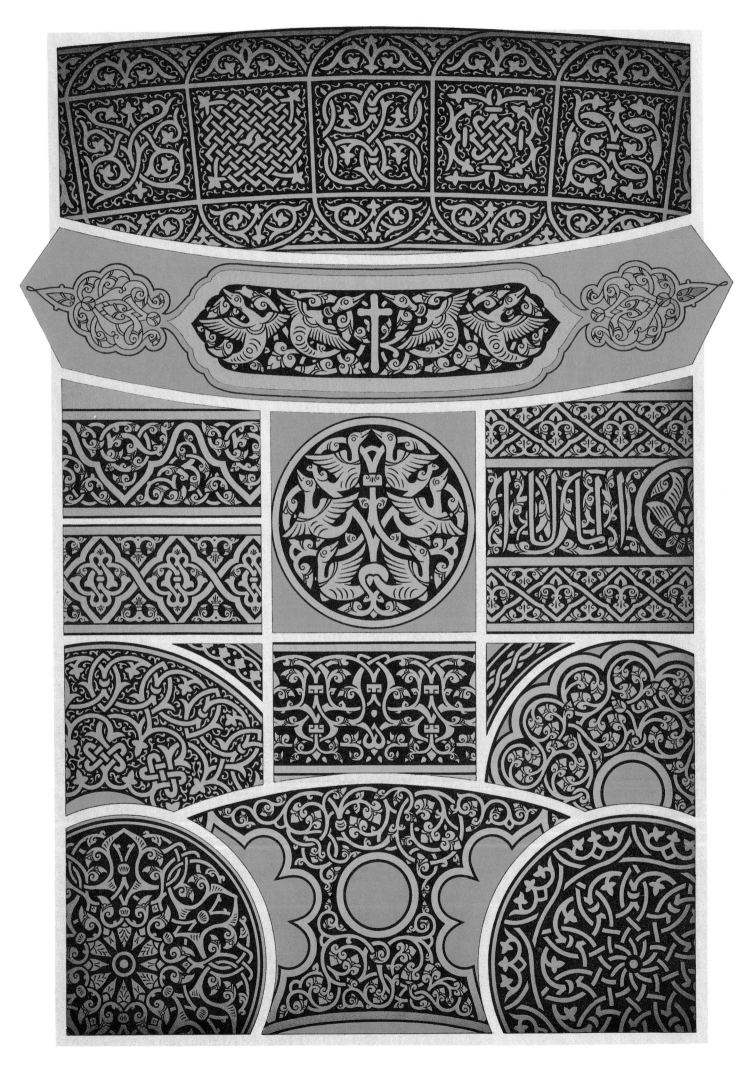

34. Islamic: Motifs from damascened metalwork.

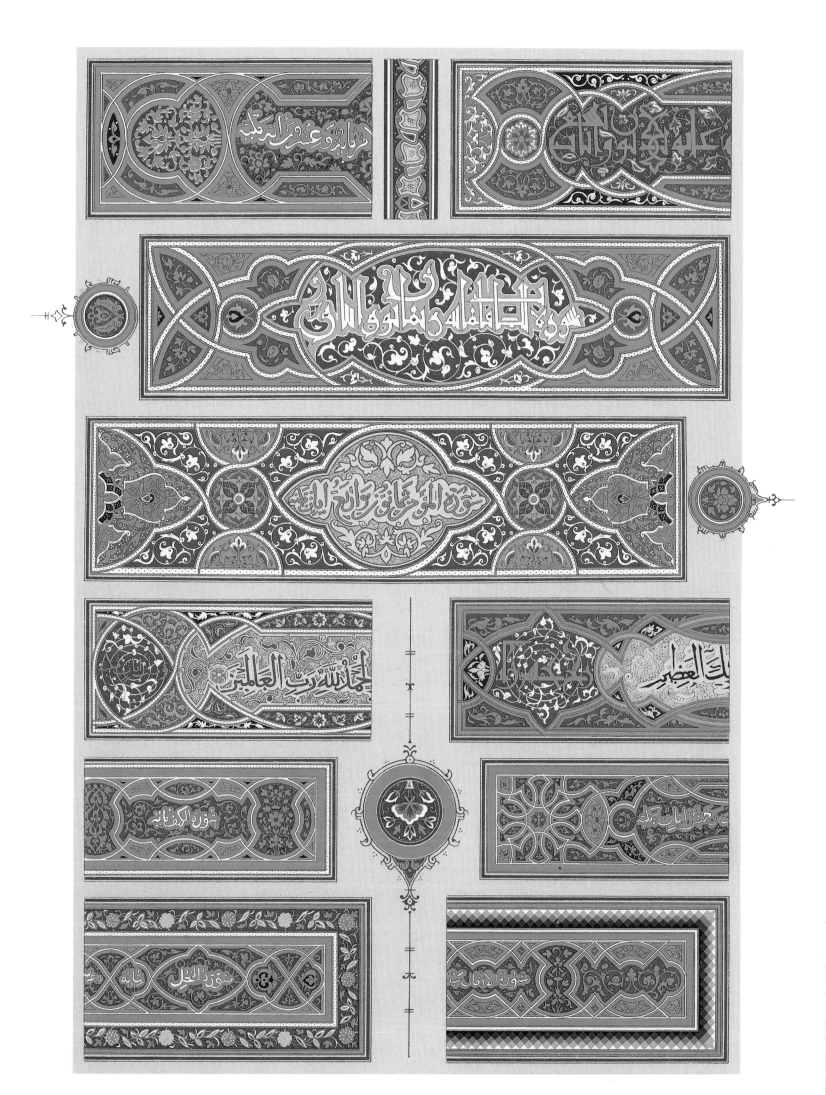

35. Islamic: Designs with lettering from an illuminated Koran, 14th or 15th century.

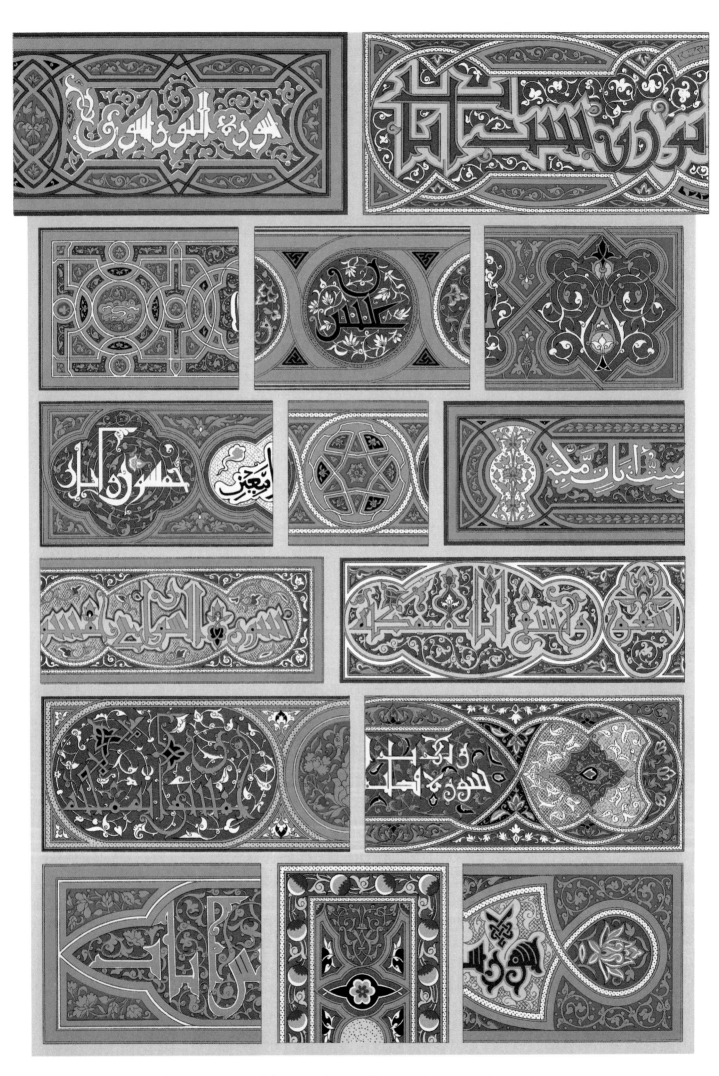

36. Islamic: Designs with lettering from an illuminated Koran, 14th or 15th century.

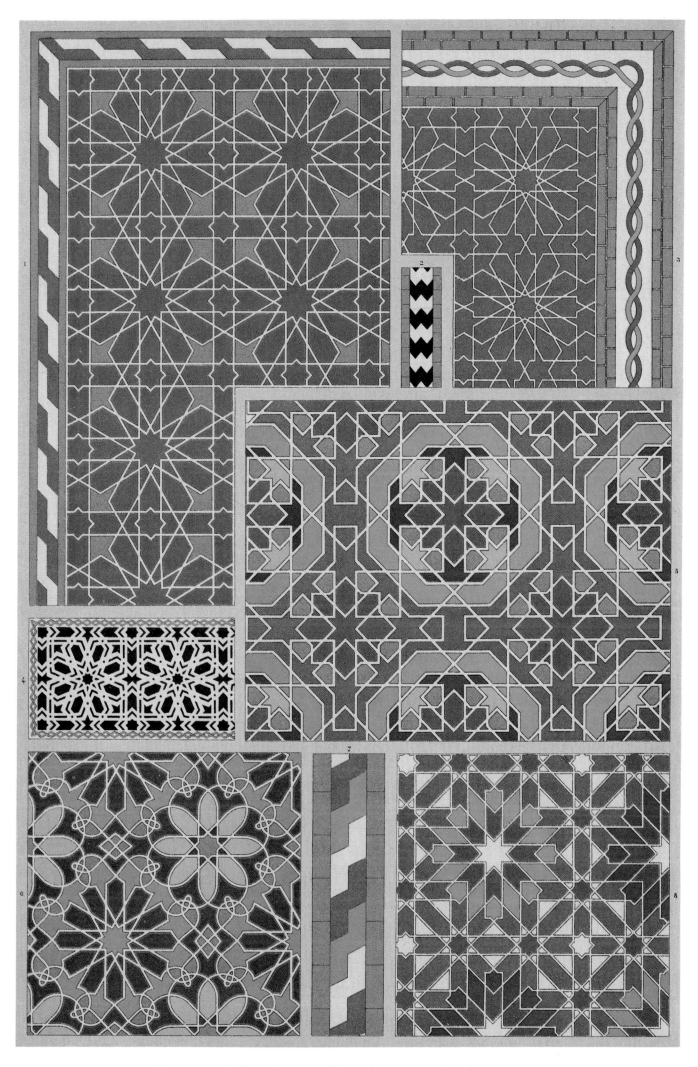

37. Islamic: Motifs from Algerian public architecture, 13th and 14th centuries.

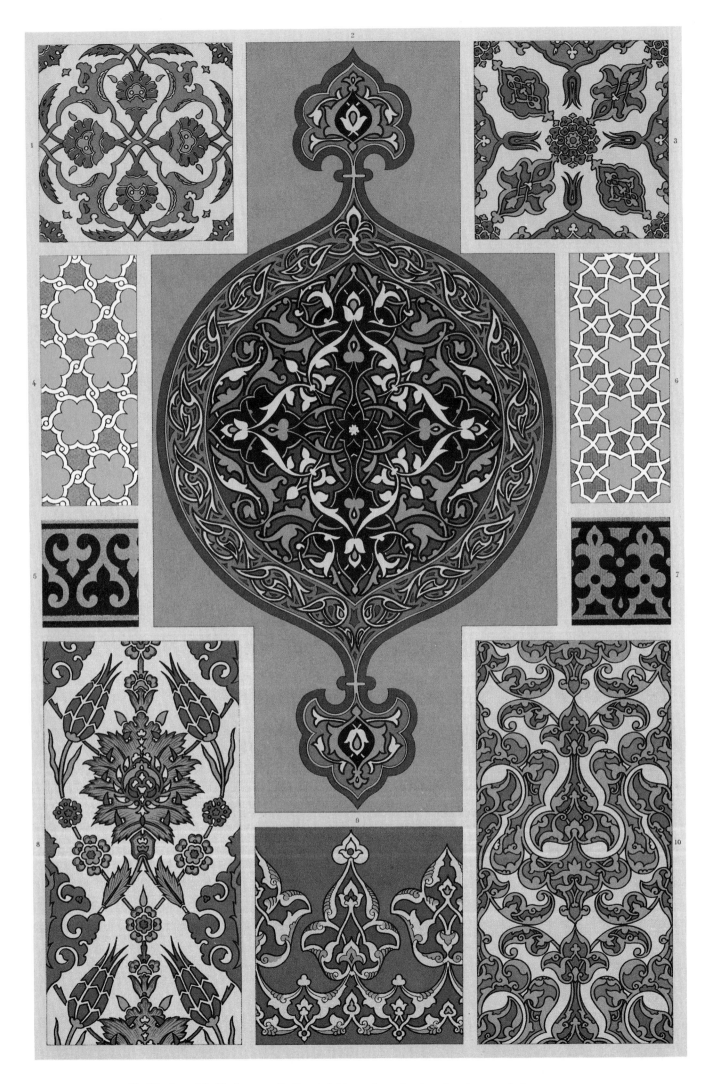

38. Turkey: Motifs from wall tiles, inlaid wood, and painted and enameled terra-cottas.

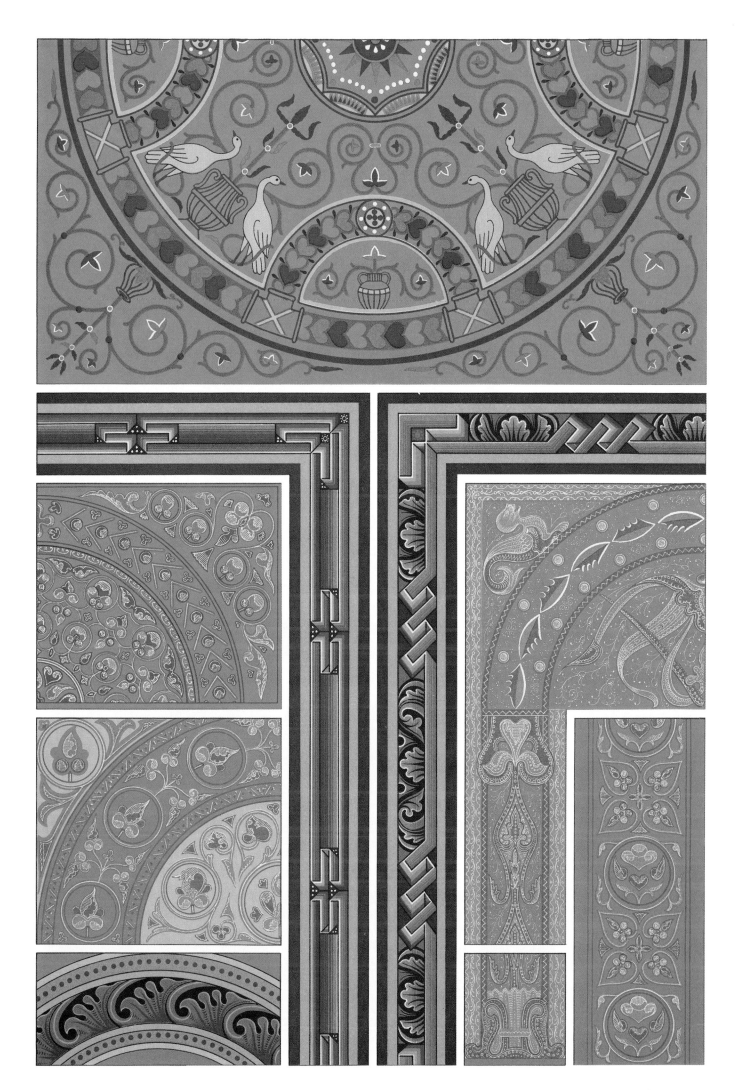

39. Byzantine and Early Medieval: Motifs from architecture and manuscripts.

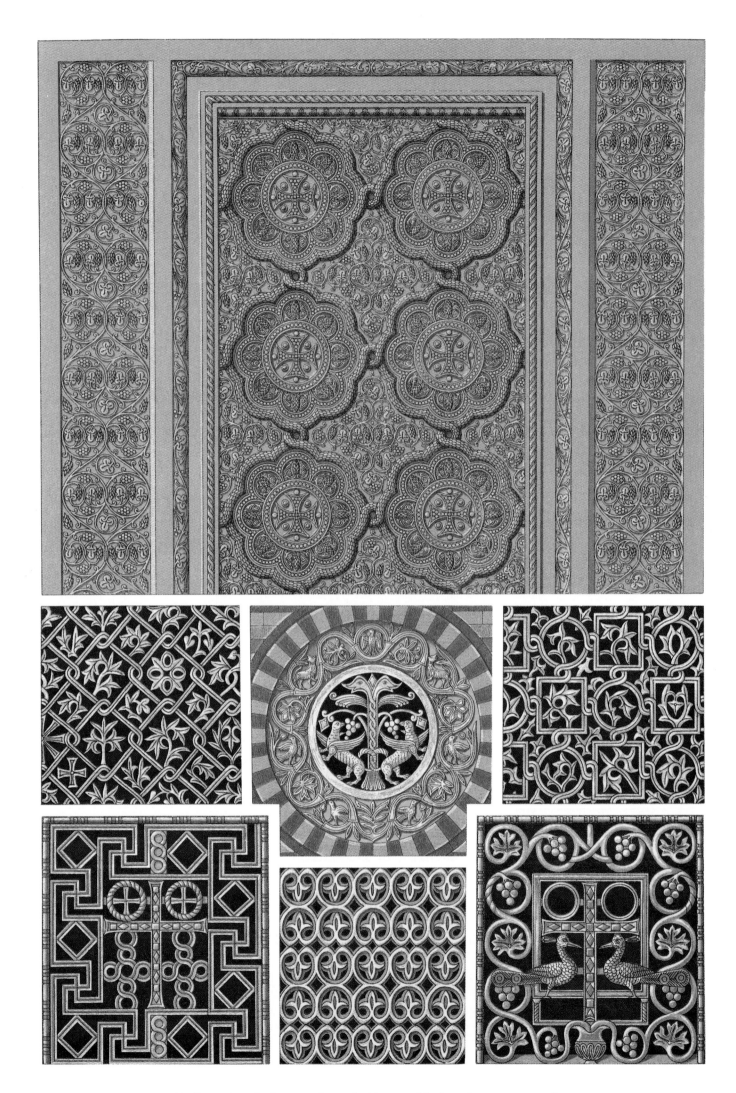

40. Byzantine: Architectural motifs, Egypt and Italy, 6th century or earlier.

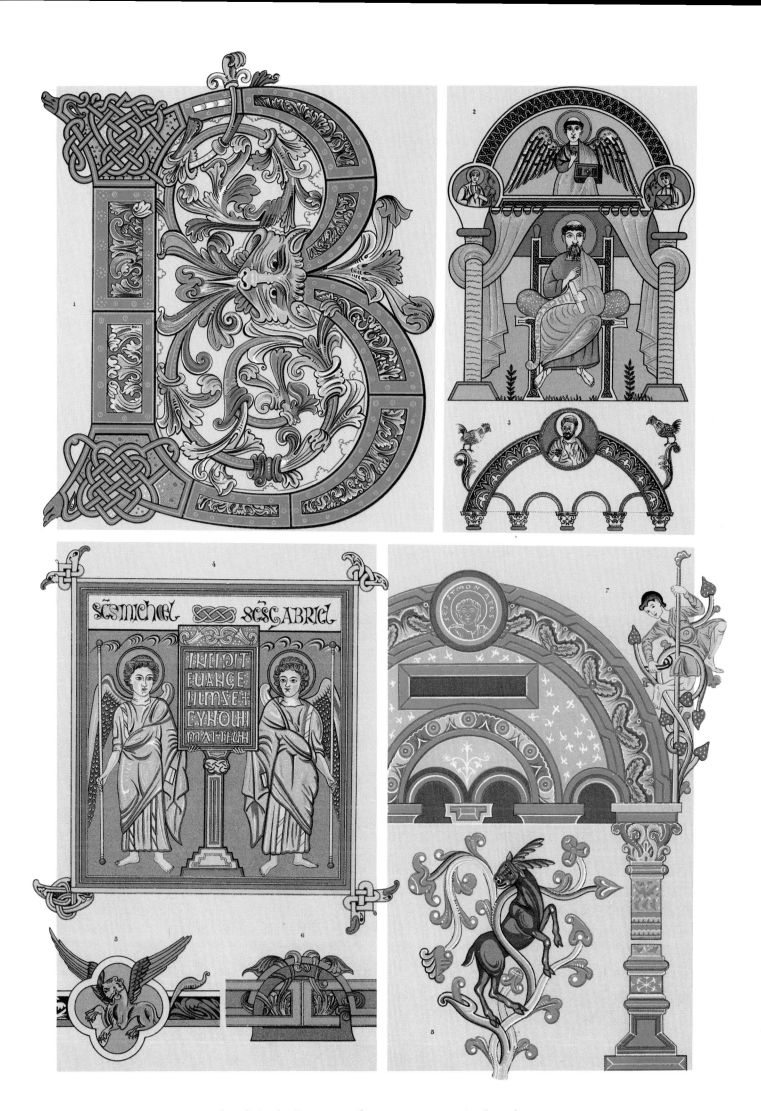

41. Medieval: "Celtic" ornament from various sources, 6th–11th centuries.

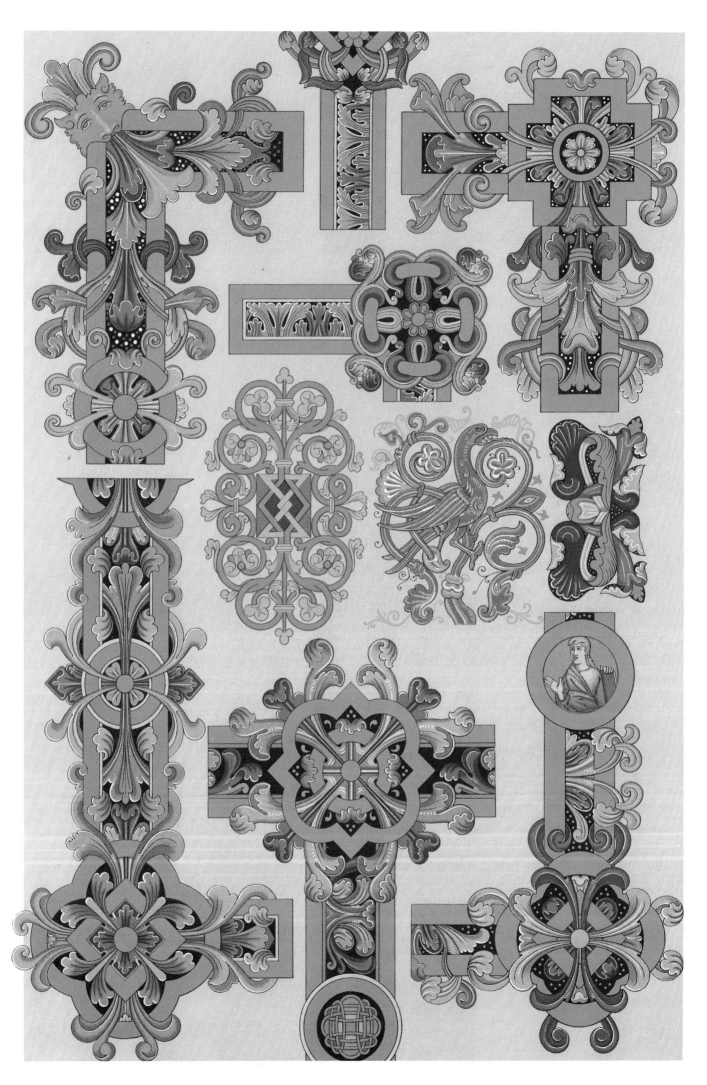

42. Medieval: Frames and ornaments from illuminated manuscripts, Western Europe.

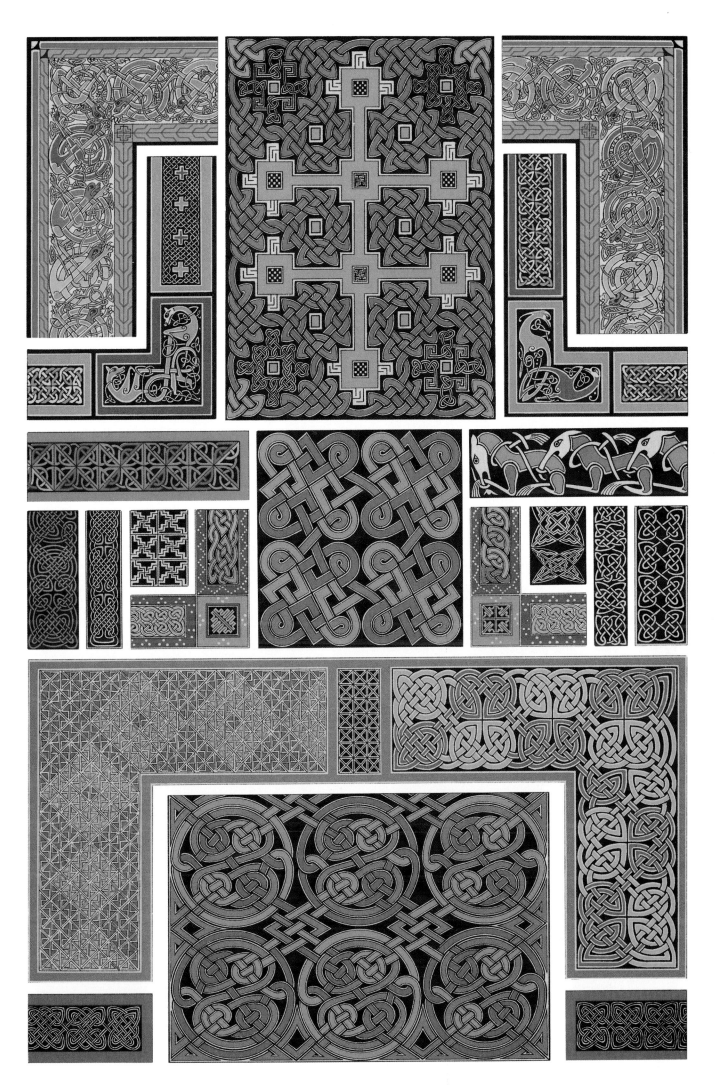

43. Medieval: "Celtic" interlace ornament from British and Scandinavian sources.

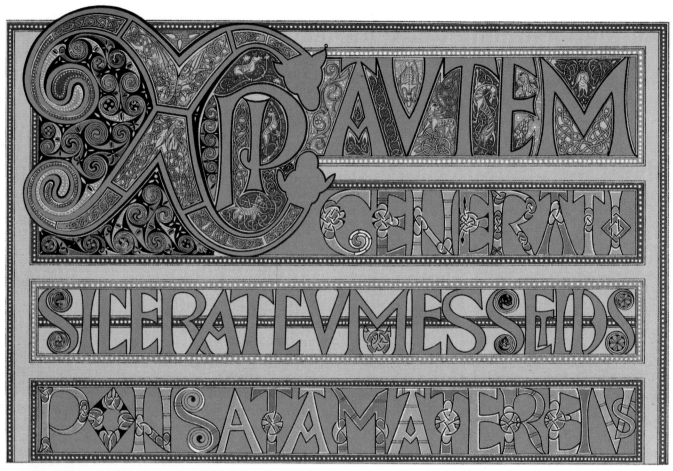

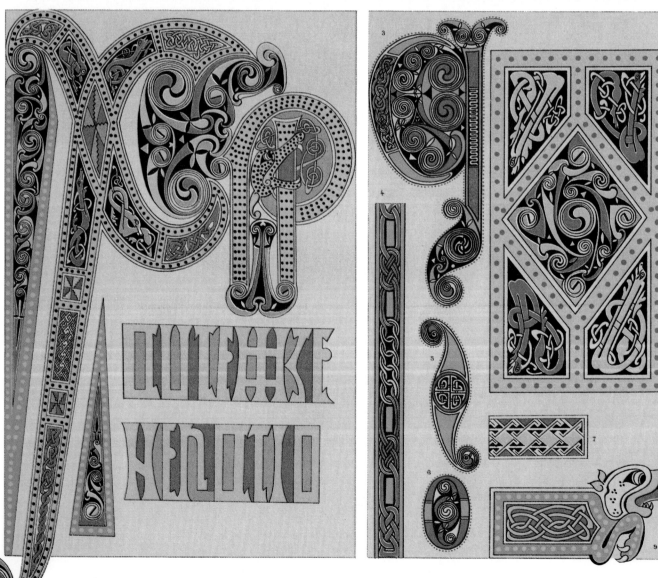

44. Medieval: "Celtic" ornament from illuminated manuscripts, 7th–9th centuries.

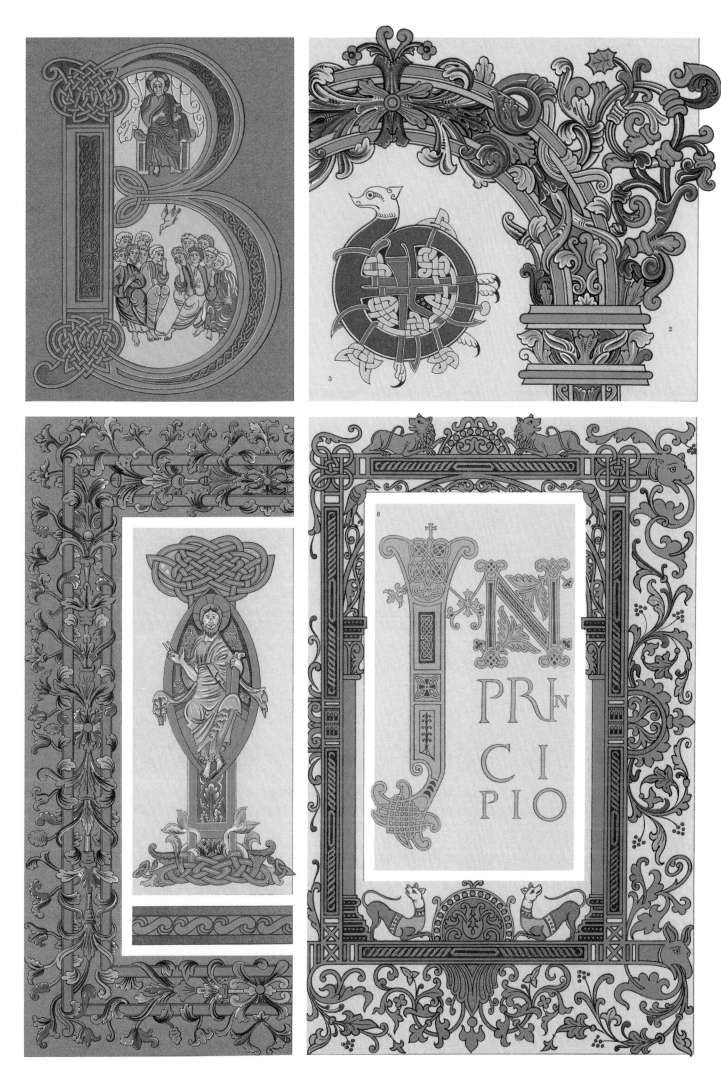

45. Medieval: Manuscript decorations, Anglo-Saxon and Frankish, 8th–10th centuries.

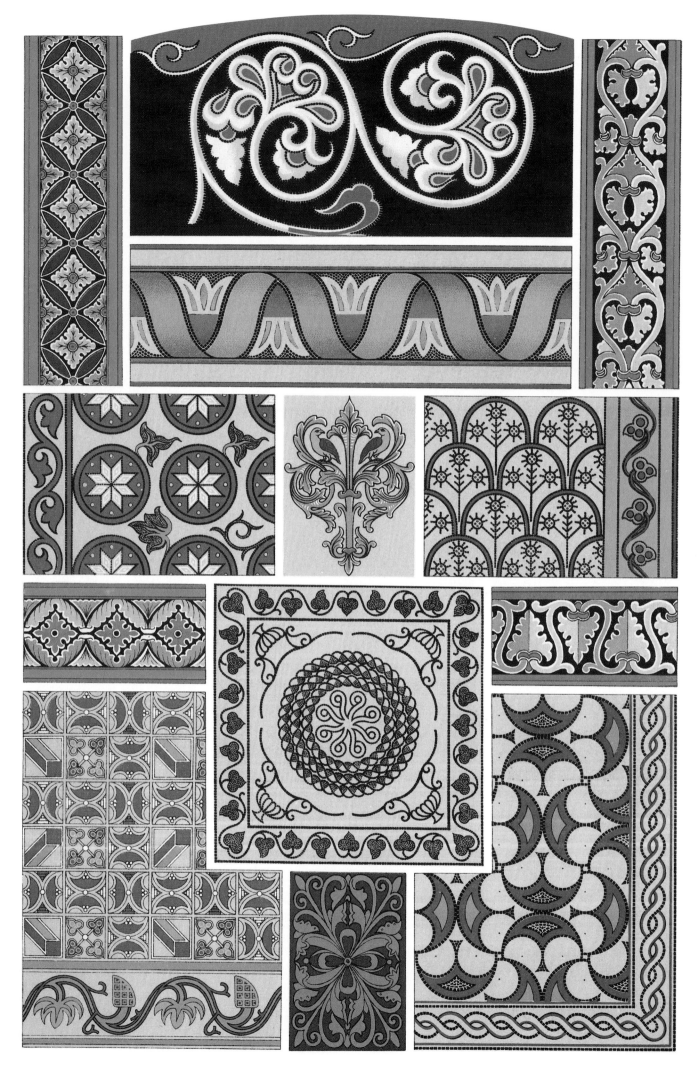

46. Medieval: Mosaic and painted ornament, France, late Roman to Romanesque periods.

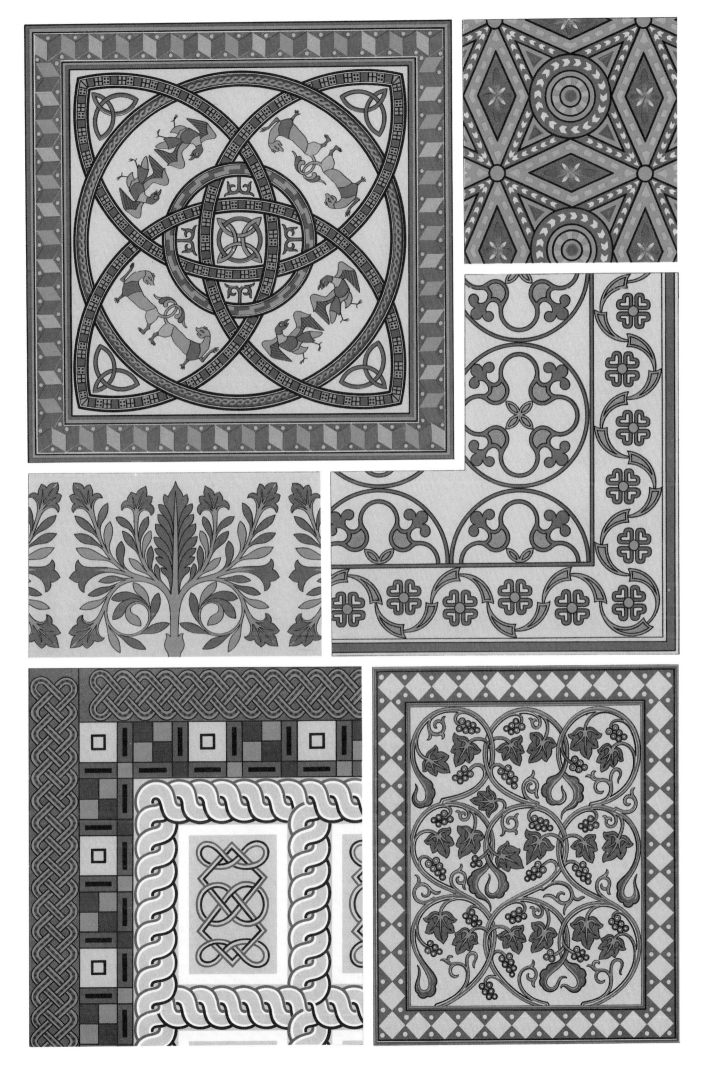

47. Medieval: Mosaic designs, France, late Roman to Romanesque periods.

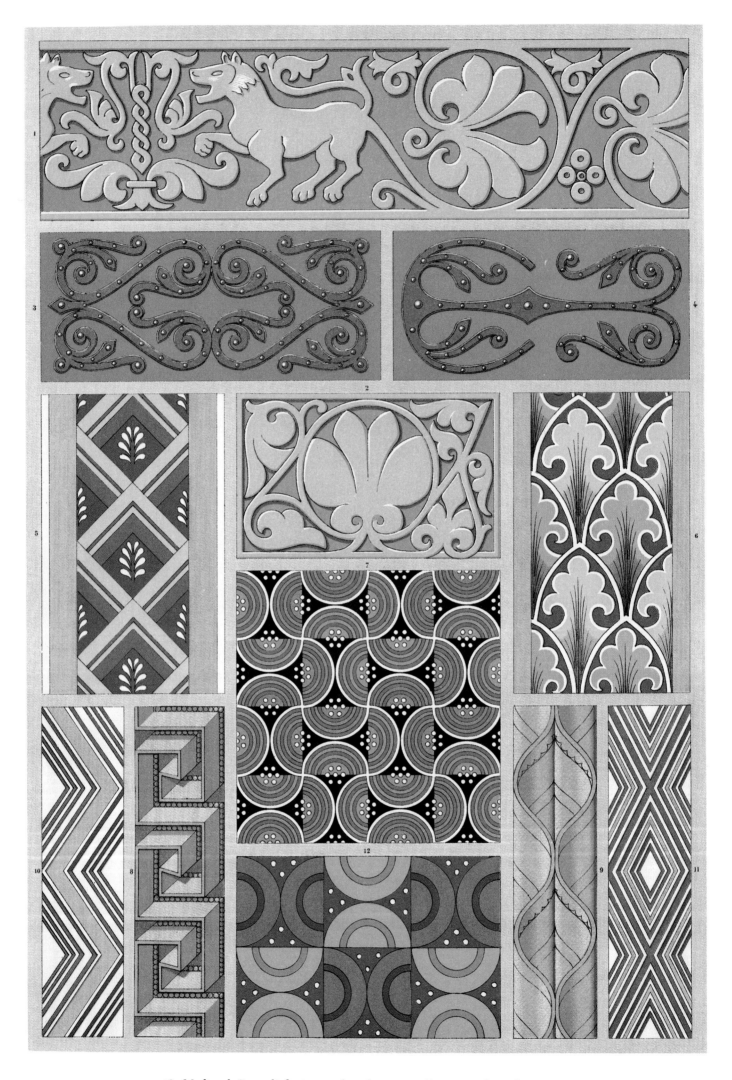

48. Medieval: Bas-reliefs, ironwork and painting, France, 11th–14th centuries.

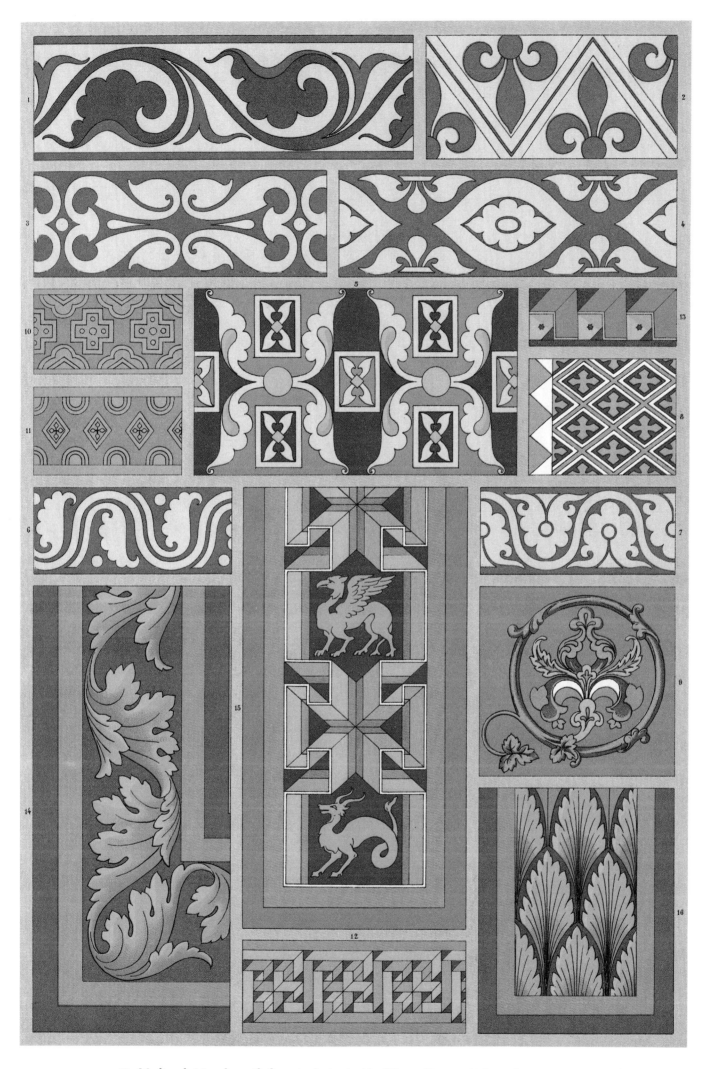

49. Medieval: Mural motifs from ecclesiastical buildings, France, 11th–14th centuries.

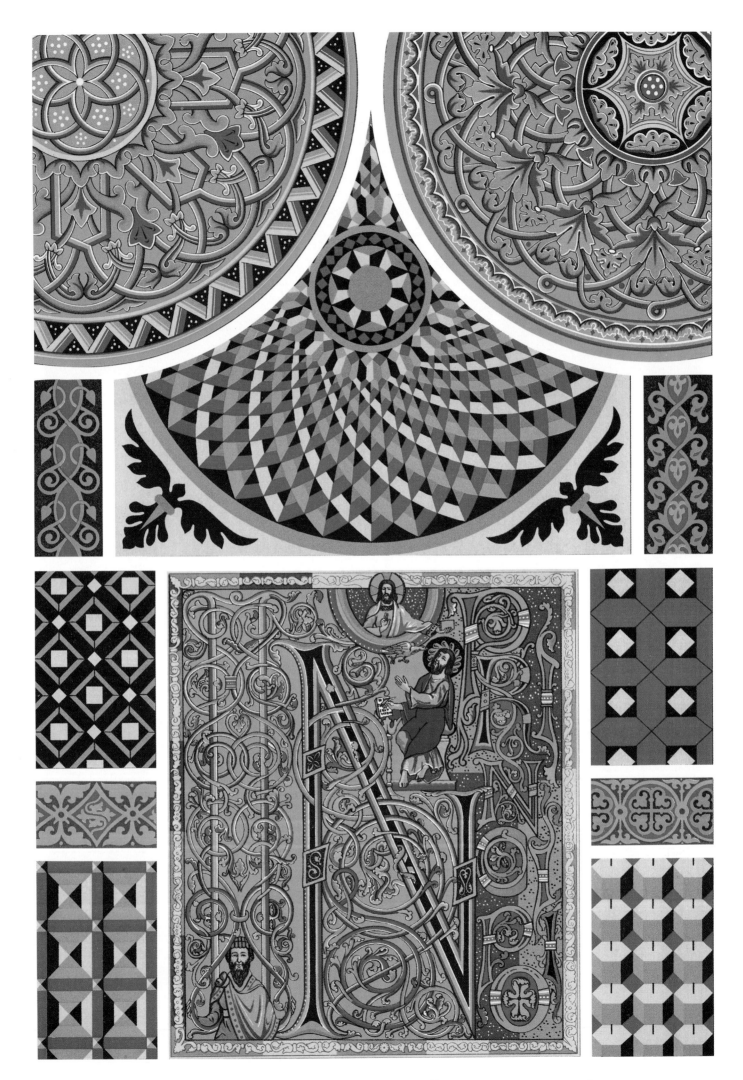

50. Medieval: Mosaics and glass paintings, St. Mark's, Venice; manuscript initial.

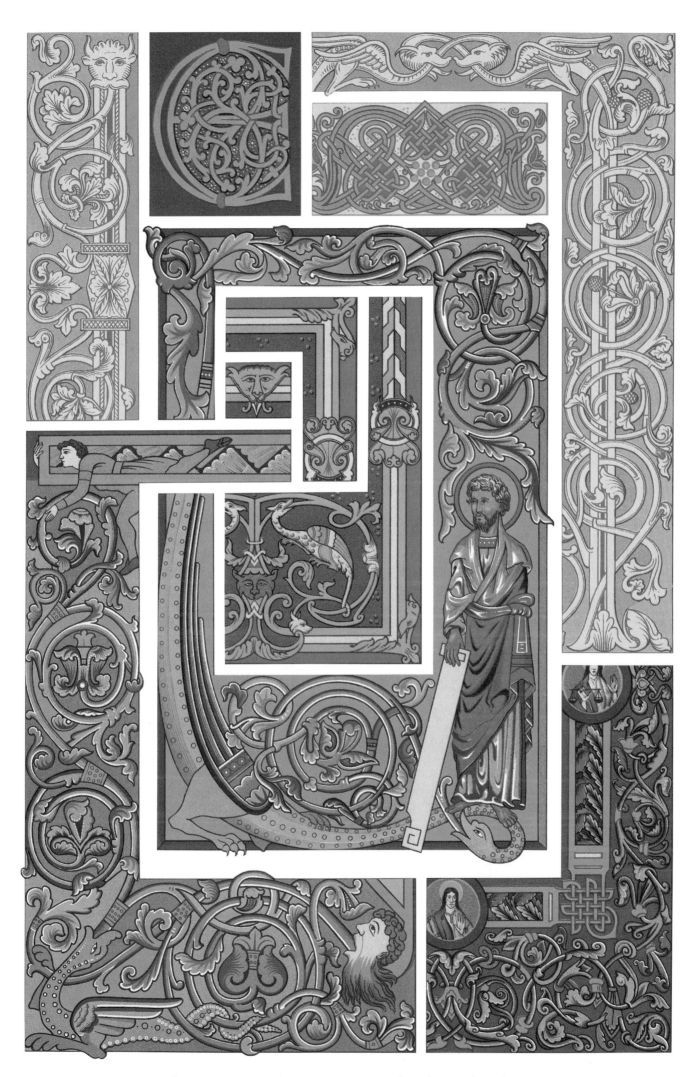

51. Medieval: Manuscript decorations, France and Germany, 8th–13th centuries.

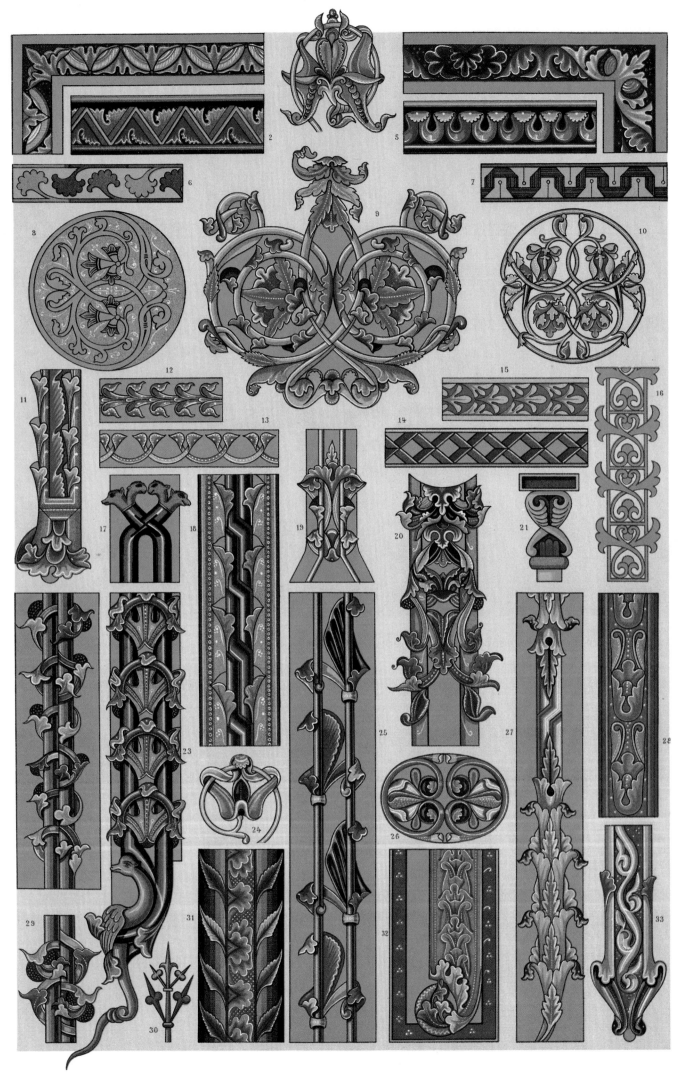

52. Medieval: Manuscript decorations, 8th–12th centuries.

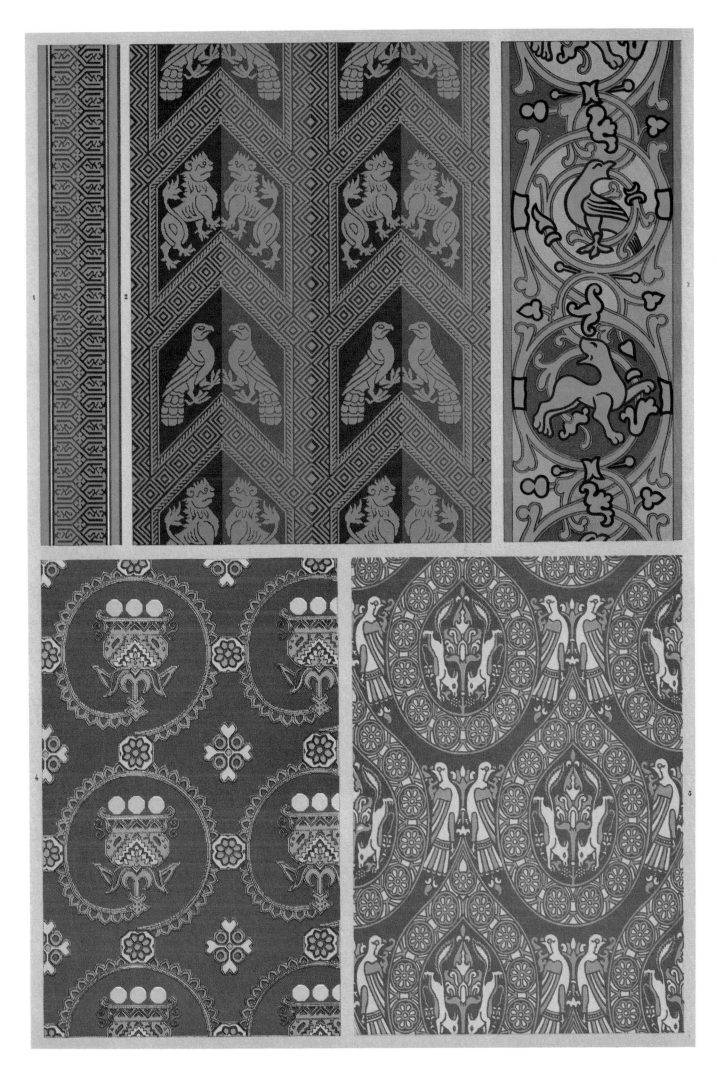

53. Medieval: Designs from textiles imported into Europe from the Near East.

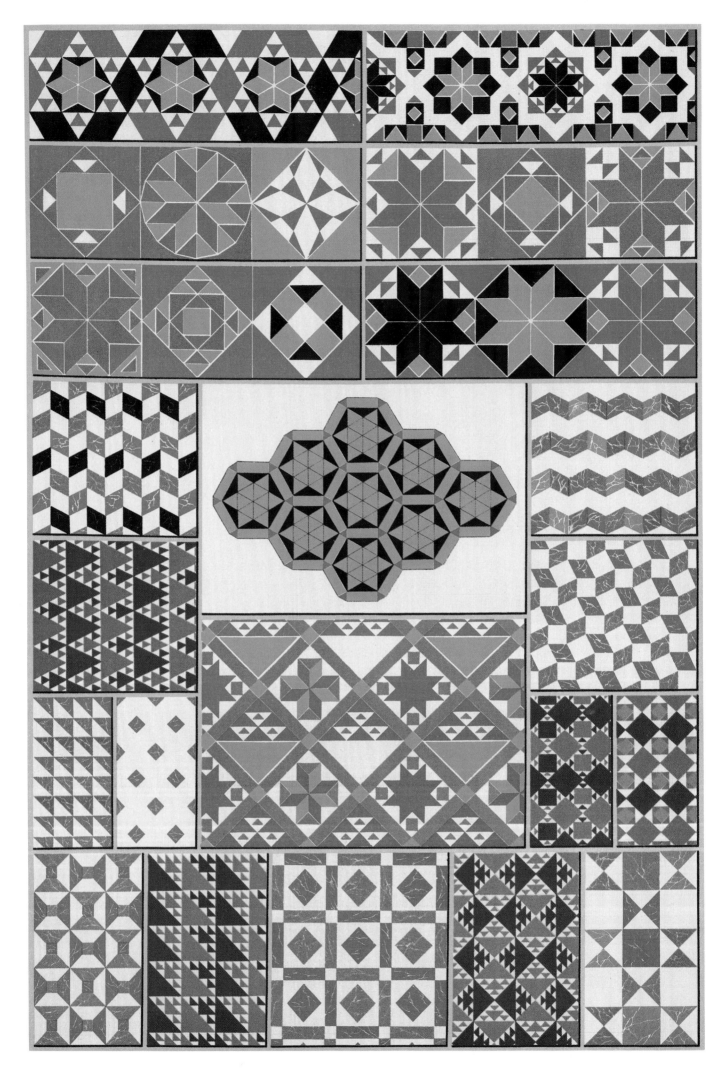

54. Early Medieval: Mosaic patterns from Italian churches.

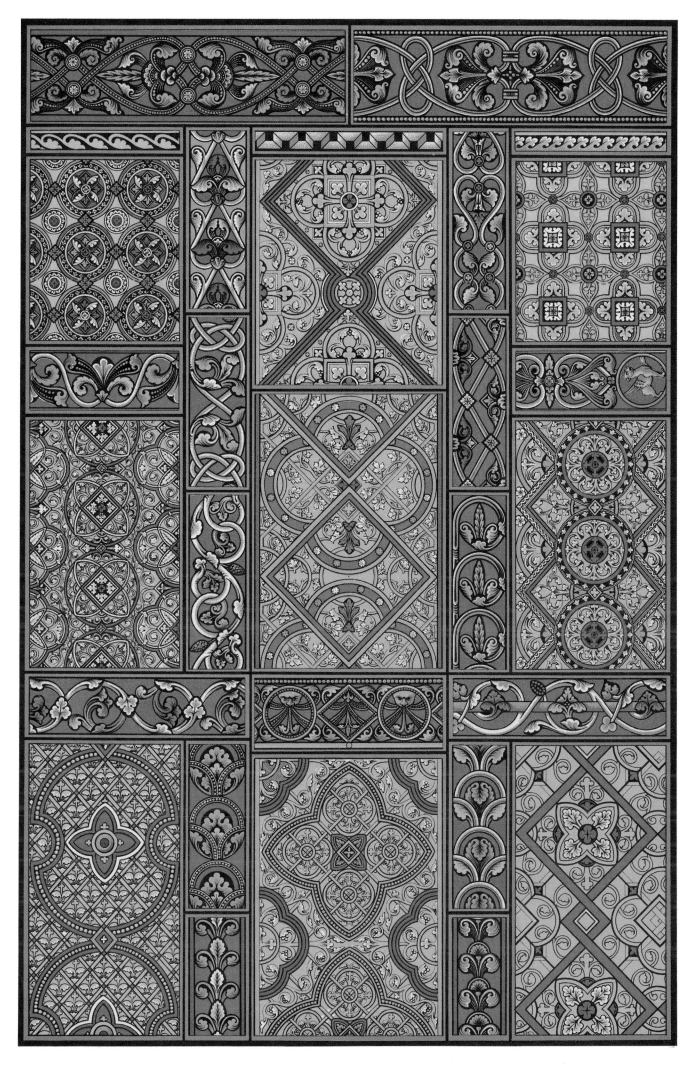

55. Medieval: Stained glass from French and English cathedrals, 12th–14th centuries.

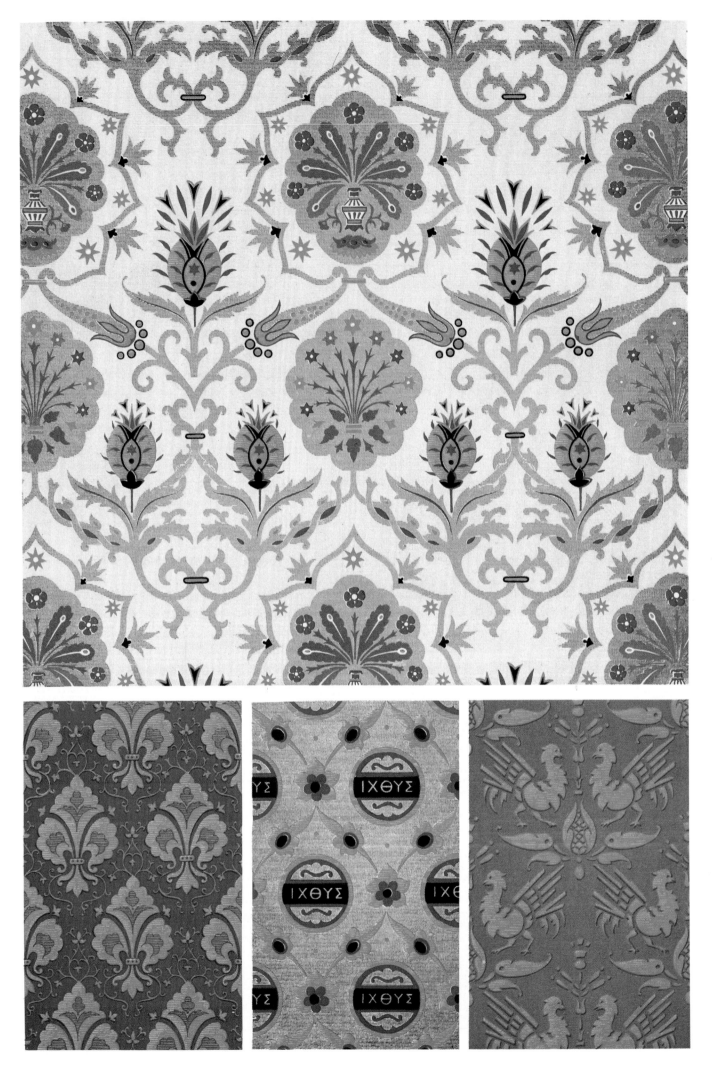

56. Medieval: Brocatelles of Near Eastern style depicted in Italian paintings.

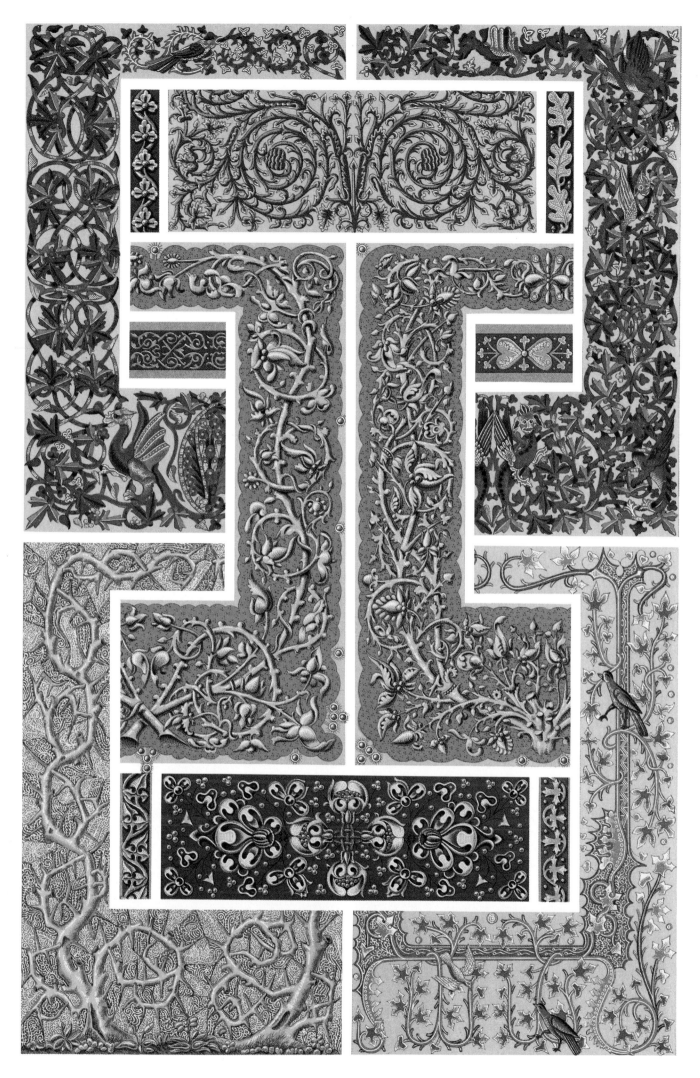

57. Medieval: Plant motifs from architecture and manuscripts.

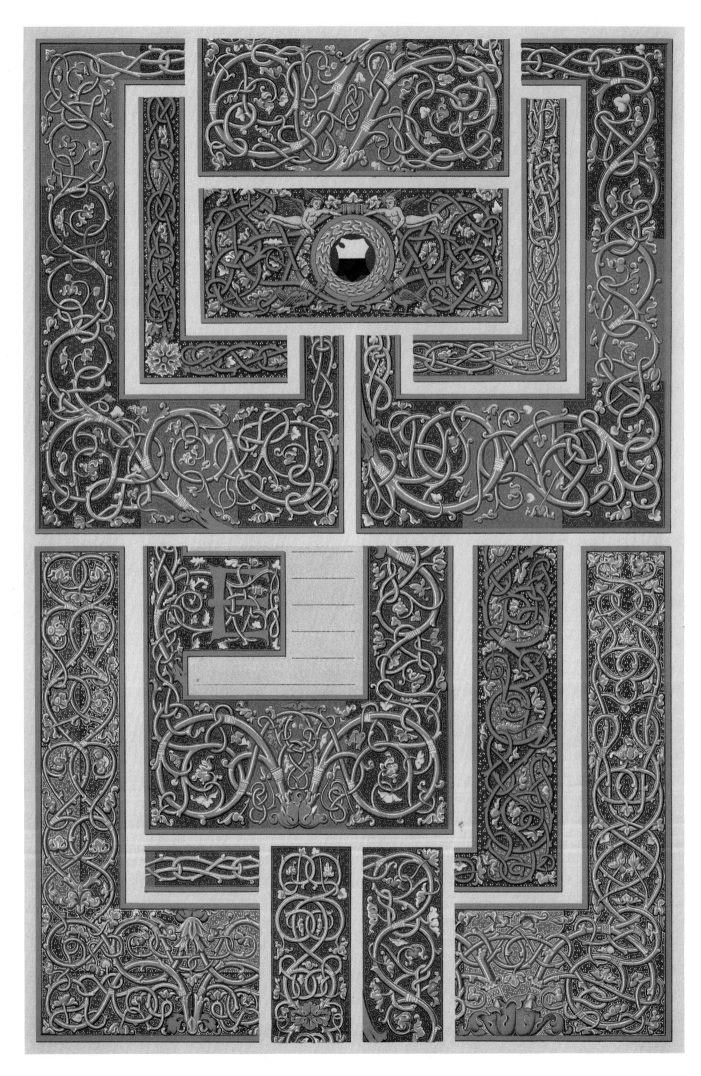

58. Medieval: Enamelwork on glass as depicted in Italian manuscripts.

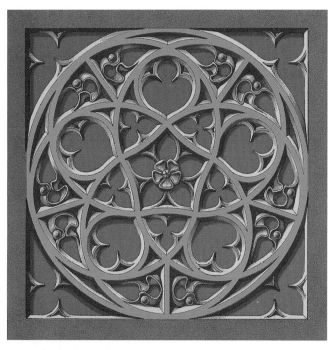
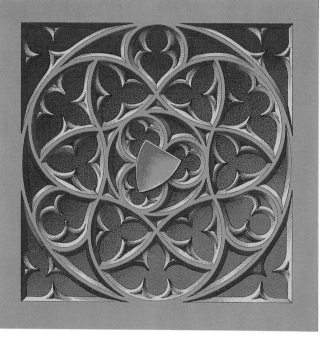
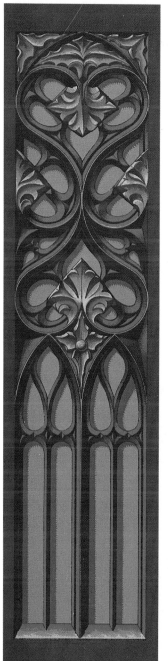
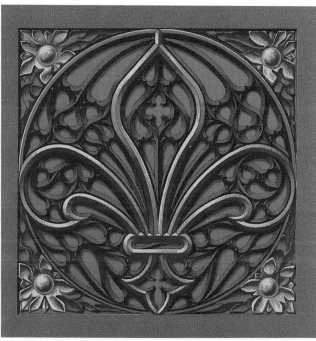
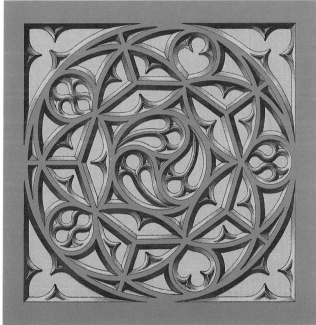
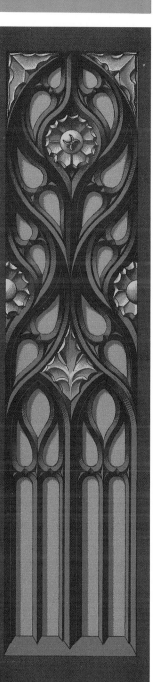

59. Medieval: Painted and gilt woodwork, 15th century.

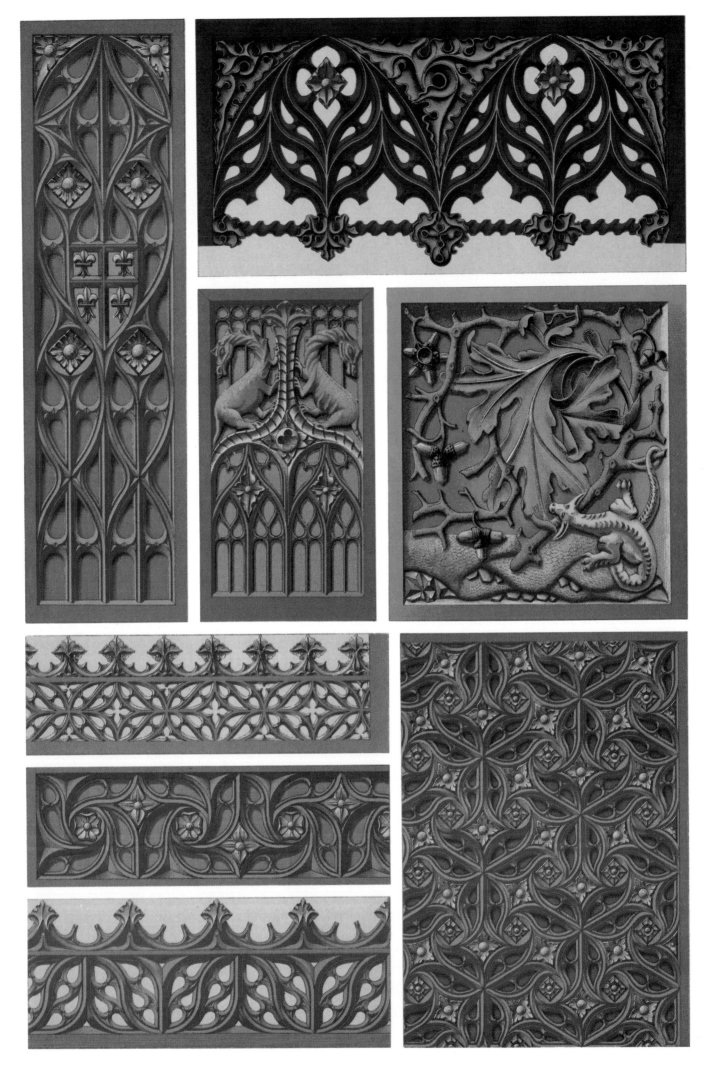

60. Medieval: Painted and gilt woodwork, 15th century.

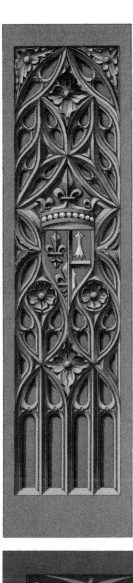
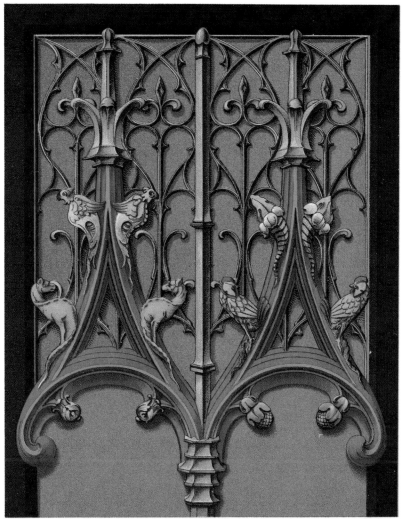
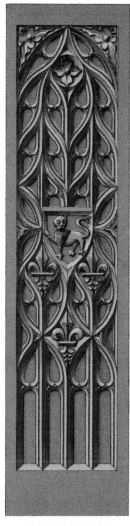
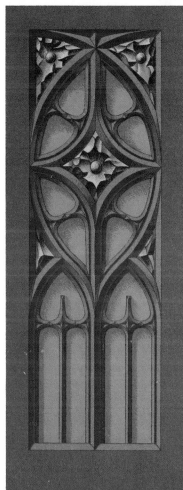
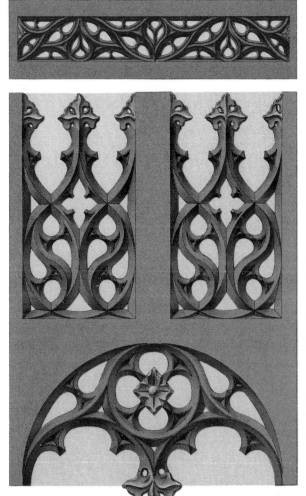
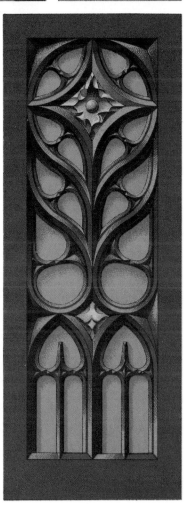

61. Medieval: Painted and gilt woodwork, 15th century.

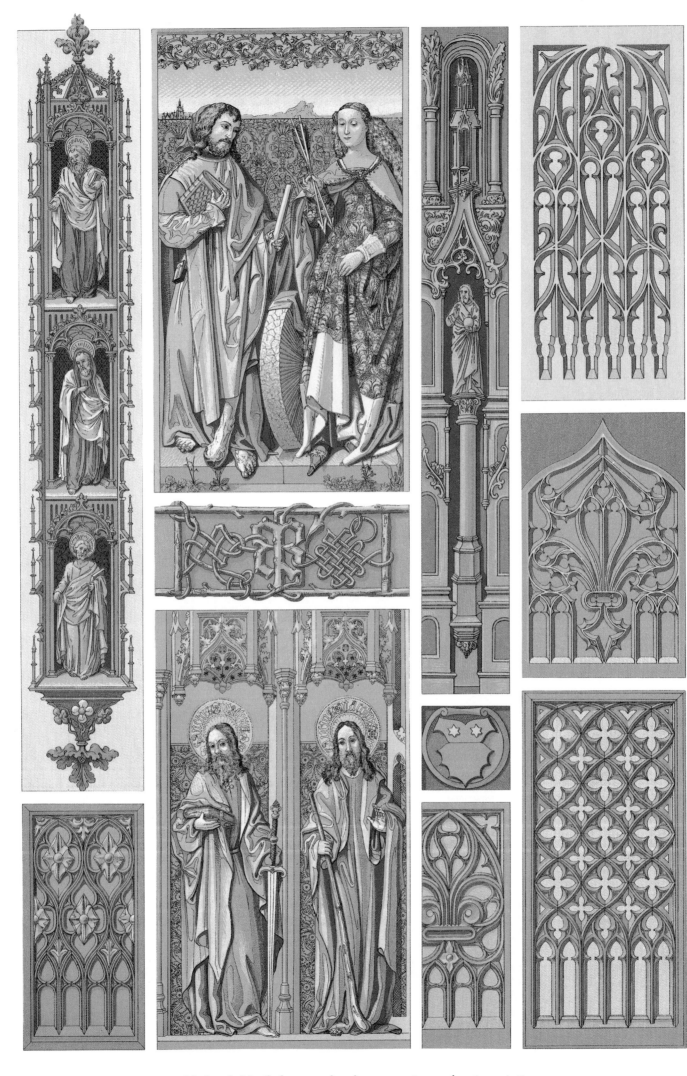

62. Medieval: Motifs from woodwork, manuscripts and votive paintings.

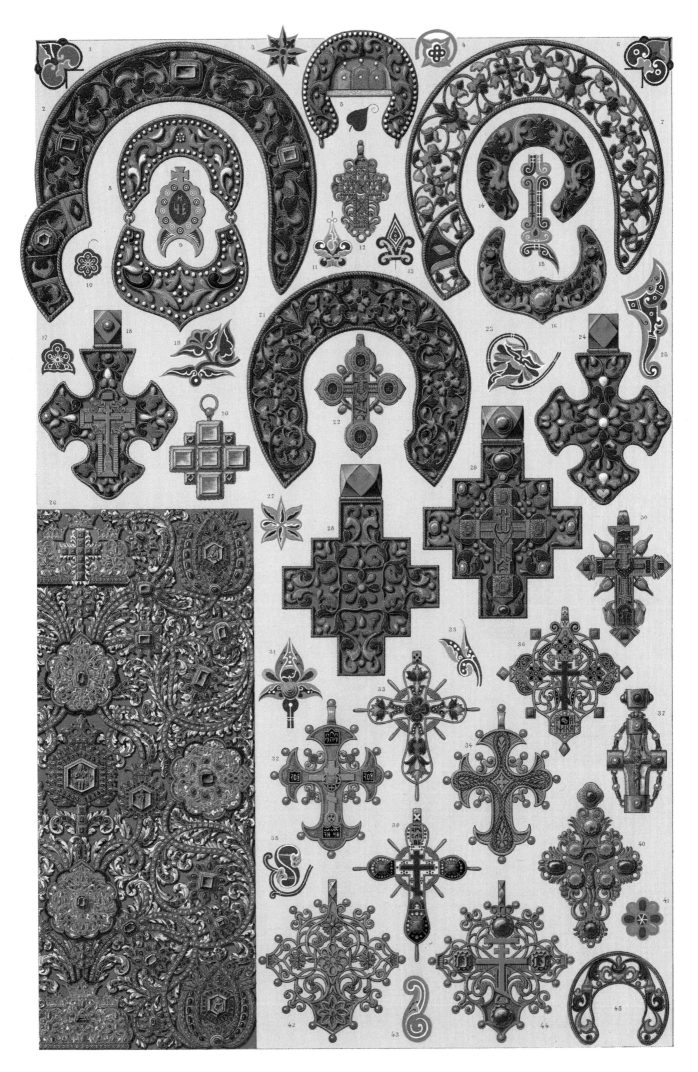

63. Russia: Gold and jewelry, 16th and 17th centuries, some based on painted depictions.

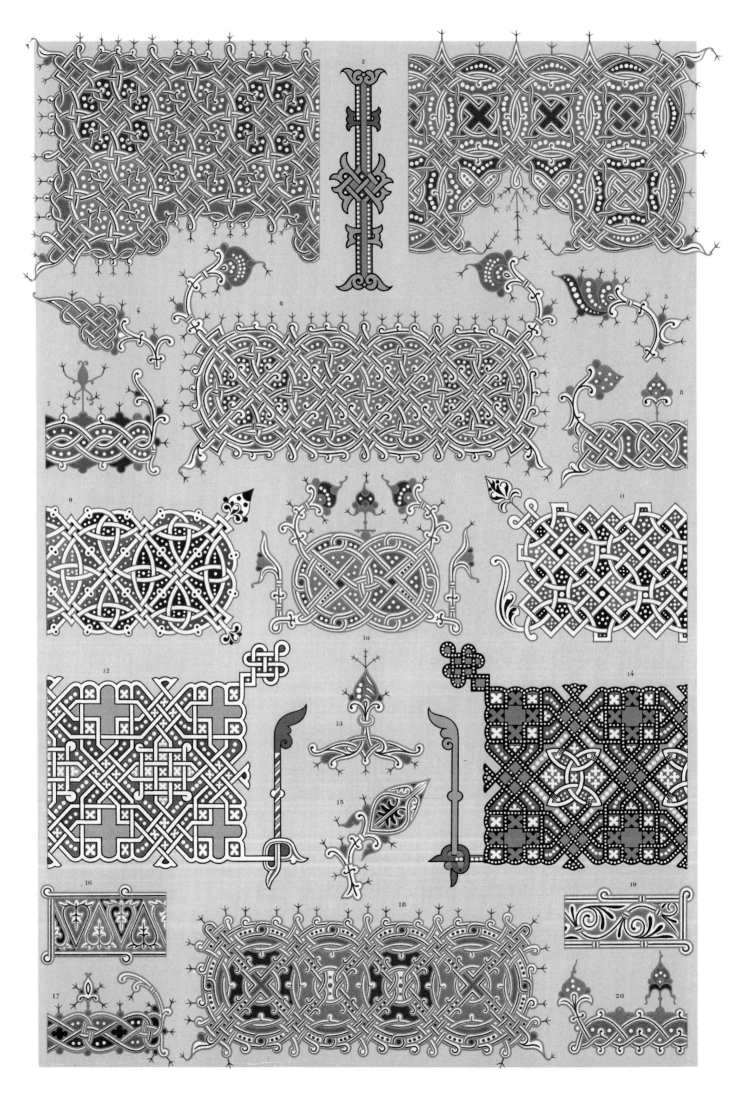

64. Russia: Interlace and other ornaments from 16th-century manuscripts.

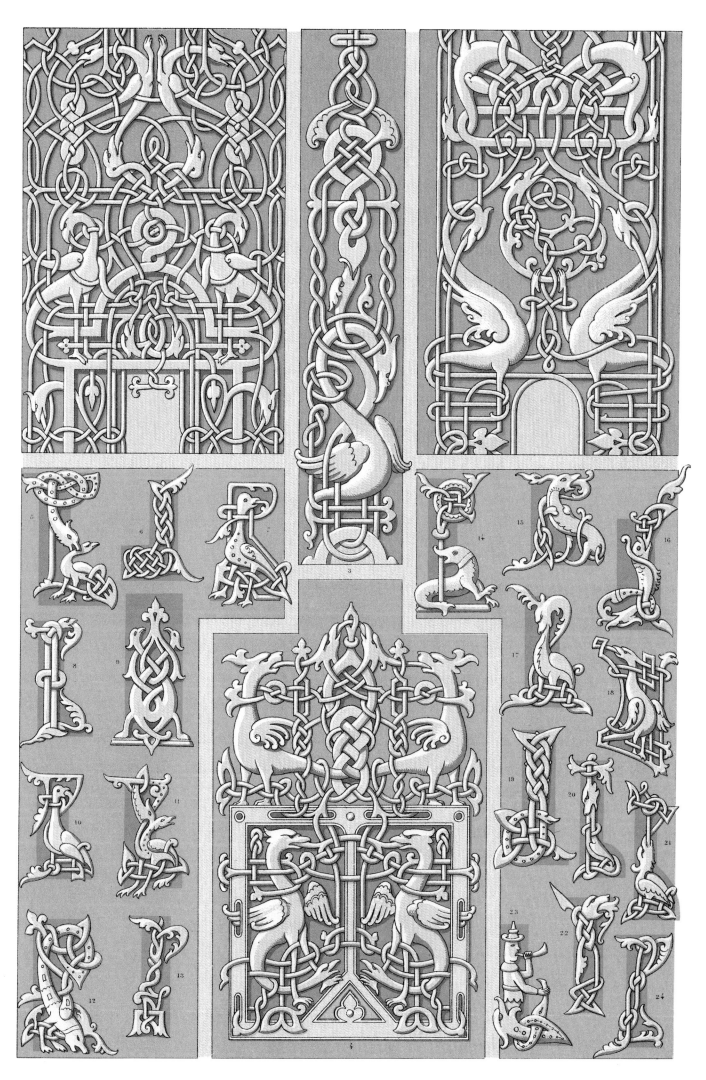

65. Russia: Ornaments from 14th-century manuscripts.

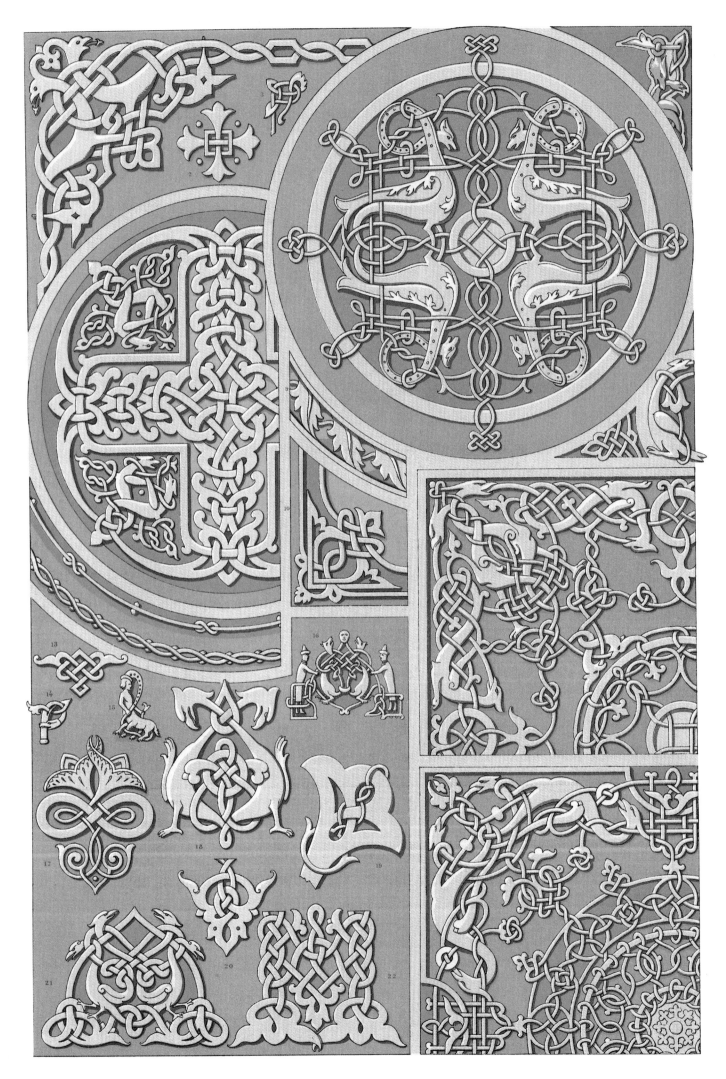

66. Russia: Motifs from metalwork and manuscripts, 12th–15th centuries.

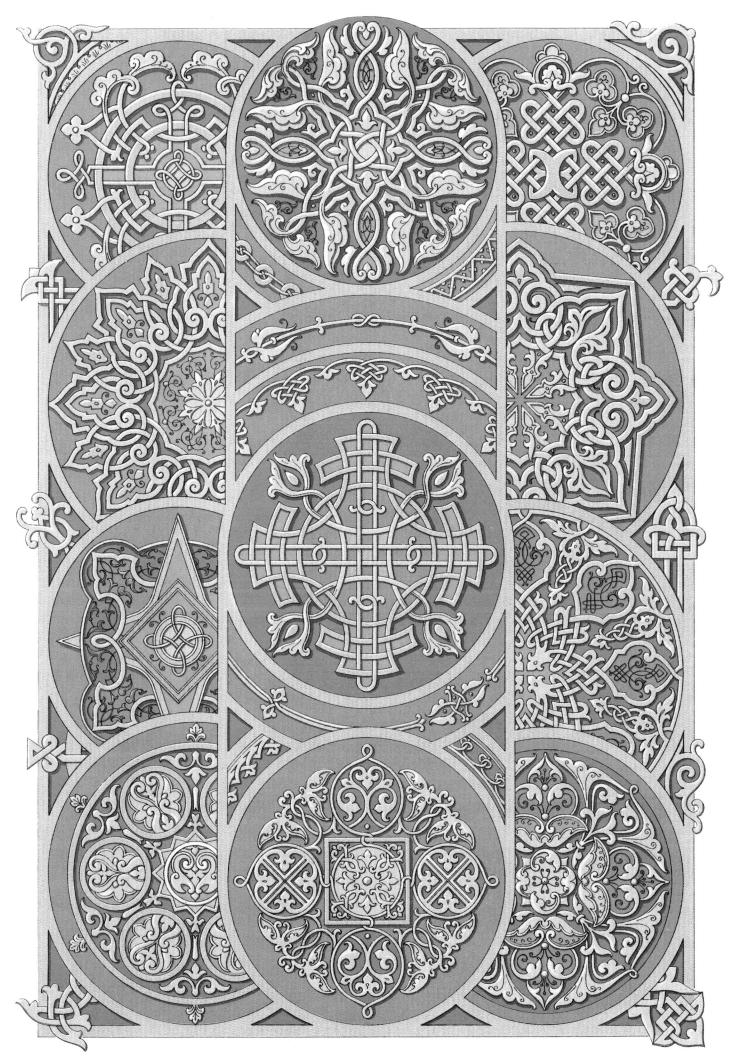

67. Russia: Motifs from engraved and chased metal.

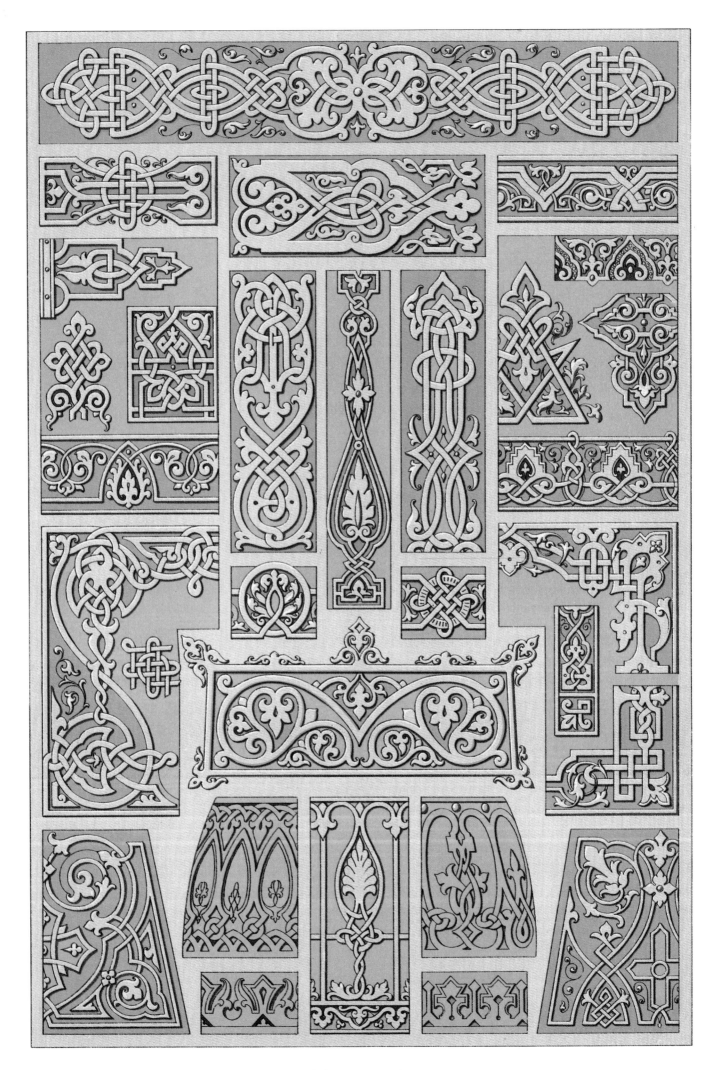

68. Russia: Motifs from metalwork and manuscripts.

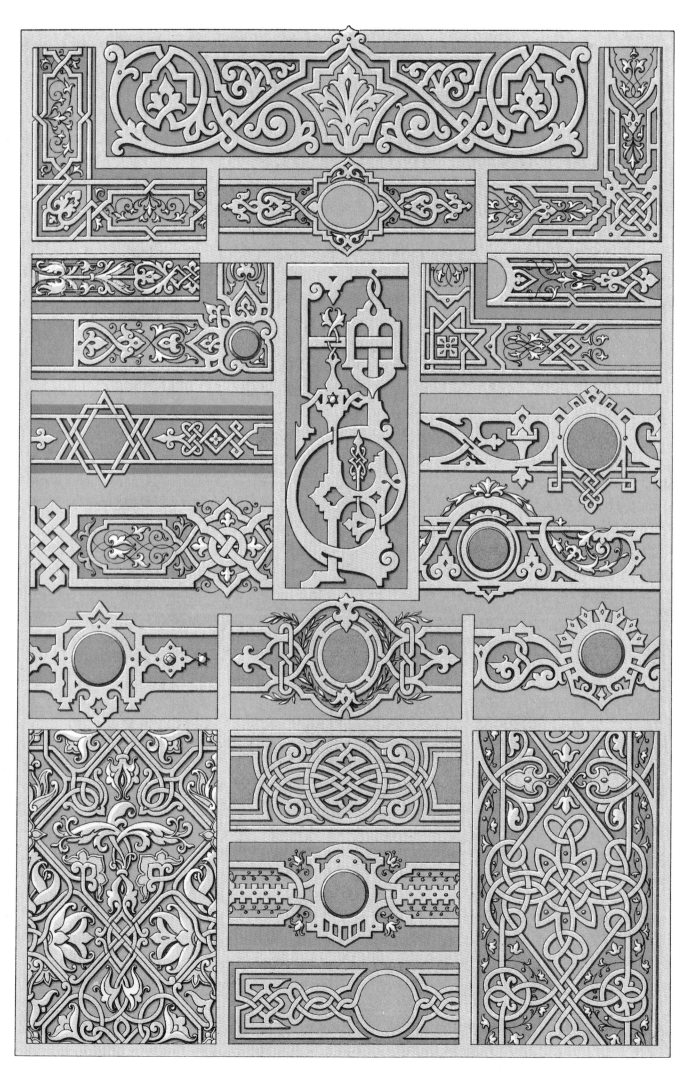

69. Russia: Motifs from metalwork.

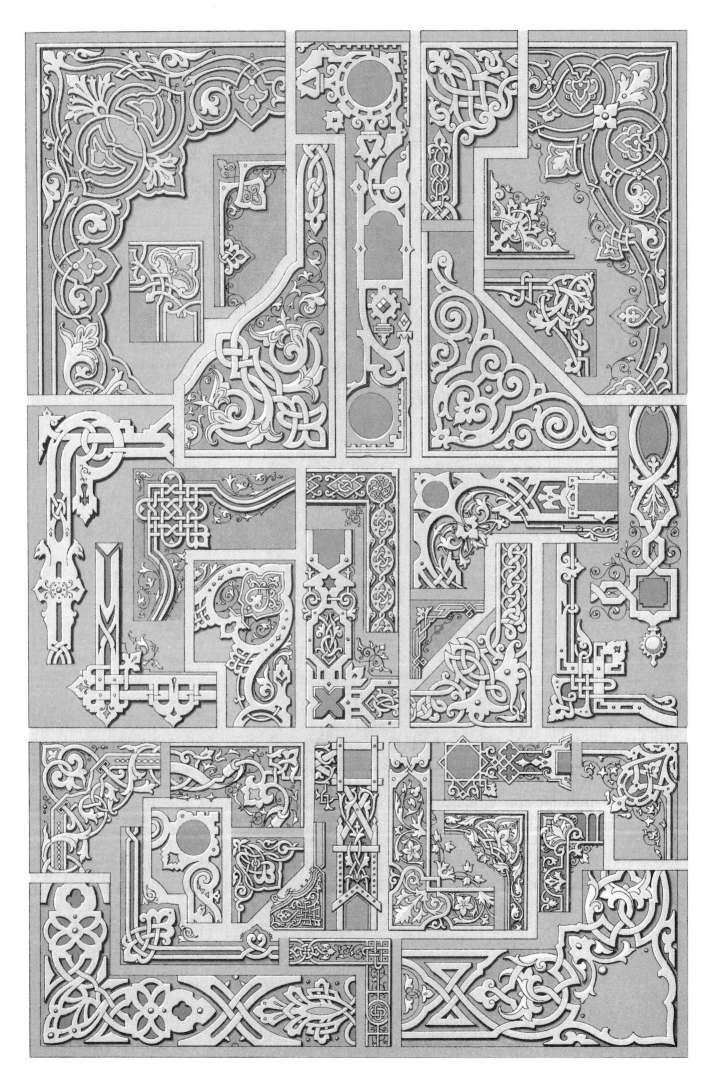

70. Russia: Corner motifs from metalwork designs.

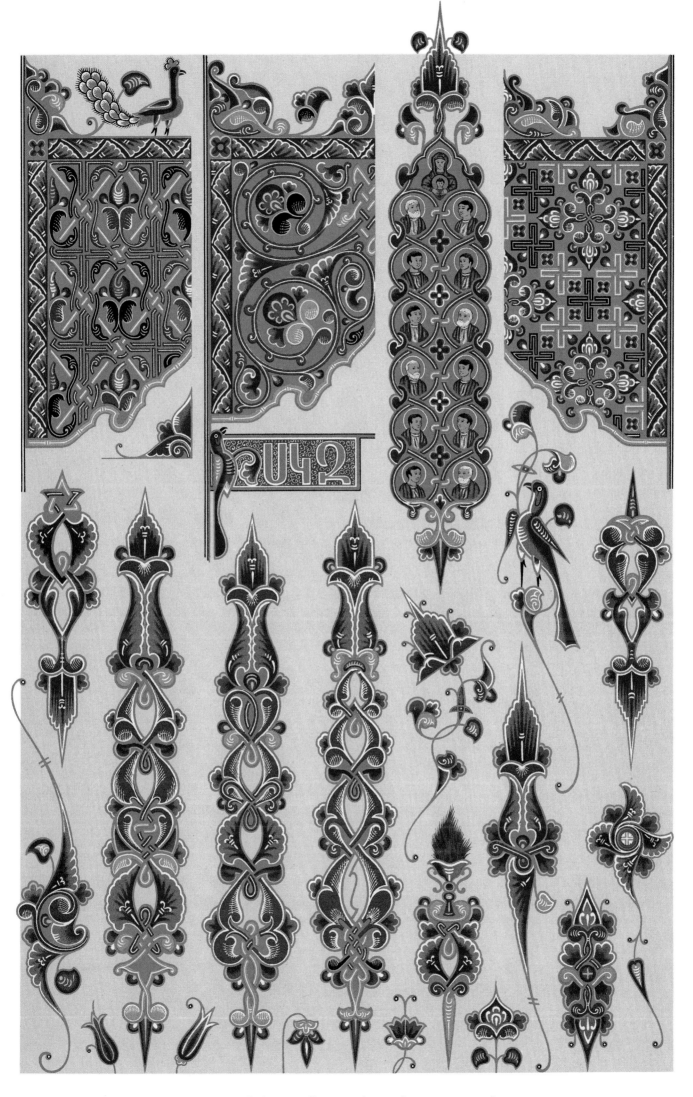

71. Armenia: Motifs from an illuminated Gospel manuscript, 16th century.

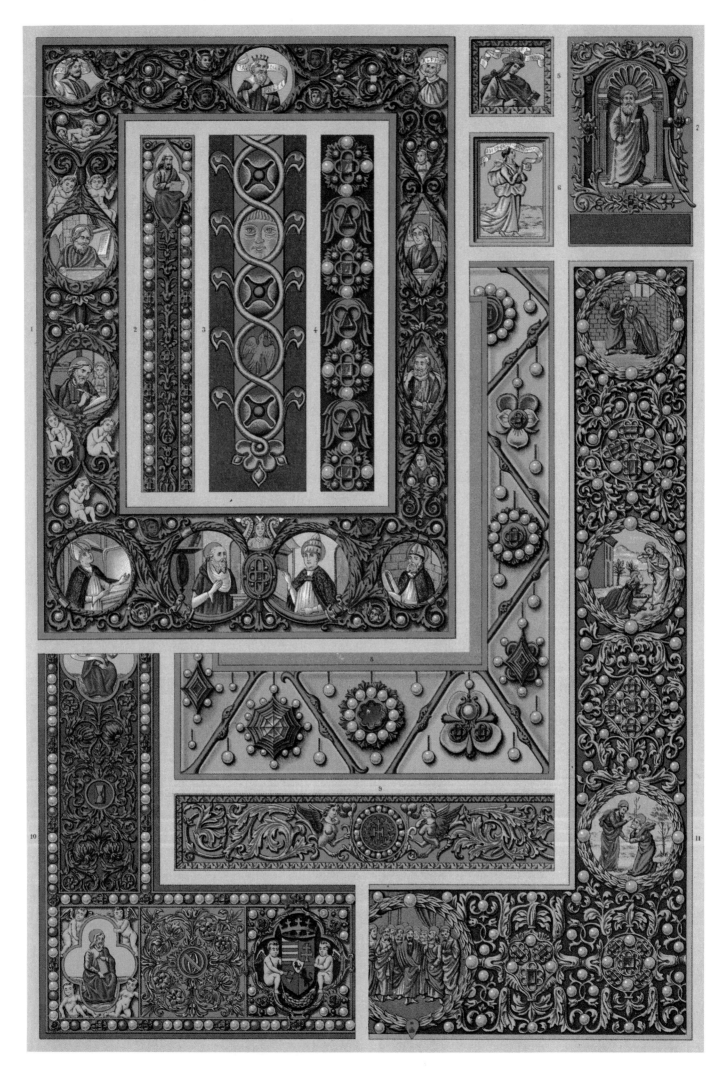

72. Medieval: Jewelry designs from illuminated manuscripts, 15th century.

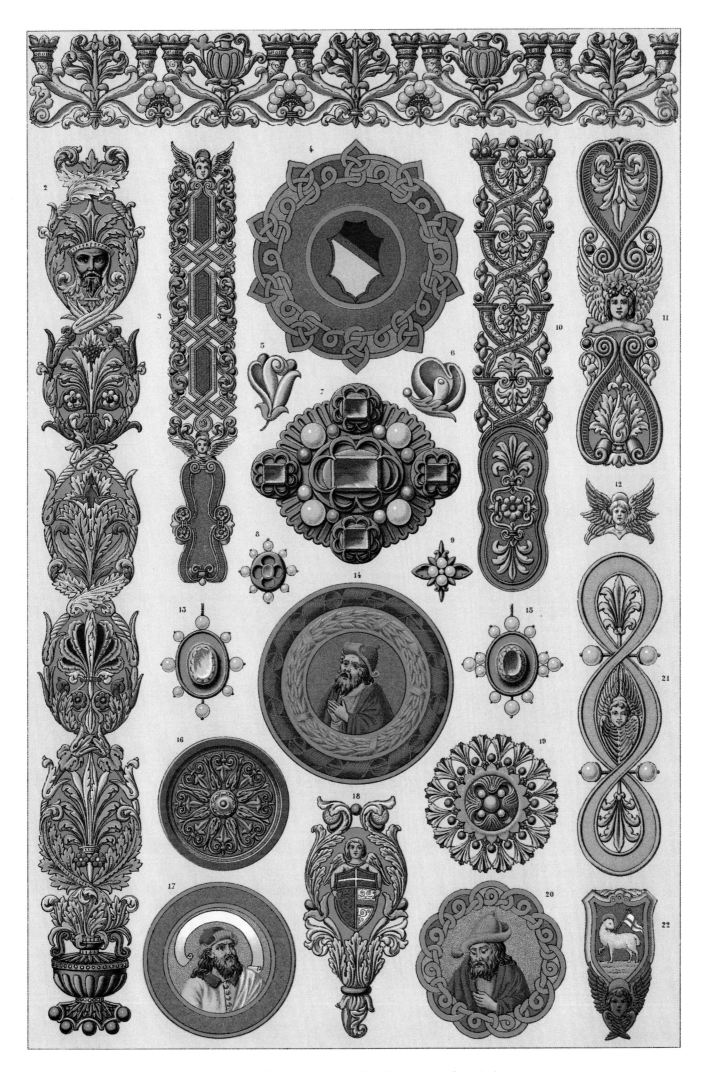

73. Renaissance: Enameled jewelry, 15th and 16th centuries, from Italian manuscripts.

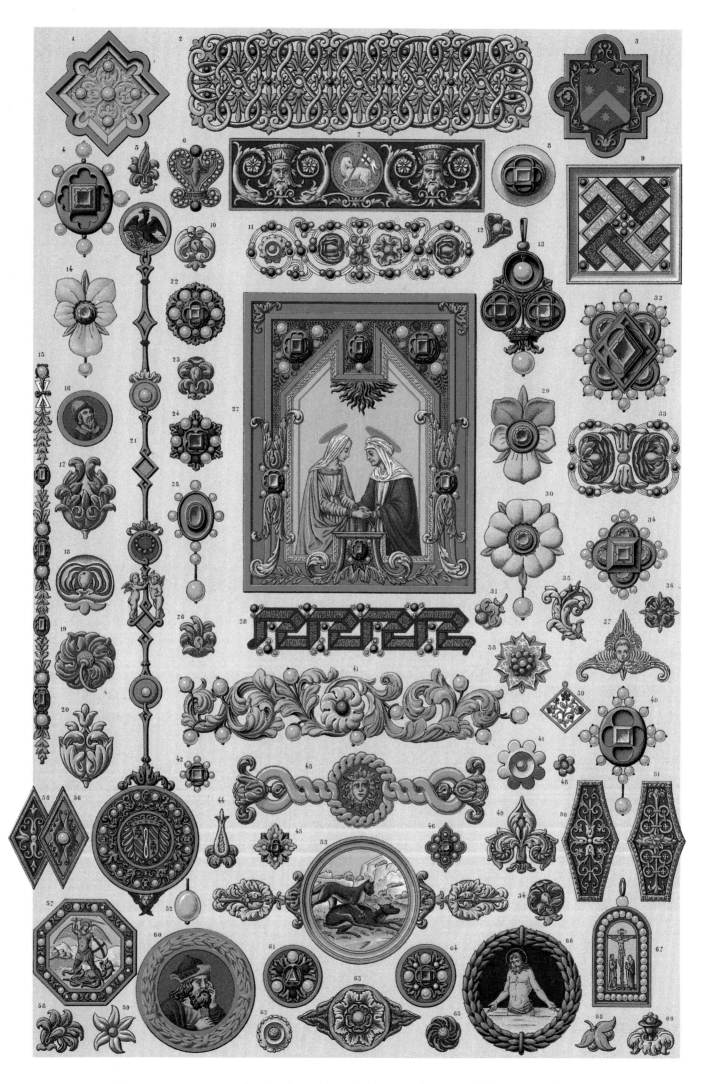

74. Renaissance: Enameled jewelry, 15th and 16th centuries, from Italian manuscripts.

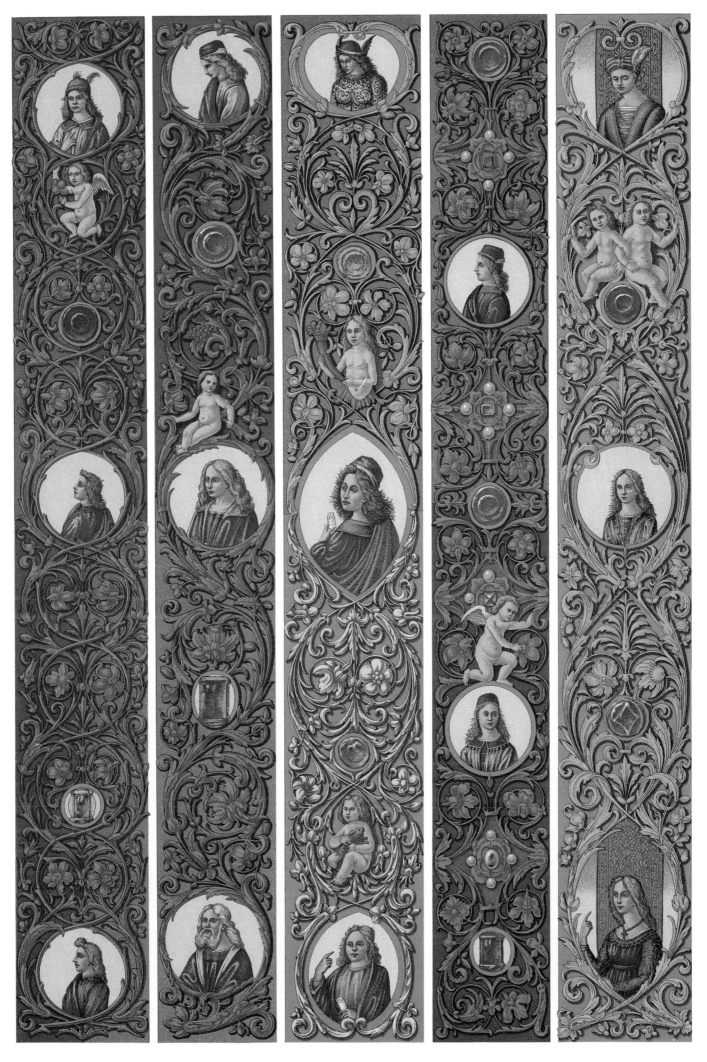

75. Renaissance: Borders from a Florentine manuscript by Attavante (1452–ca. 1520).

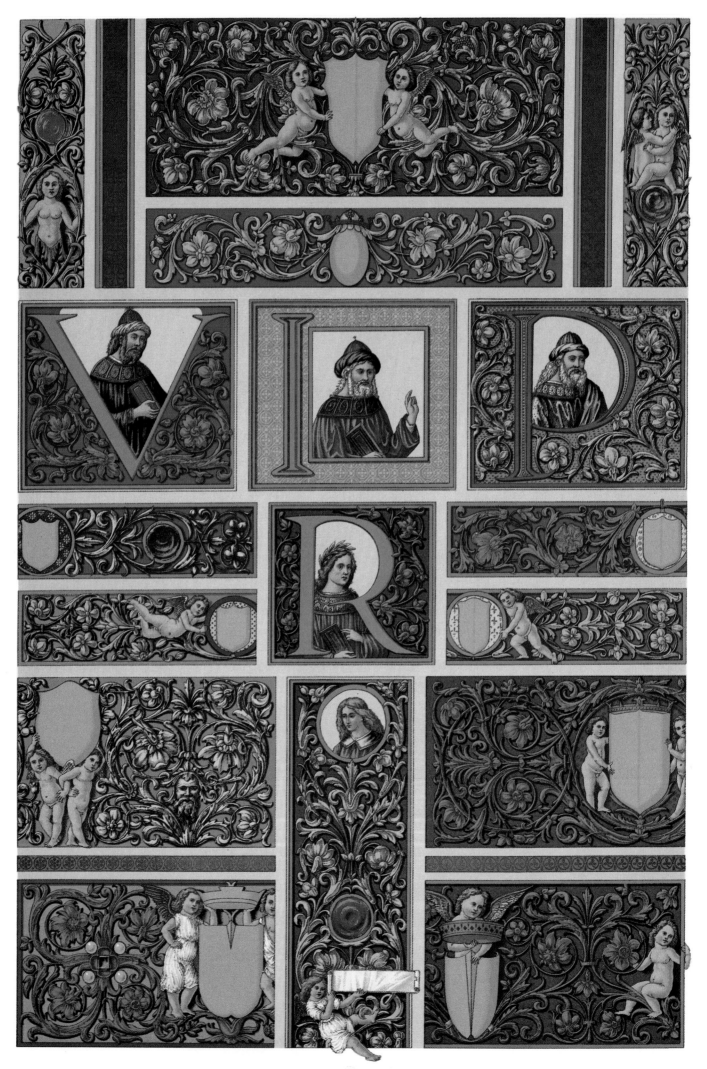

76. Renaissance: Panels and borders from a Florentine manuscript by Attavante.

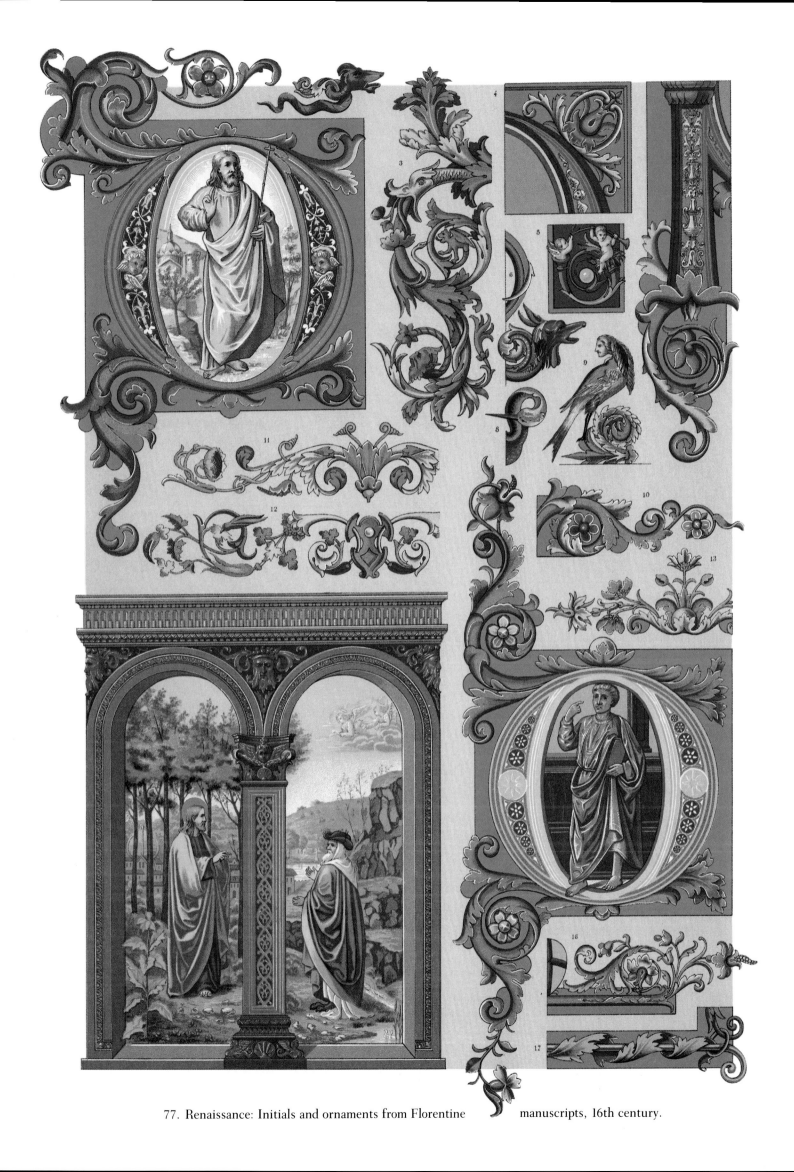

77. Renaissance: Initials and ornaments from Florentine manuscripts, 16th century.

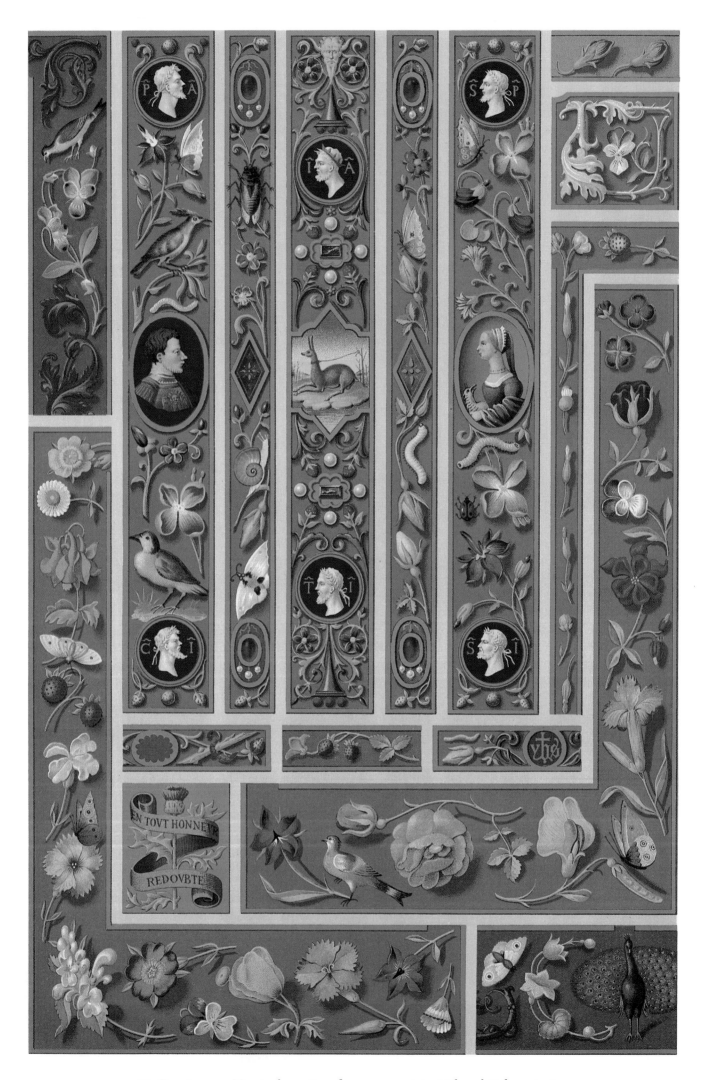

78. Renaissance: Margin decorations from manuscripts, 15th and 16th centuries.

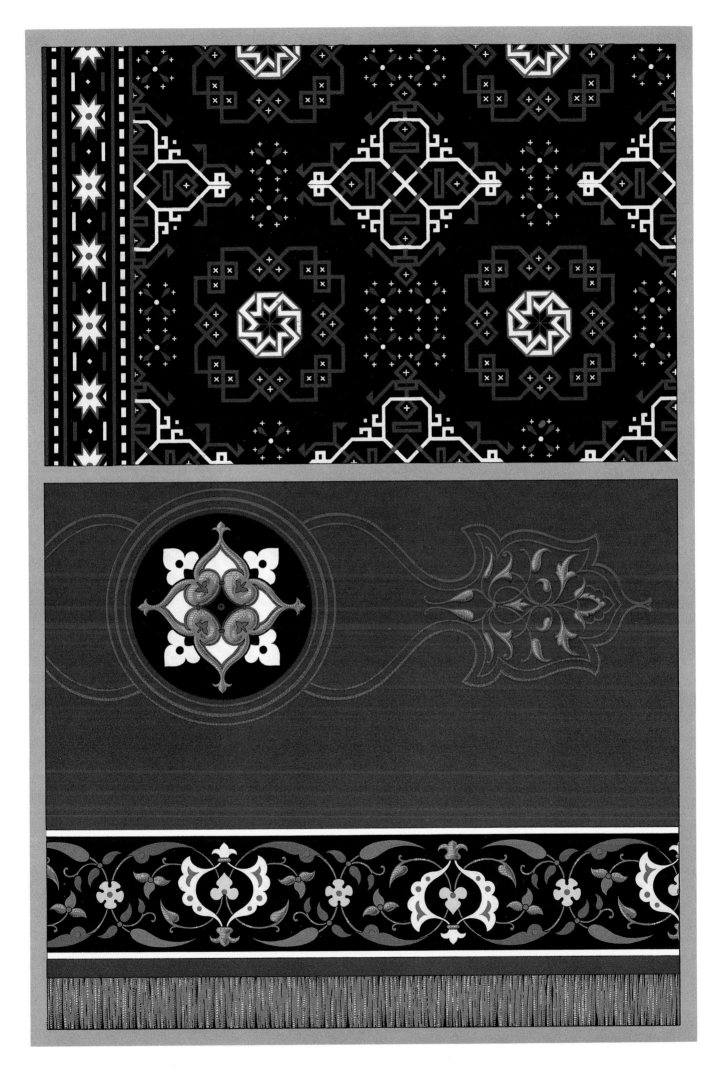

79. Renaissance: Carpet designs of Near Eastern style from 15th-century paintings.

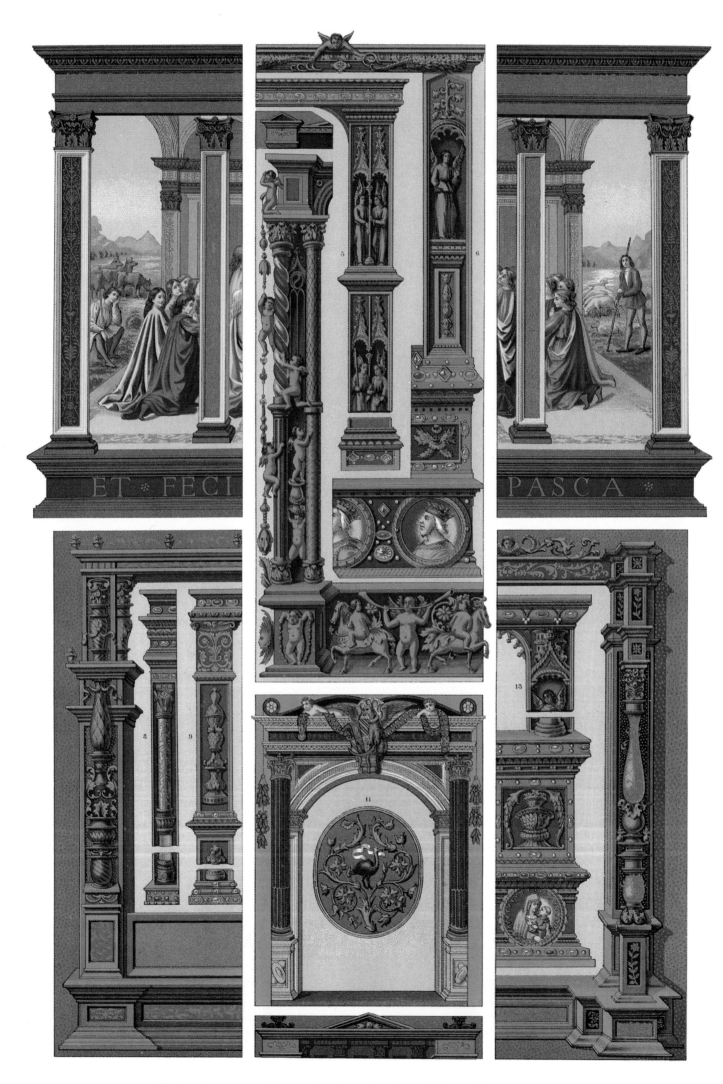

80. Renaissance: Architectural and metalwork motifs from Italian manuscripts.

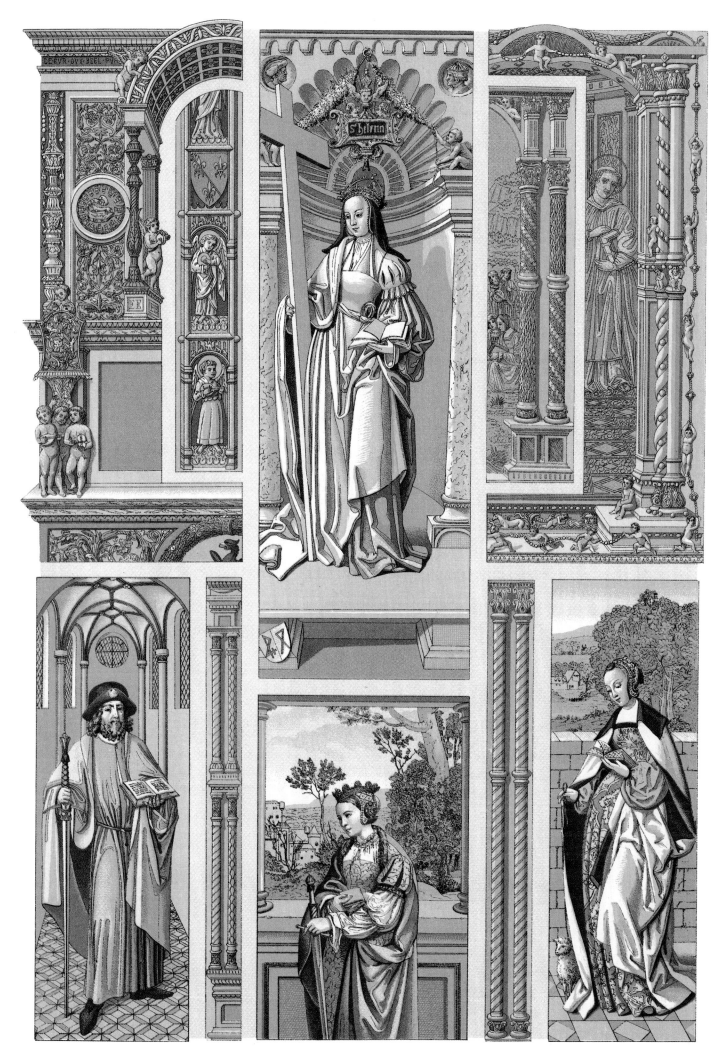

81. Renaissance: Architectural and figural motifs from paintings and manuscripts.

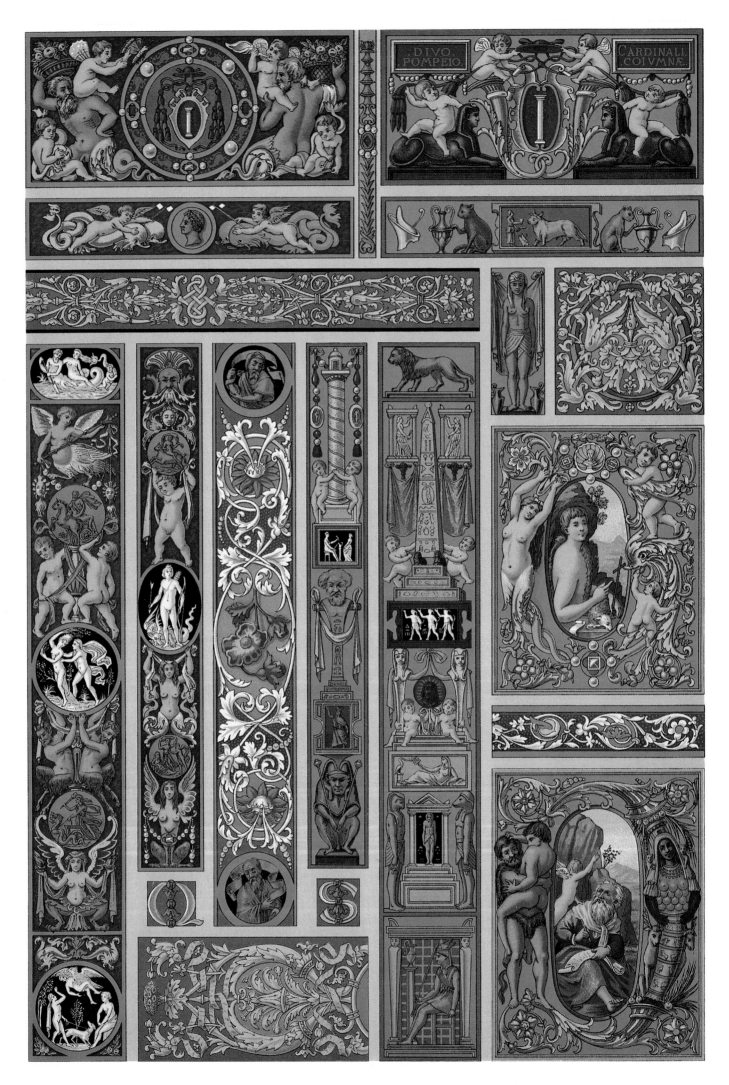

82. Renaissance: Ornaments from Italian manuscripts, 16th and 17th centuries.

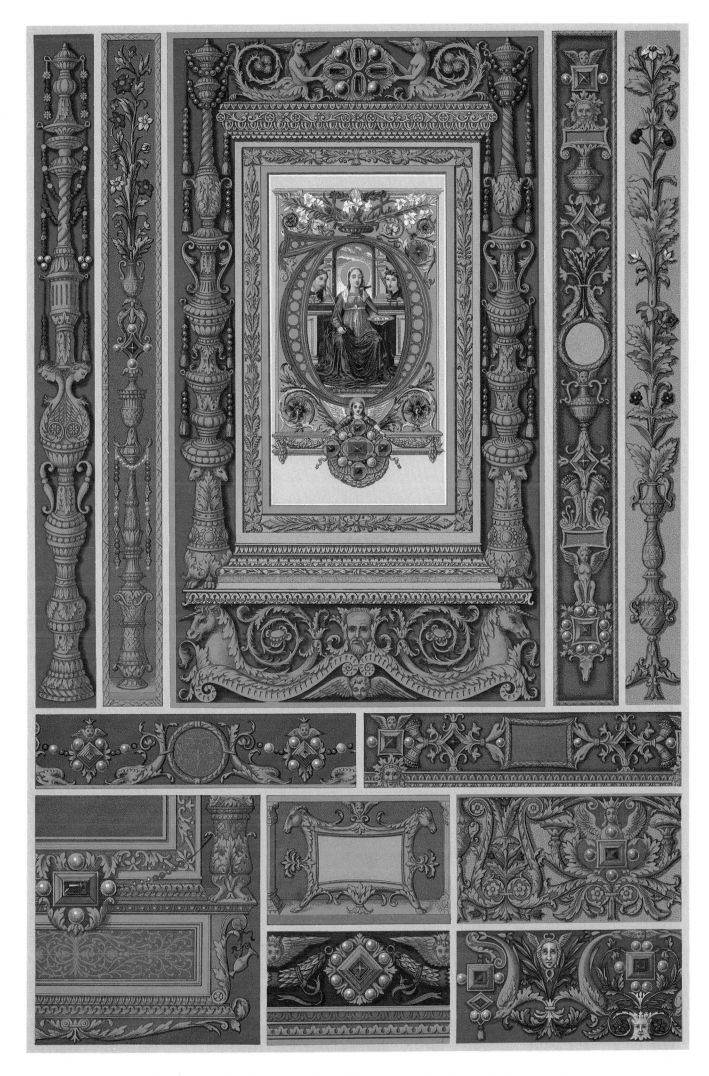

83. Renaissance: Jewelry designs from Italian manuscripts, 15th and 16th centuries.

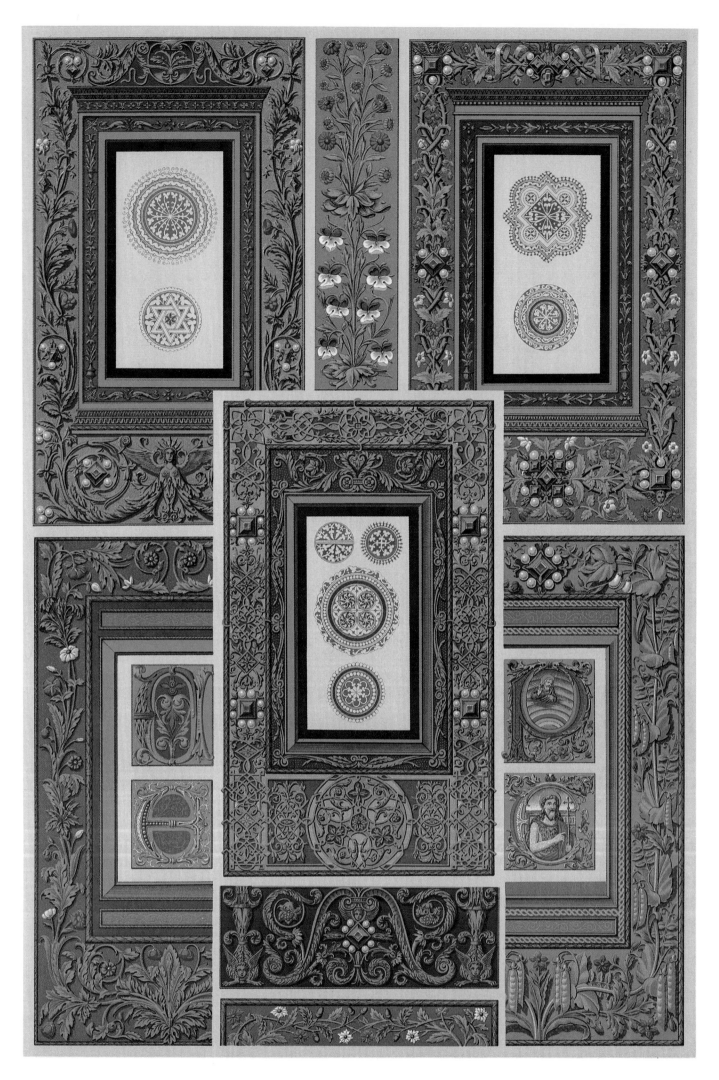

84. Renaissance: From Italian and French manuscripts, 15th and 16th centuries.

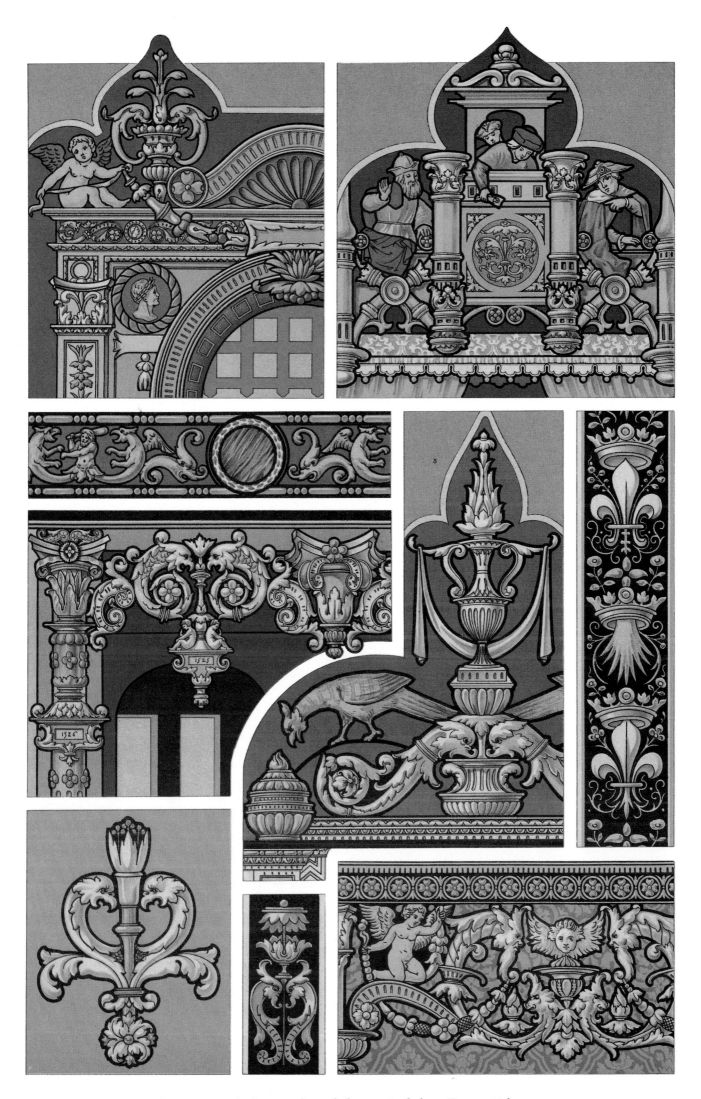

85. Renaissance: Architectural motifs from stained glass, France, 16th century.

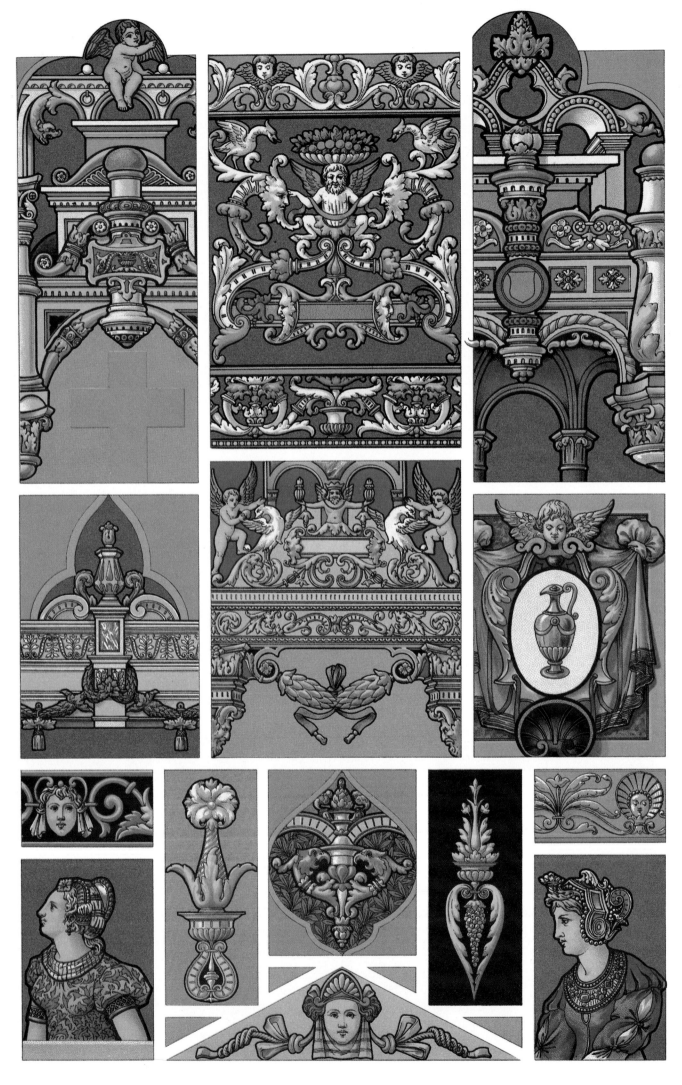

86. Renaissance: Sculptural and pictorial motifs from stained glass, France, 16th century.

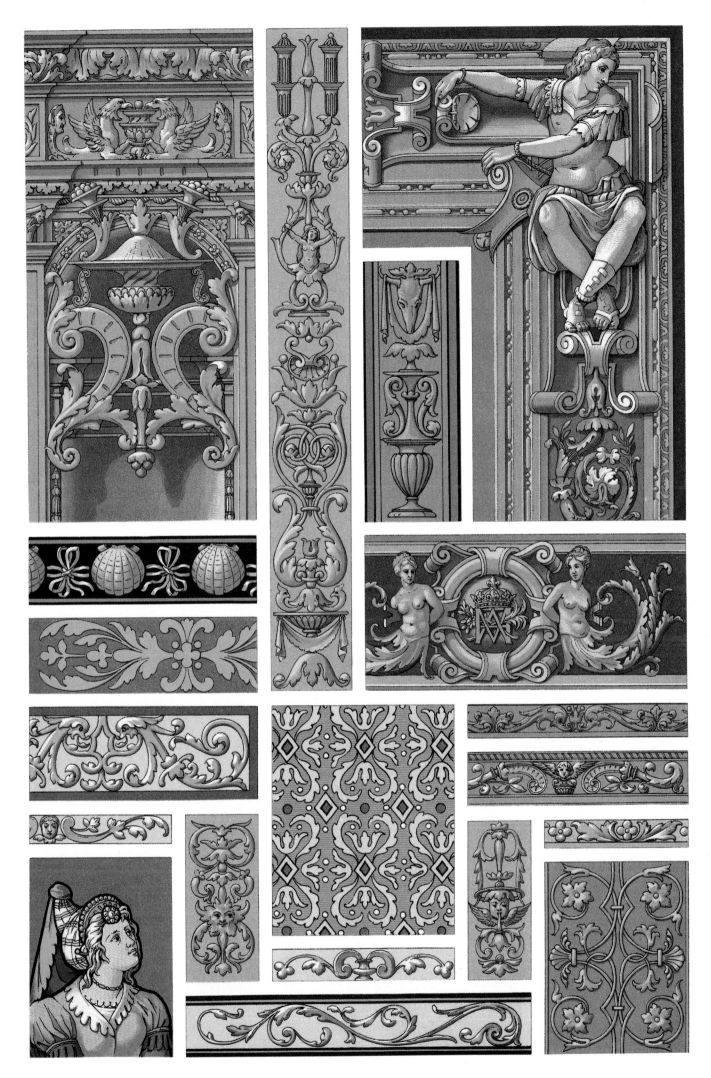

87. Renaissance: From stained glass, tapestries and sculpture, France, 16th century.

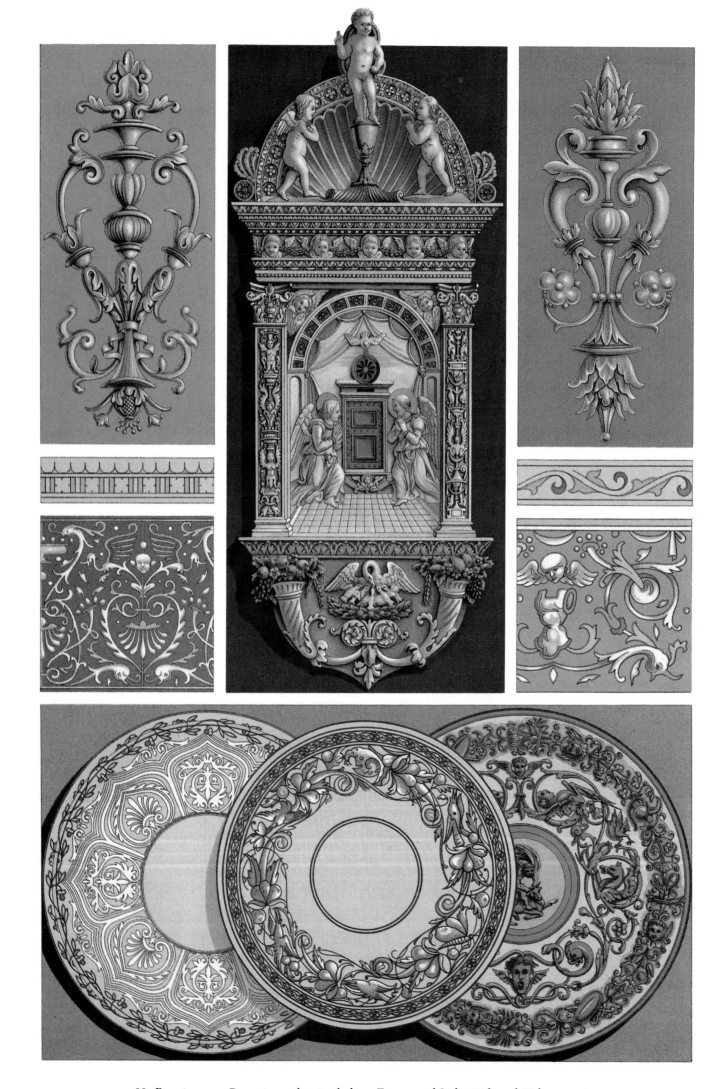

88. Renaissance: Ceramics and stained glass, France and Italy, 15th and 16th centuries.

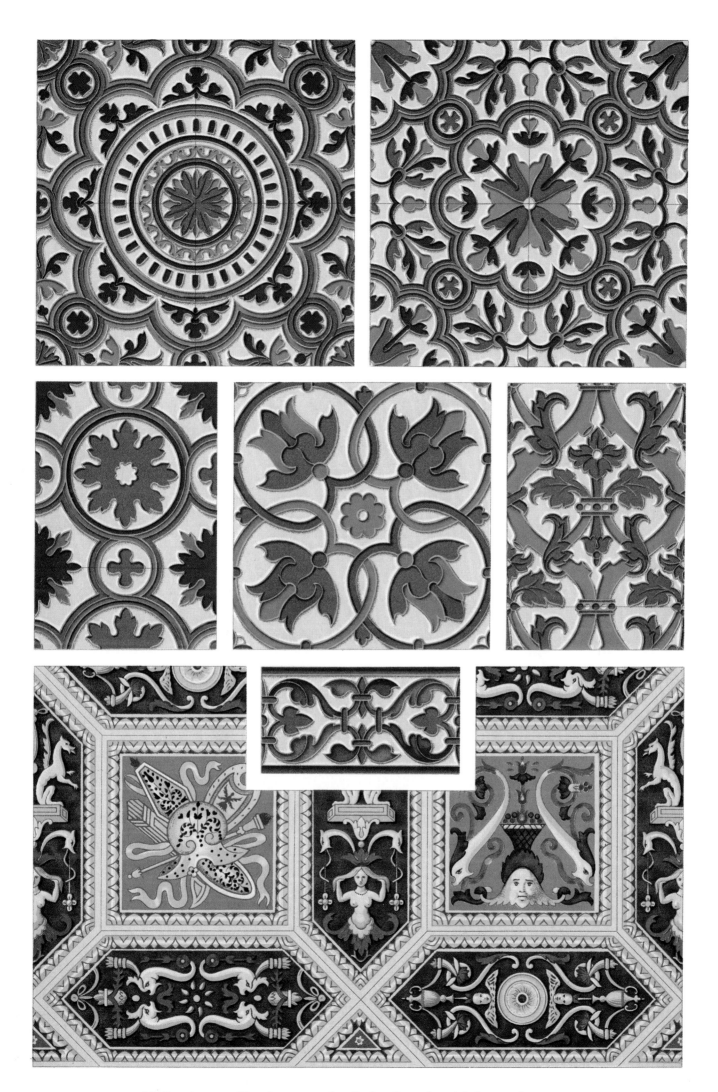

89. Renaissance: Glazed paving and wall tiles, Spanish and Italian, 16th century.

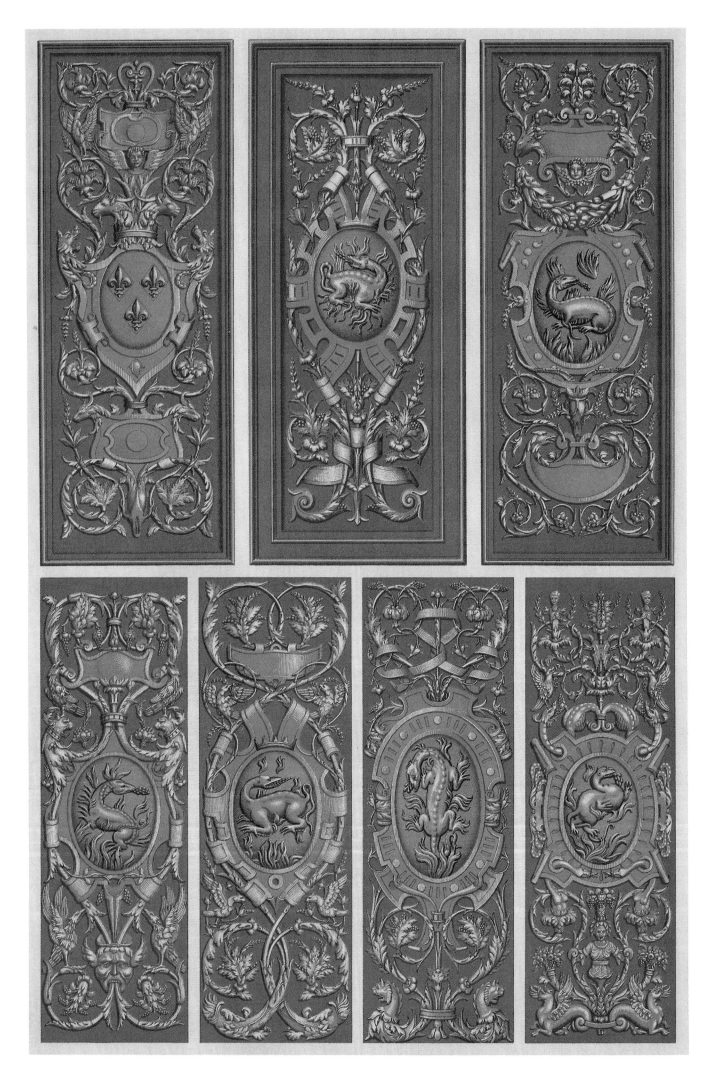

90. Renaissance: Panels from the palace of Fontainebleau, 16th century.

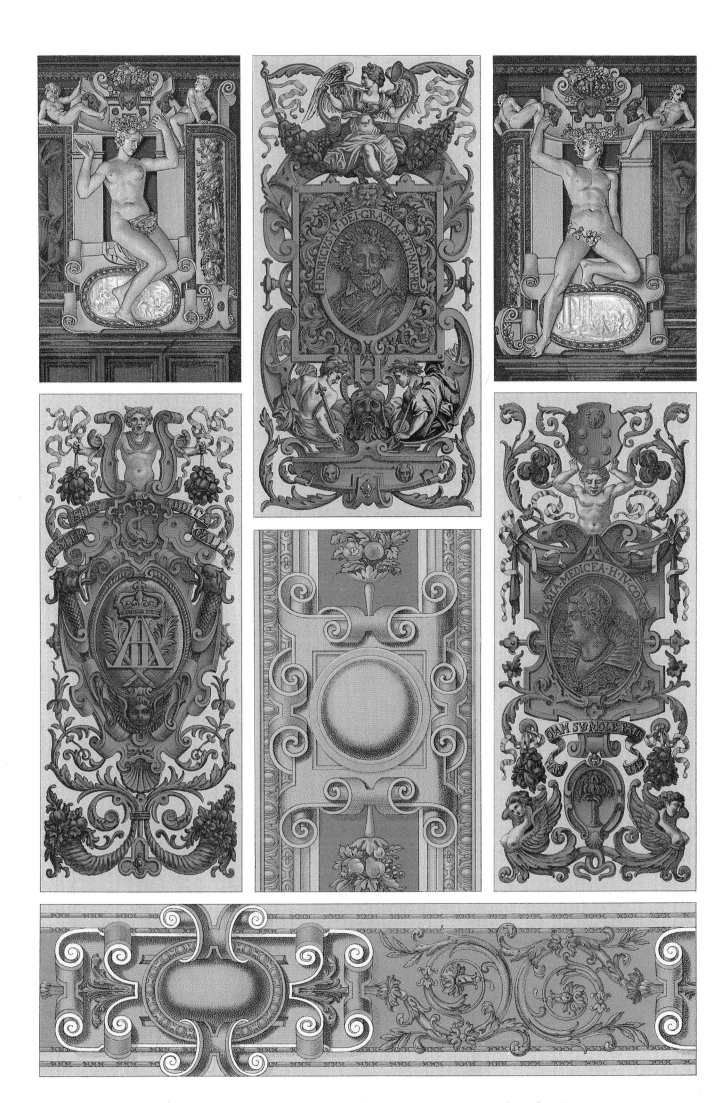

91. 16th and 17th Centuries: Cartouches from sculpture, painting and textiles, France.

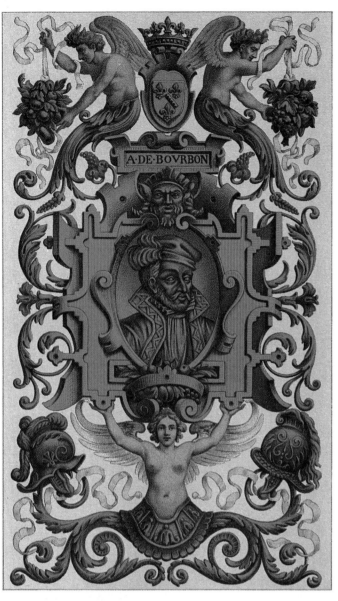
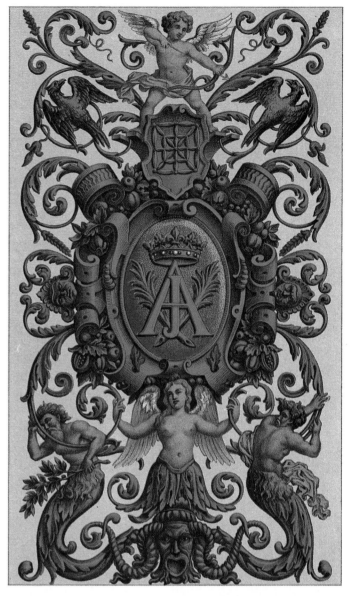
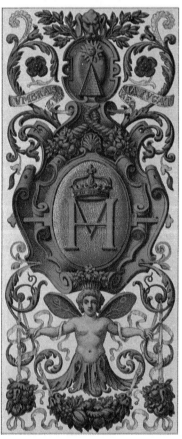
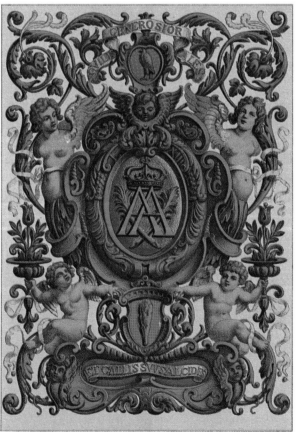
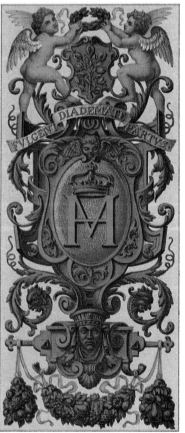

92. 17th Century: Decorative paintings from the palace of Fontainebleau.

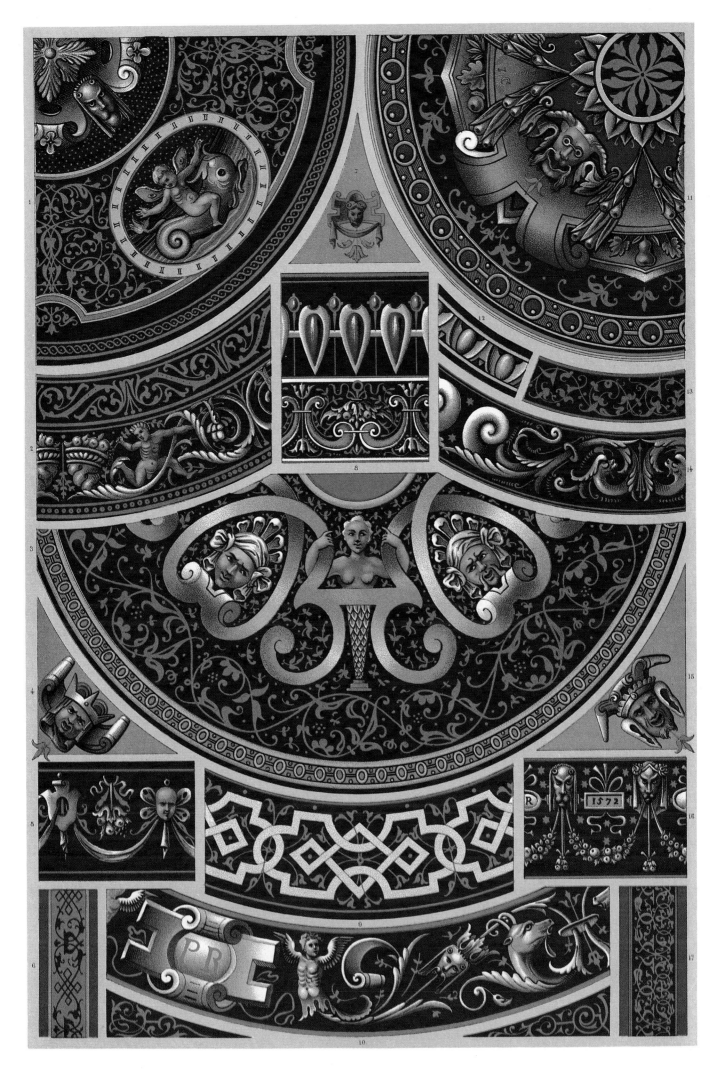

93. Renaissance: Motifs from Limoges enamels, 16th century.

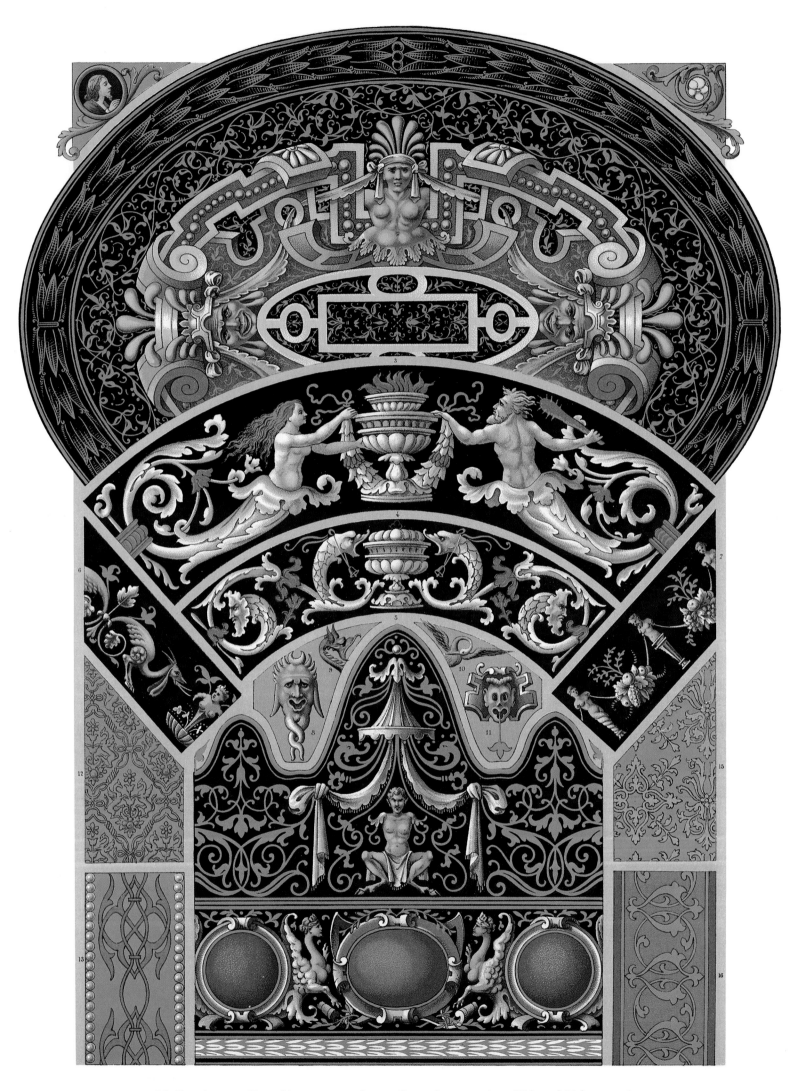

94. Renaissance: From Limoges enamels, textiles and manuscripts, 15th and 16th centuries.

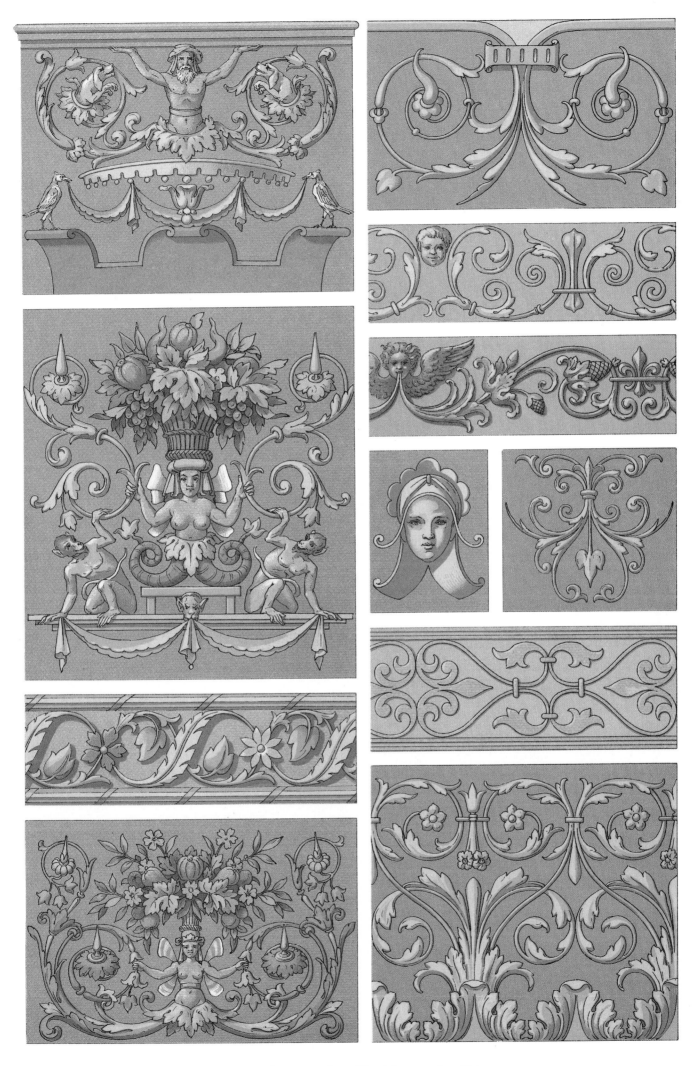

95. Renaissance: Ornament from Flemish tapestries, 16th century.

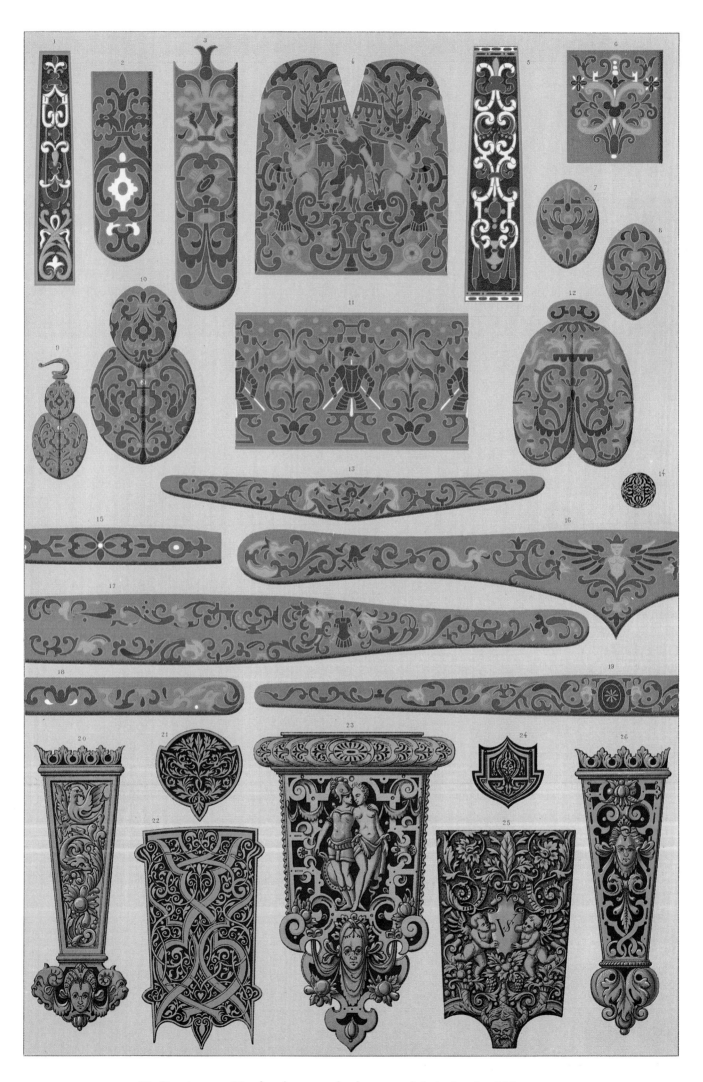

96. Renaissance: Metalwork on swords, daggers and their sheaths, 16th century.

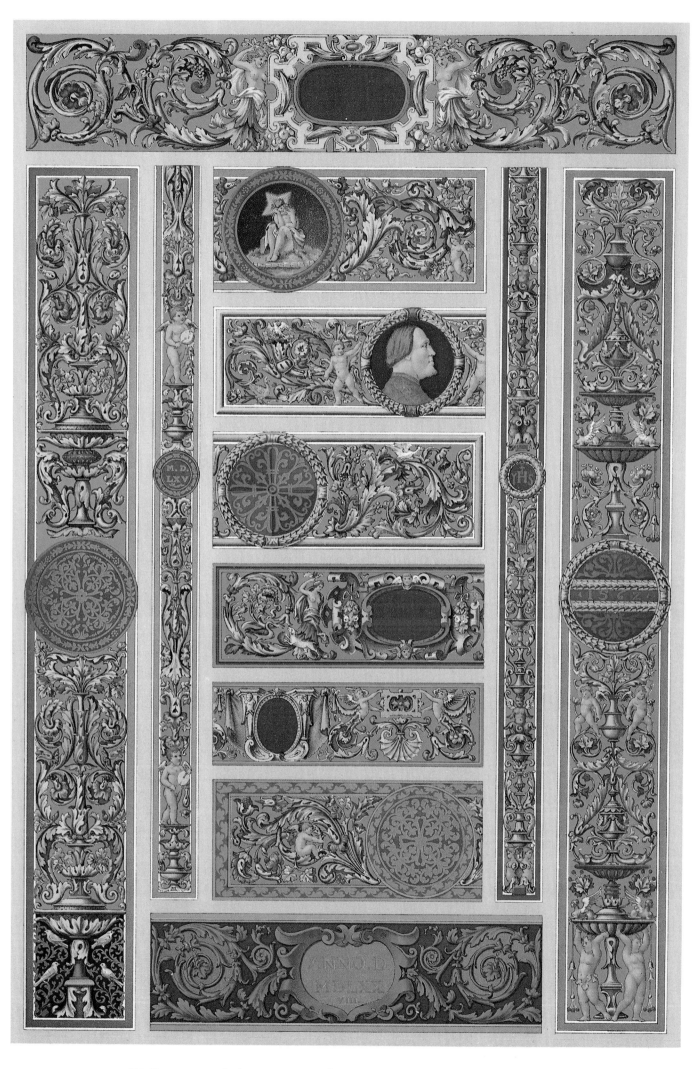

97. Renaissance: Italian manuscript decorations, second half of the 16th century.

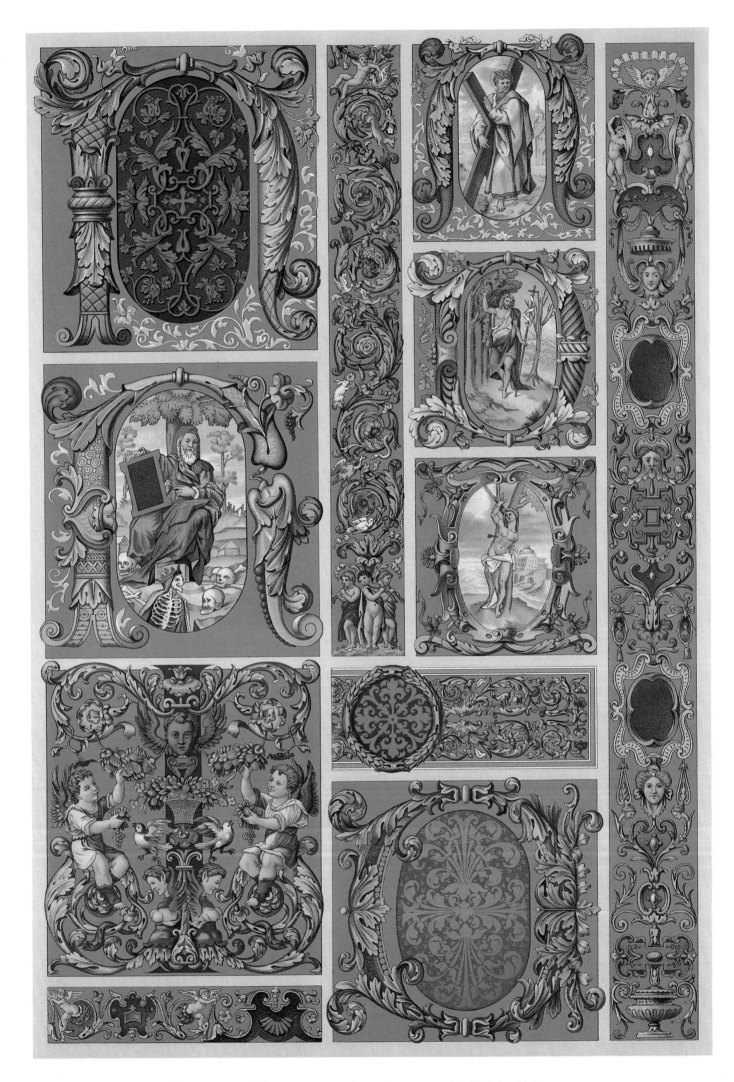

98. Renaissance: Italian manuscript decorations, second half of the 16th century.

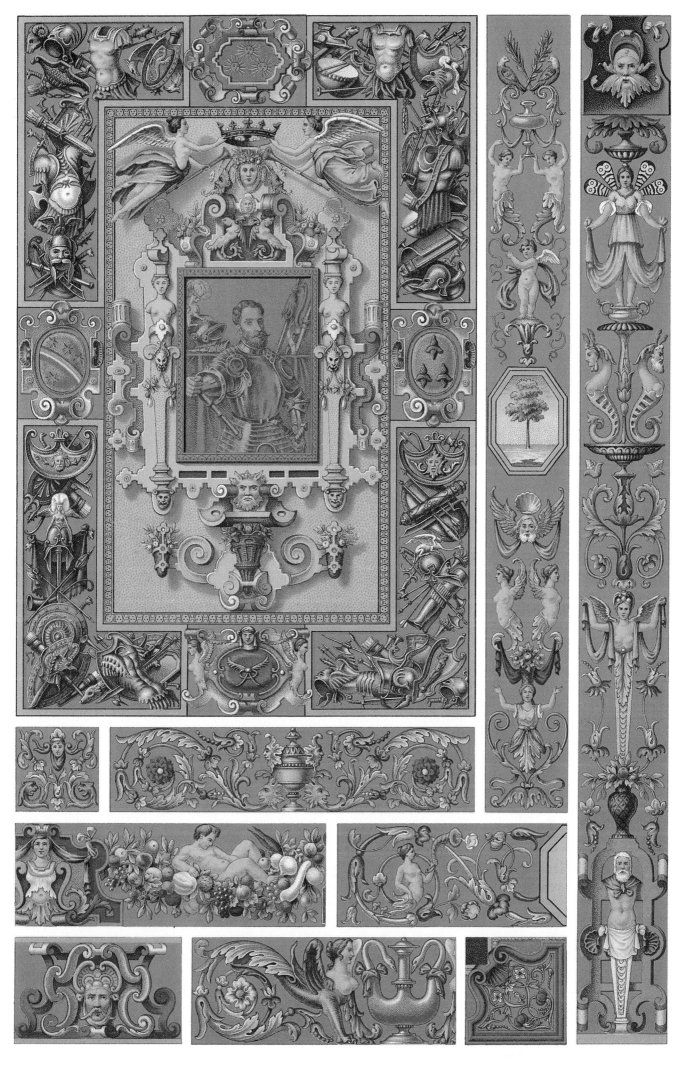

99. Renaissance: Carved-wood motifs from a 16th-century Italian manuscript.

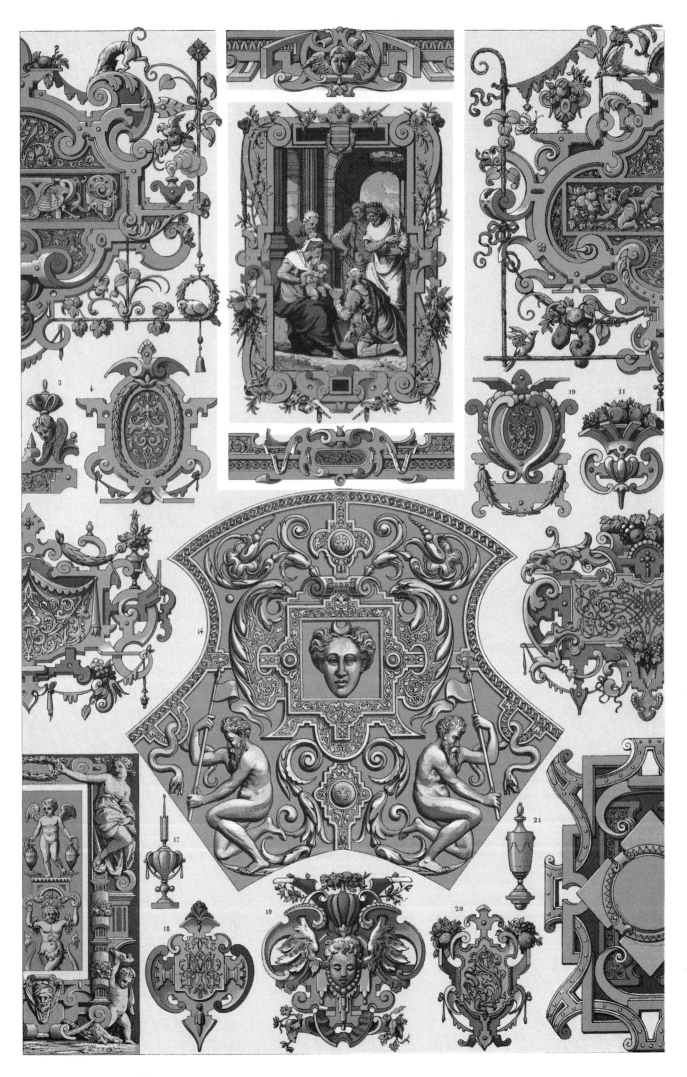

100. Renaissance: Frames and ornaments based on woodwork, 16th century.

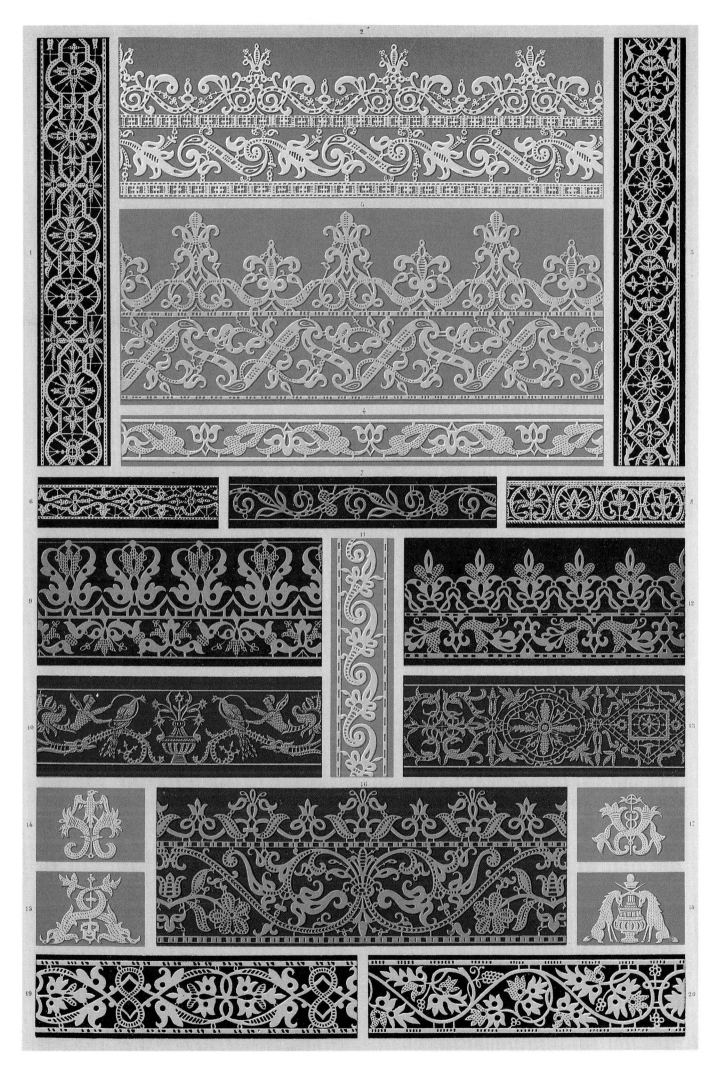

101. Renaissance: Lace motifs from a volume published in Liège in 1597.

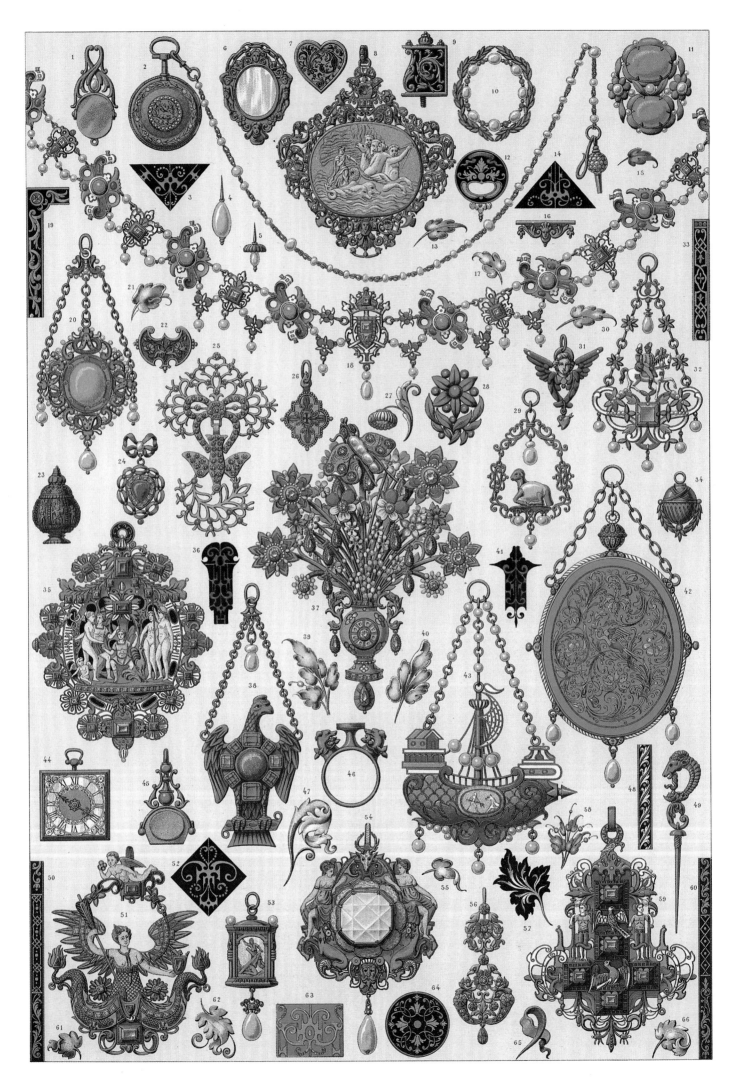

102. 15th–18th Centuries: Jewelry.

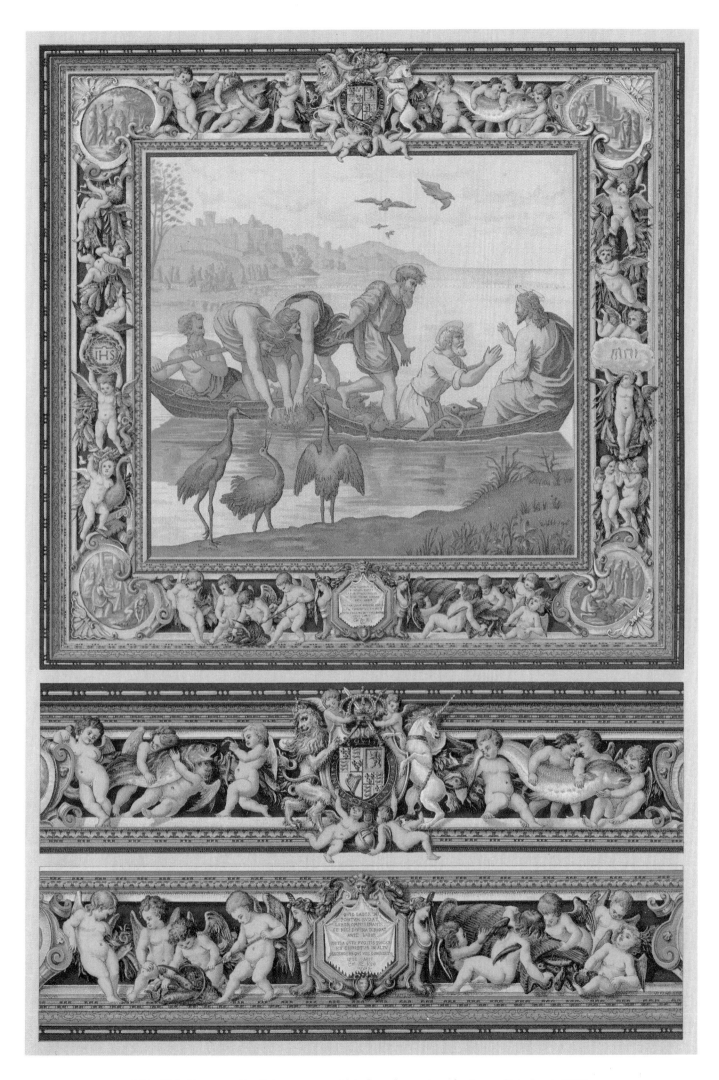

103. 17th Century: English tapestry said to have been given by James II to Louis XIV.

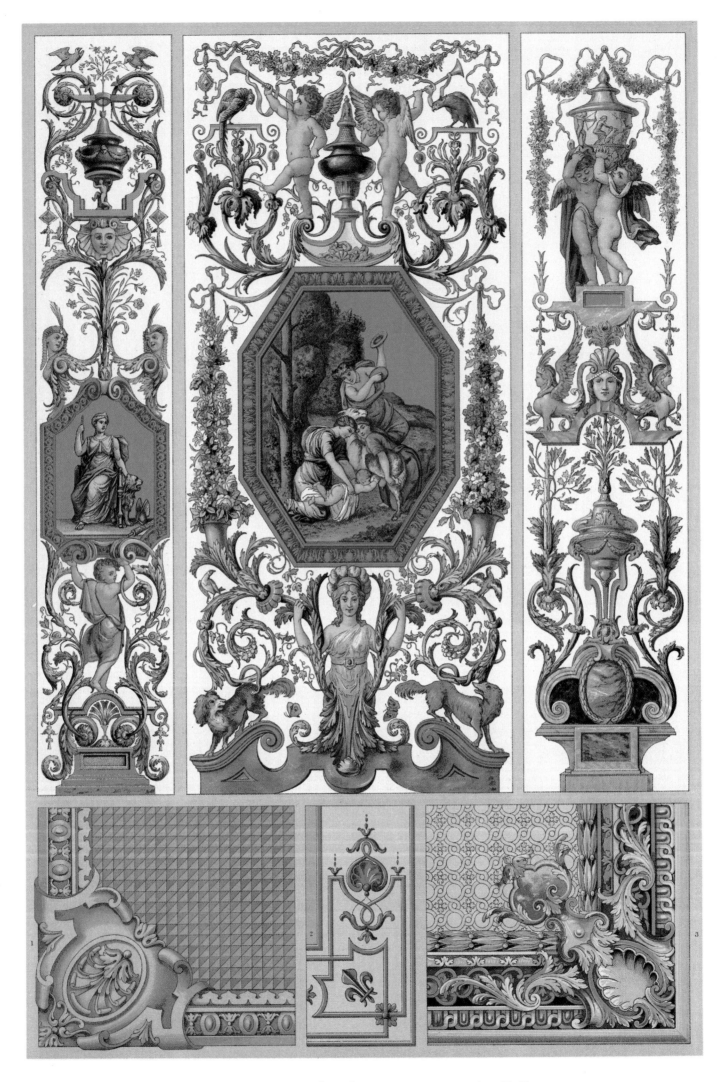

104. 17th Century: Interior décor (painting, tapestry, woodwork), France.

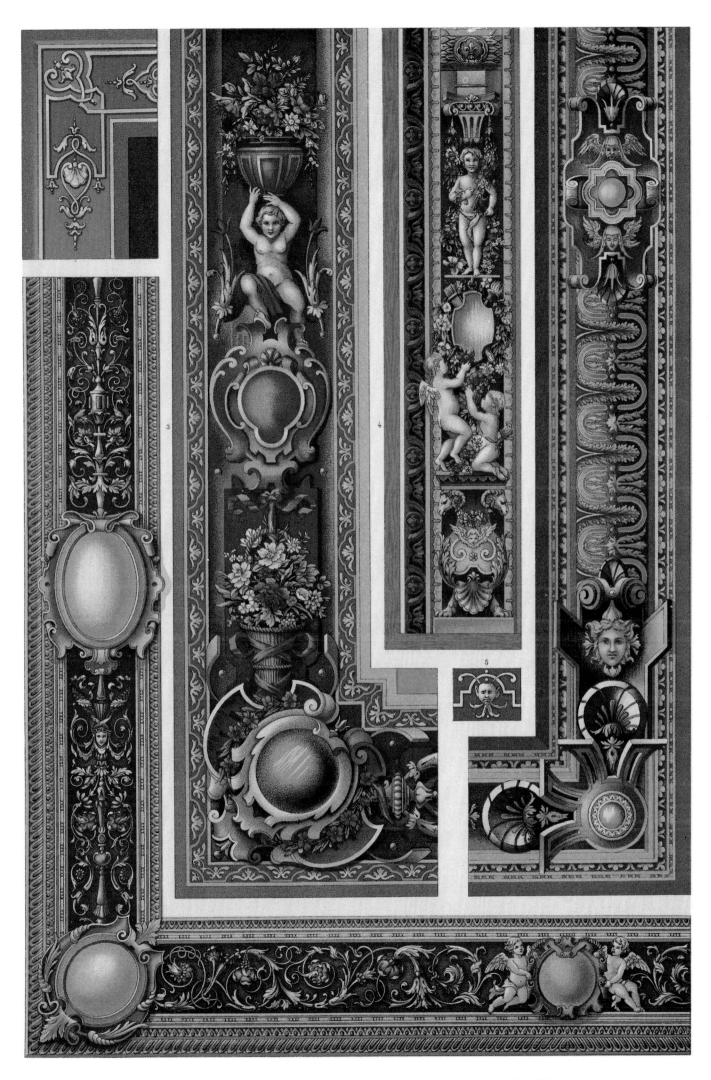

105. 16th and 17th Centuries: Tapestry borders and corners, England and France.

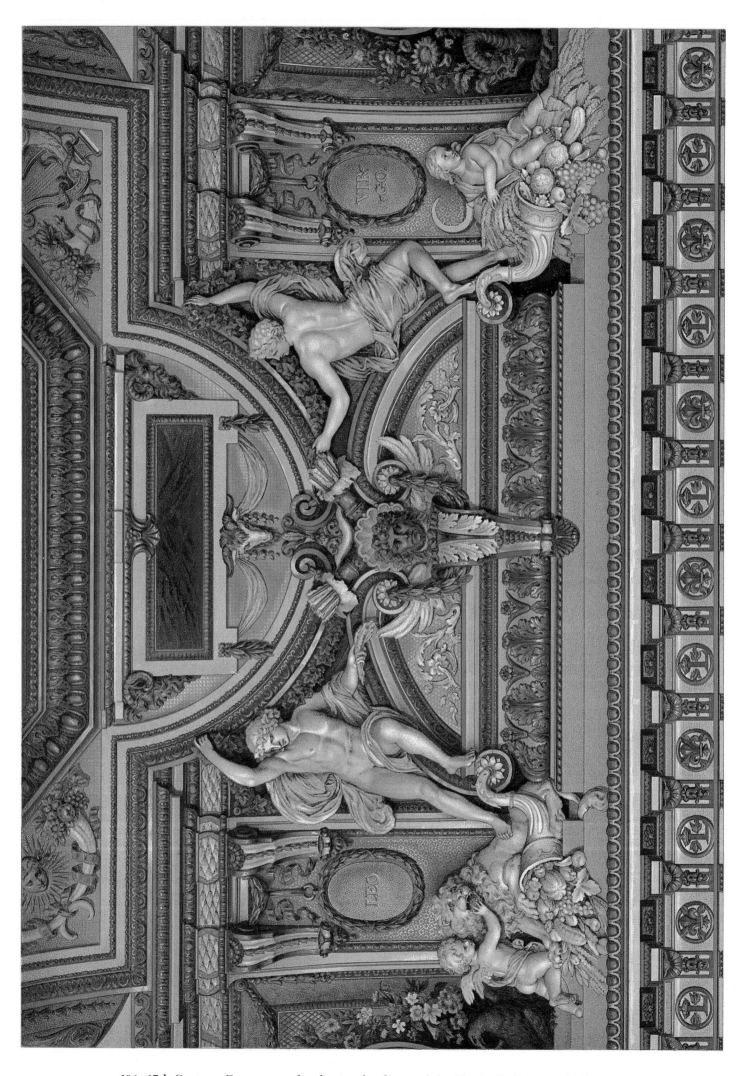

106. 17th Century: From a carved and painted ceiling vault by Charles Le Brun in the Louvre.

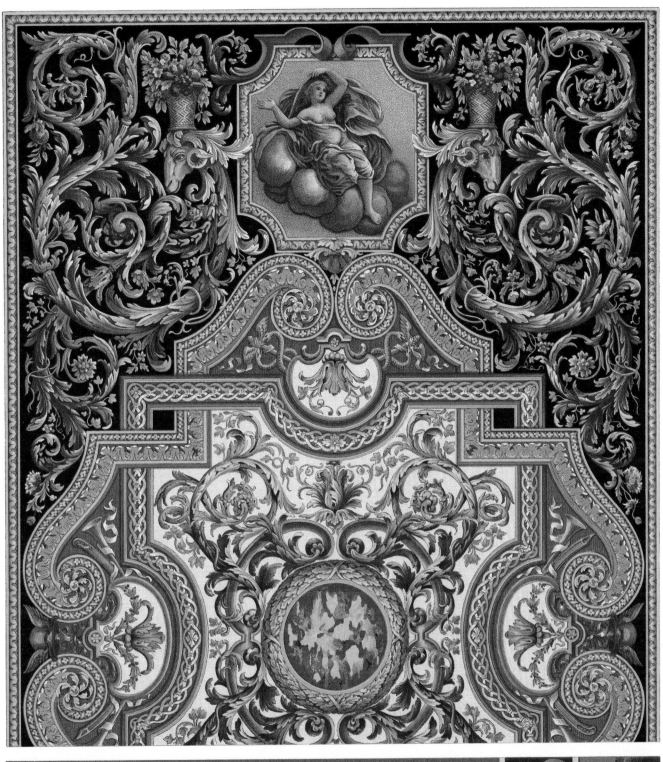

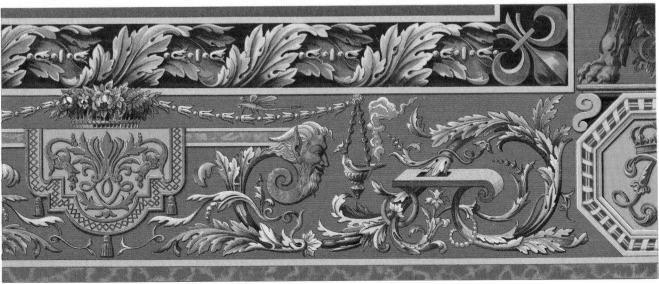

107. 17th Century: Details from a carpet and a wall hanging, France.

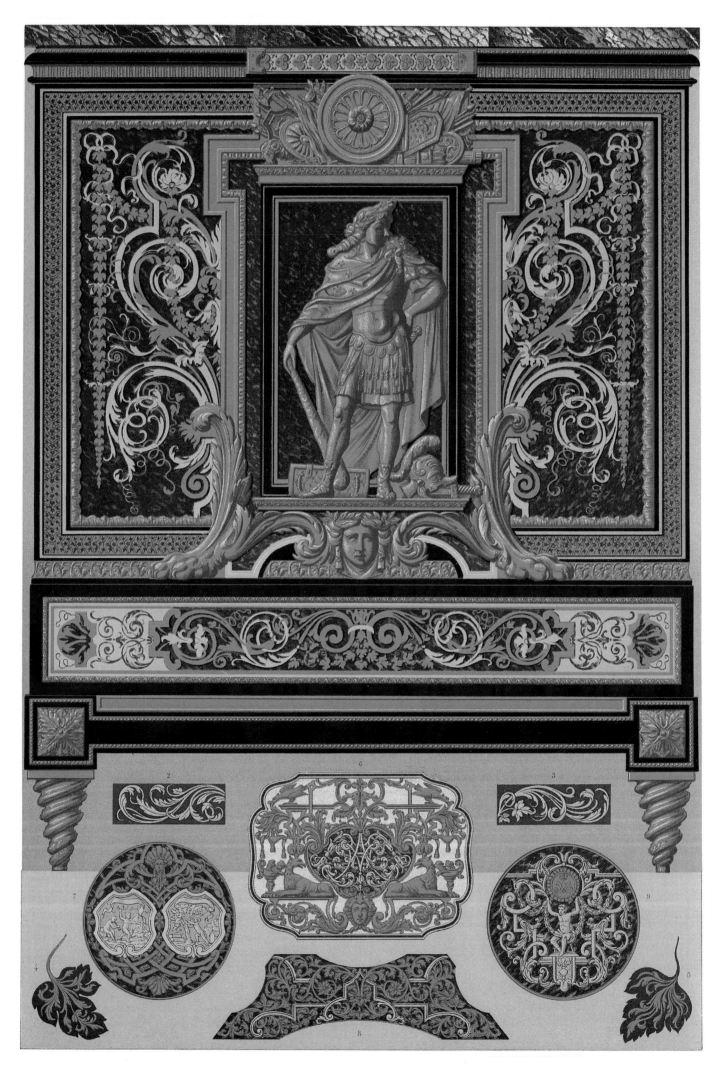

108. 17th Century: Metallic inlay from furniture, France.

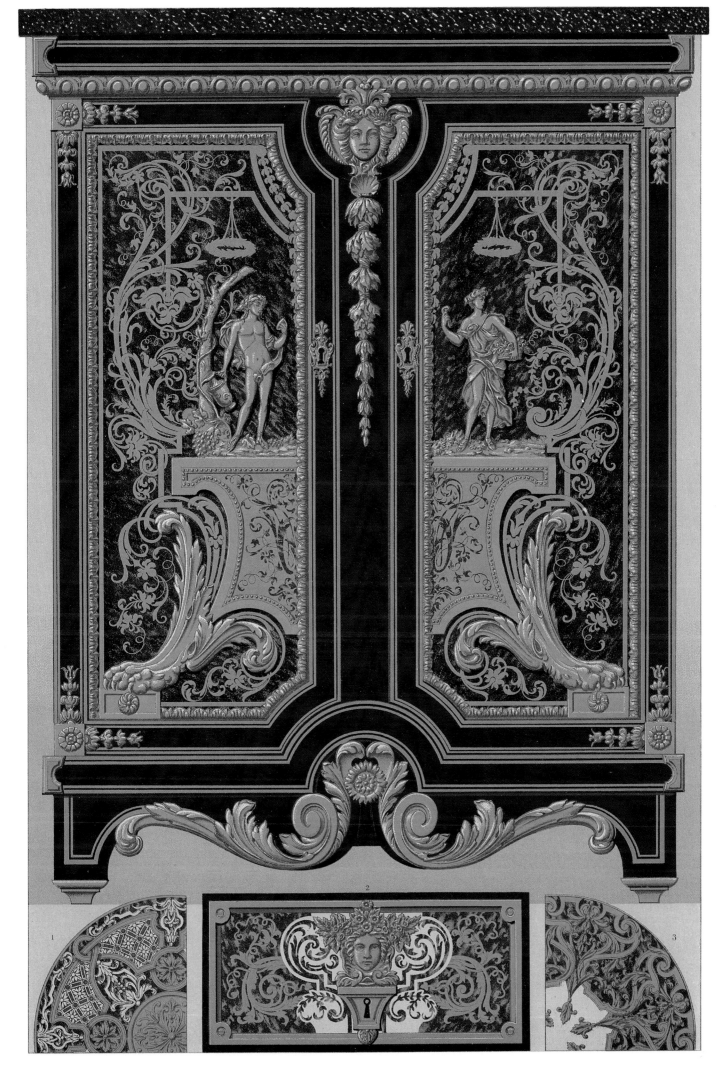

109. 17th Century: Metallic inlay from furniture, France.

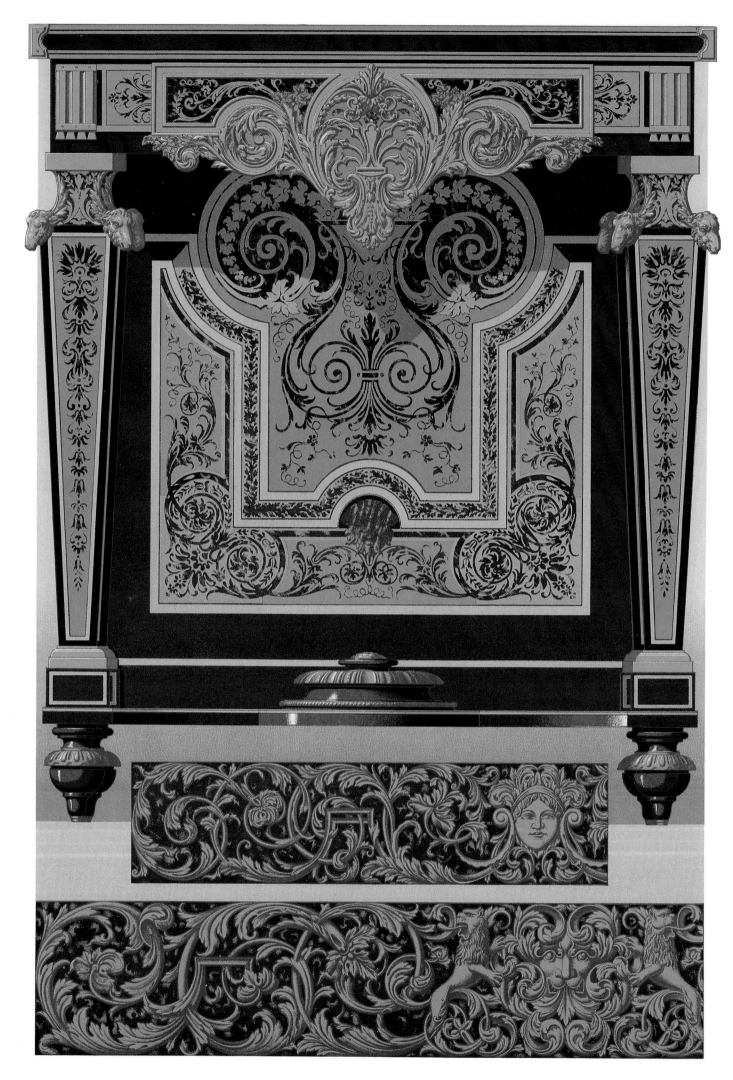

110. 17th Century: Console table by Charles-André Boulle with metallic inlay.

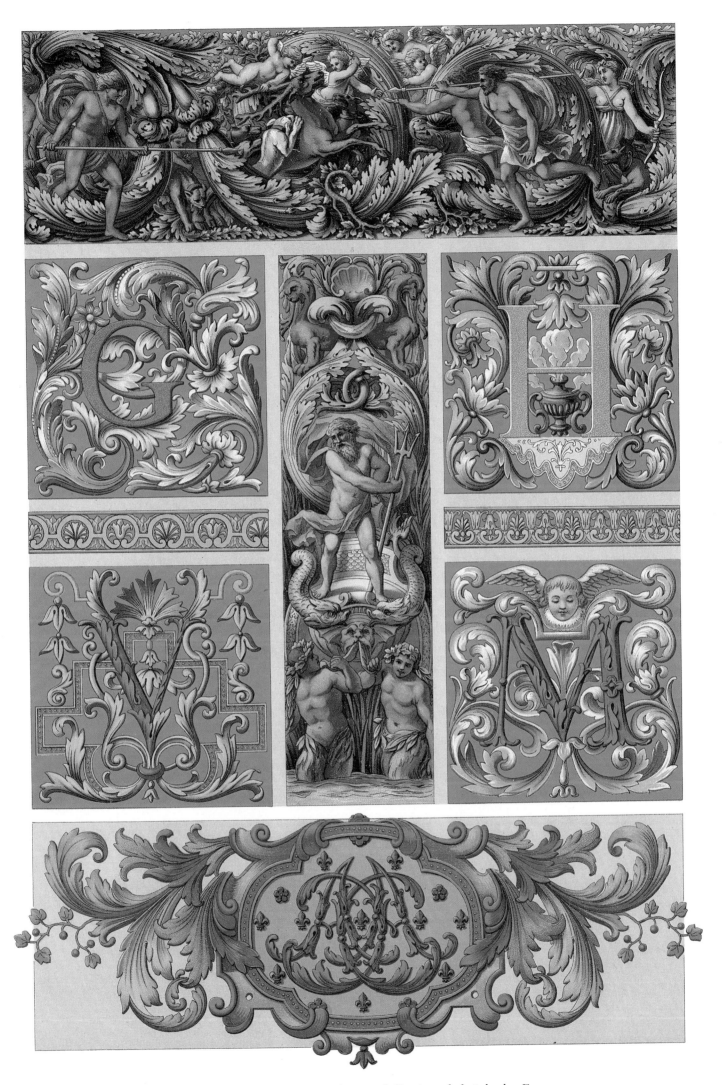

111. 17th Century: From interior decor and illuminated choir books, France.

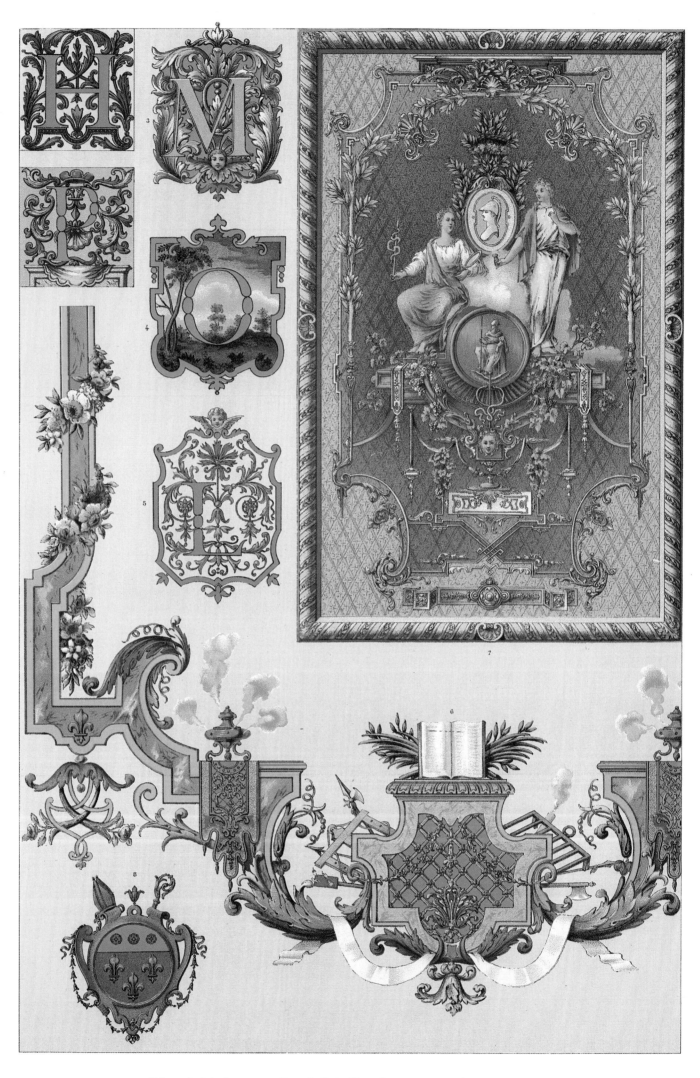

112. 17th and 18th Centuries: Details from French tapestries and miniature paintings.

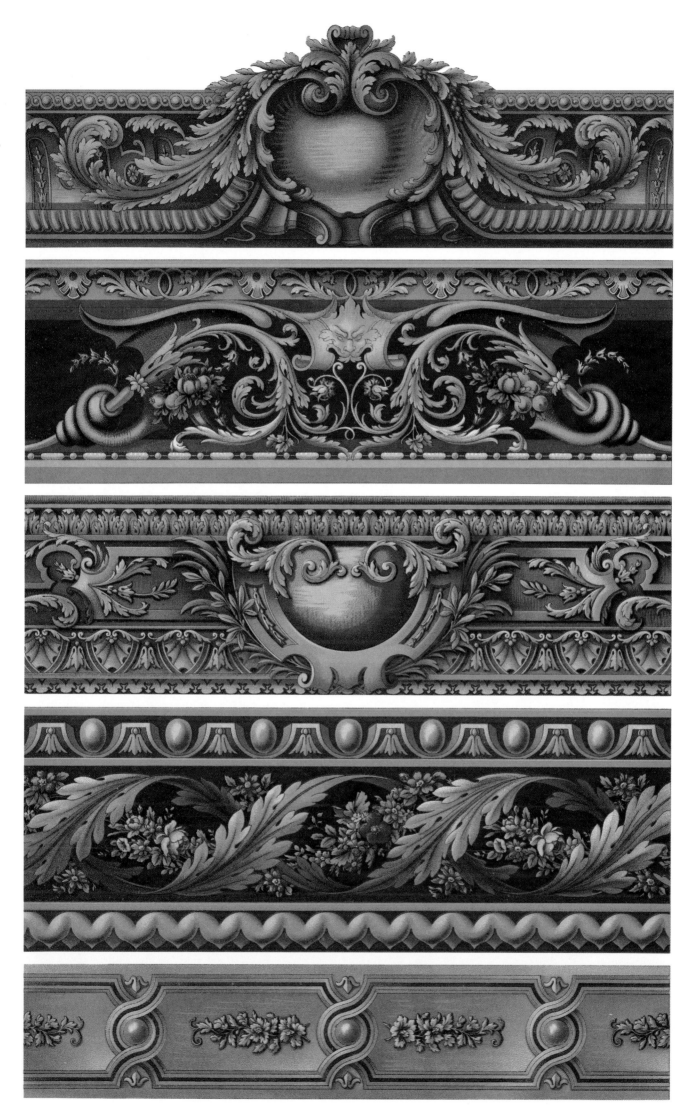

113. 17th and 18th Centuries: Details from French tapestries.

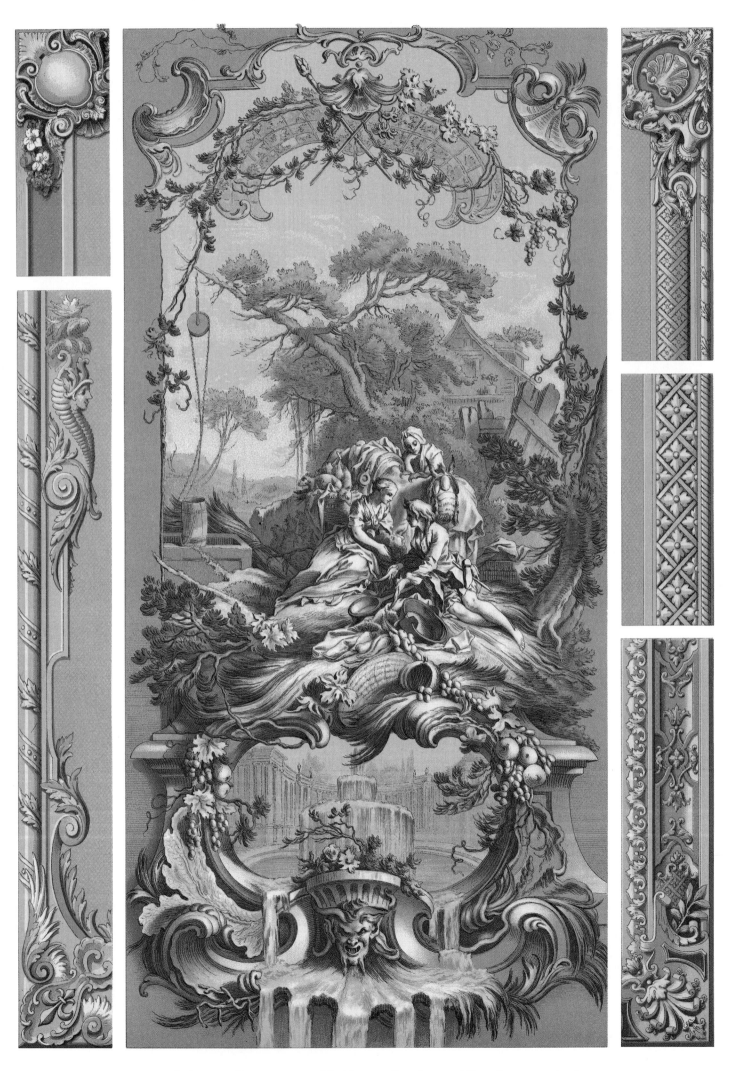

114. 18th Century: Decorative panel by François Boucher, and French tapestry borders.

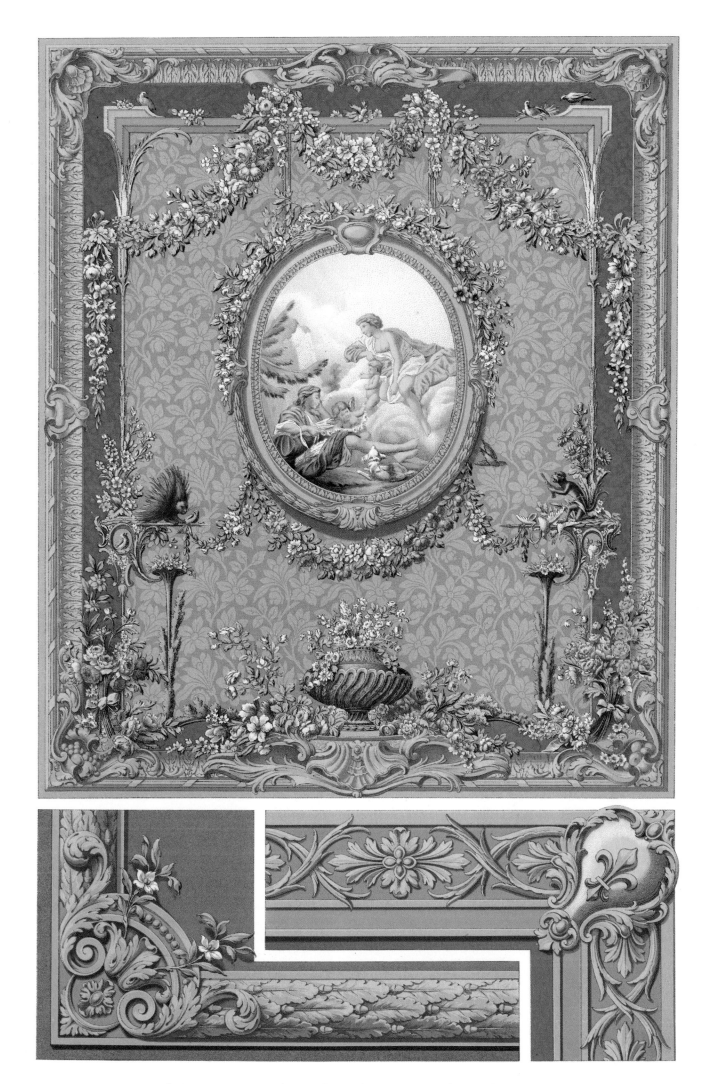

115. 18th Century: Tapestry by Boucher and Louis Tessier; details of tapestry corners.

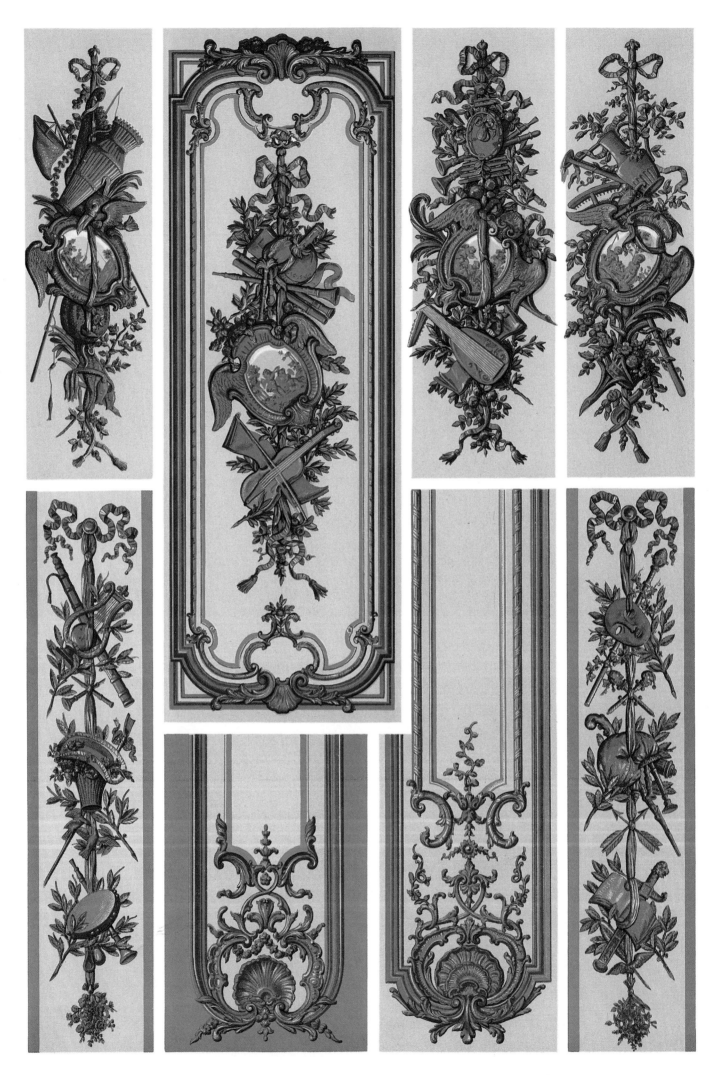

116. 18th Century: Carved and gilt wall panels from the palace of Versailles.

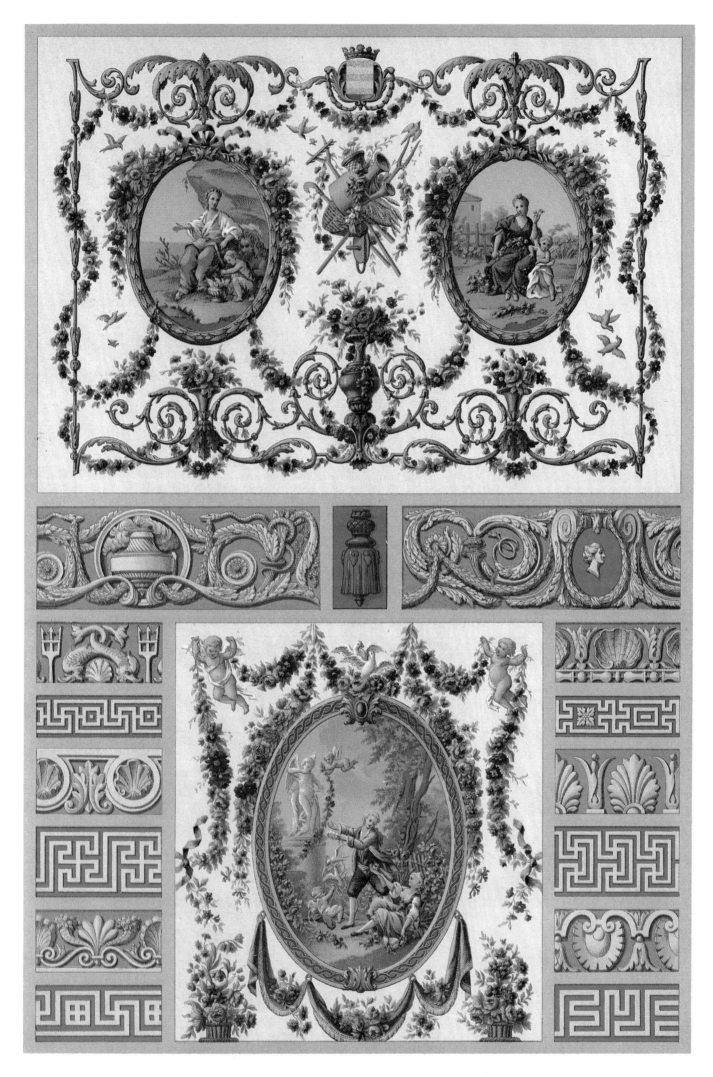

117. 18th Century: Details from French tapestries and wall panels.

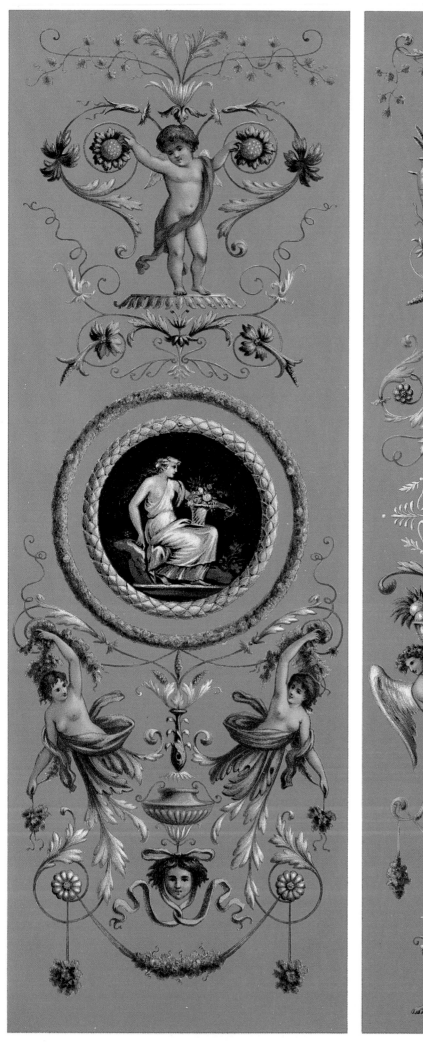
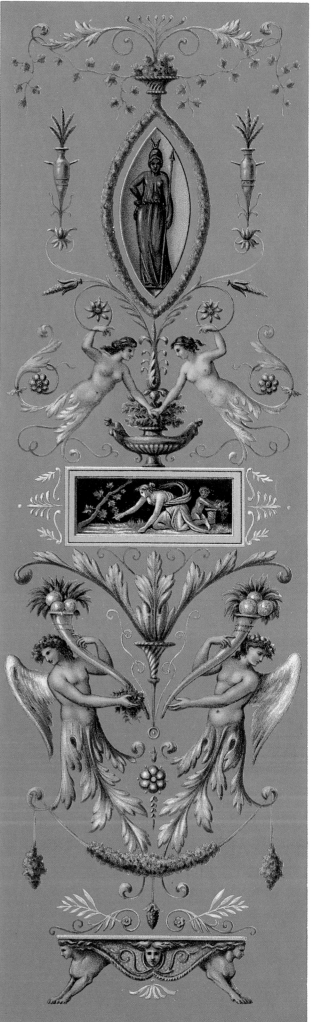

118. 18th Century: Paintings on the glass panes of a Louis XVI armoire.

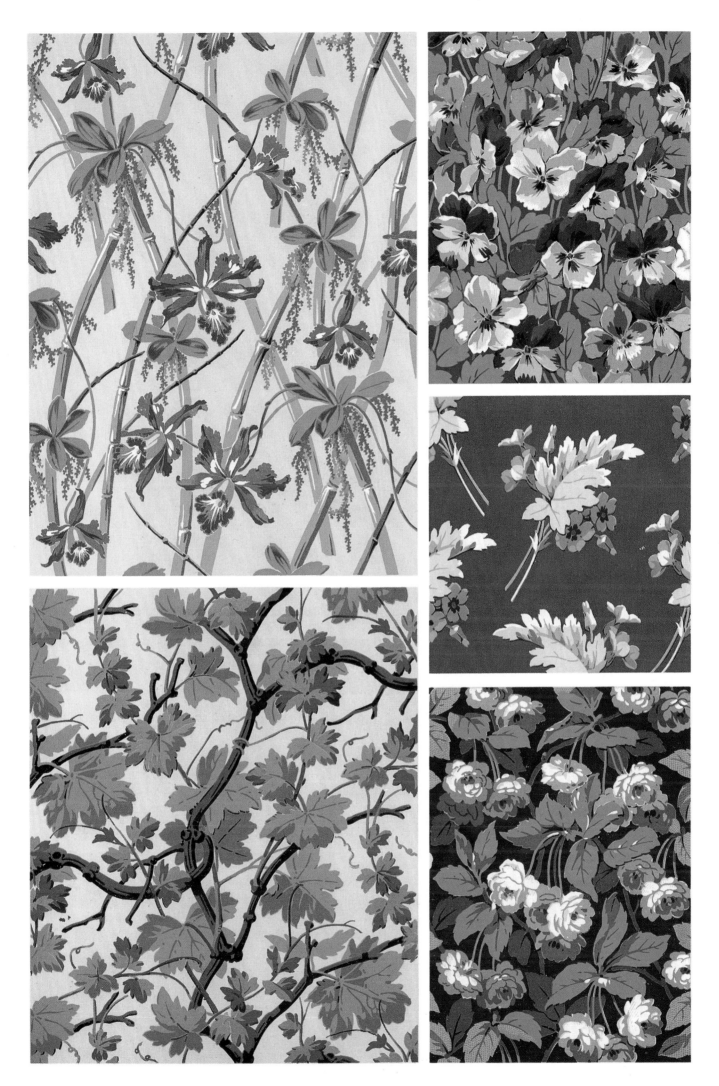

119. 19th Century: Designs from painted fabrics and wallpapers.

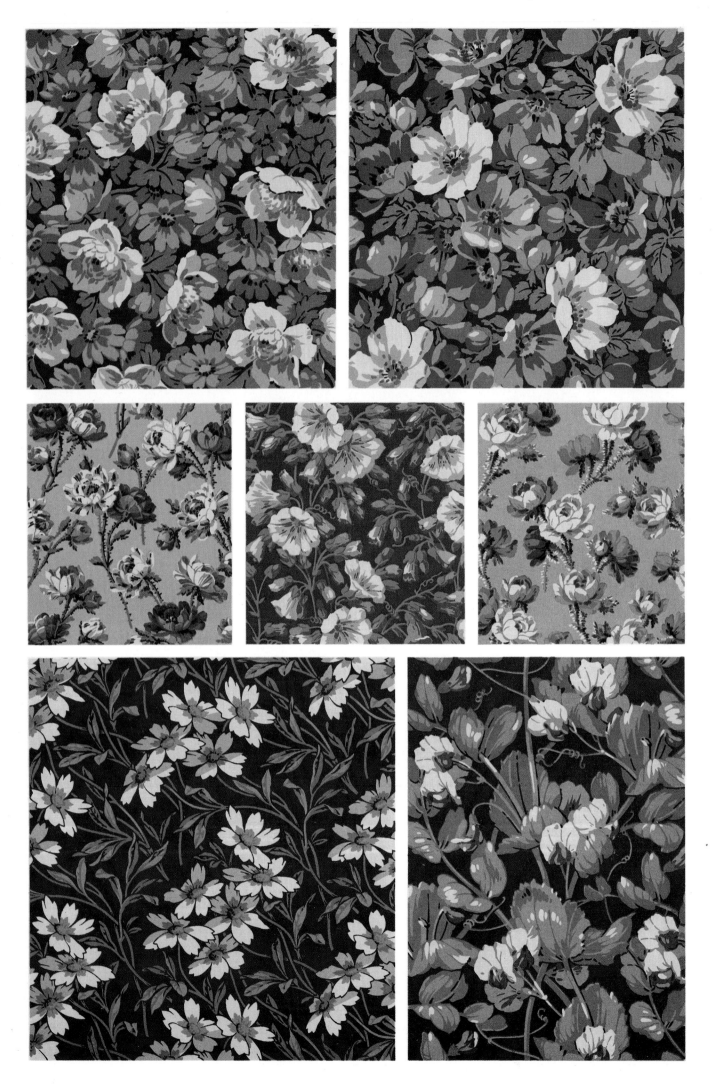

120. 19th Century: Floral designs from printed fabrics.